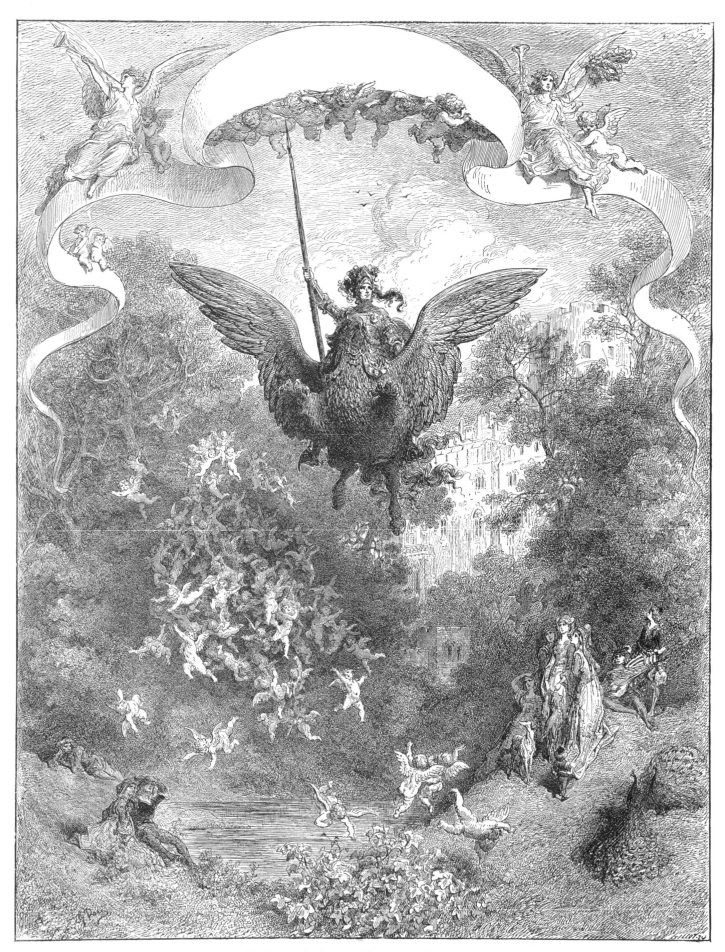

A knight on the hippogriff (original frontispiece).

DORÉ'S
Illustrations for
ARIOSTO'S
"ORLANDO FURIOSO"

A Selection of 208 Illustrations by
GUSTAVE DORÉ

Dover Publications, Inc.
New York

Published in Canada by General Publishing Company, Ltd., 30 Lesmill Road, Don Mills, Toronto, Ontario.
Published in the United Kingdom by Constable and Company, Ltd.

Doré's Illustrations for Ariosto's "Orlando Furioso": A Selection of 208 Illustrations is a new selection of illustrations from *Ariost's Rasender Roland. Illustrirt von Gustav Doré. Metrisch übersetzt von Hermann Kurz, durchgesehen und herausgegeben von Paul Heyse*, originally published by S. Schottlaender, Breslau, n.d. (See the Introduction for further bibliographical details.) The selection, Introduction and captions were done specially for the present edition by Stanley Appelbaum.

DOVER *Pictorial Archive* SERIES

International Standard Book Number: 0-486-23973-X
Library of Congress Catalog Card Number: 79-55233

Manufactured in the United States of America
Dover Publications, Inc.
31 East 2nd Street
Mineola, N.Y. 11501

INTRODUCTION

The outstanding nineteenth-century French book illustrator Gustave Doré (1832–1883) wanted his name to be associated with the greatest possible number of classics of world literature. To mention just high points, his Perrault appeared in 1861, his *Don Quixote* in 1863, his *Paradise Lost* and *Bible* in 1866, his La Fontaine in 1867, his complete *Divine Comedy* in 1868, his definitive Rabelais in 1873 and his *Rime of the Ancient Mariner* in 1875.

Doré's last major undertaking was the 618 illustrations for Ariosto's *Orlando Furioso*, the major epic poem of the Italian Renaissance, which was to be endlessly influential in form and content (Tasso's *Gerusalemme Liberata*, Spenser's *Faerie Queene* and Byron's *Don Juan* are just three of the works indebted to Ariosto). Always intrigued by medieval settings, battles, amorous escapades, monsters and sorcerers, Doré must have welcomed the challenges offered by Ariosto's unbridled imagination and sly humor, and by the world-ranging adventures contained in the great poem.

Lodovico (or Ludovico) Ariosto, born at Reggio Emilia in 1474, moved to the duchy of Ferrara when he was ten, and spent his life—as courtier, diplomat, travel companion, military governor—in the service of the Ferrarese ruling family. His master from 1503 to 1517 was Cardinal Ippolito d'Este, brother of the Duke of Ferrara; from 1518 on, Ariosto served the Duke himself. Author of several other poems and of significant plays, Ariosto is best known for his huge epic (46 cantos, each containing from 72 to 199 eight-line stanzas in *ottava rima*), of which the first edition appeared in 1516 and the third (last in the author's lifetime) in 1532.

Like all Renaissance literature, *Orlando Furioso* borrows many themes and details directly from Greek and Roman sources, but its large-scale structure is basically a clever intermingling of two epic strands that had been strongly developed in medieval literature. One of these strands was the Charlemagne legend, in which the historical Frankish king Charles the Great (742–814) was elevated to the position of sacred defender of European soil against Islam, with his nephew Roland as his doughtiest champion. The other chief strand was the vast Arthurian cycle, in which knights errant, living up to an intricate code of love and honor, roamed the world in search of magical, mystical and romantic adventures.

The first poet to combine these strands was Ariosto's predecessor Matteo Boiardo (1434–1494), whose never-completed *Orlando Innamorato* appeared in 1483. As the title indicates, Orlando (= Roland) here falls in love —as do many other heroes, both Christian and Moorish

—with Angelica, an exquisite virgin princess from India who rebuffs them all. Ariosto's poem was actually a continuation of Boiardo's, with many of the same characters. Even though Orlando is not the central figure, Ariosto chose a title that made clear the connection between the two works (*Furioso* indicates that Orlando goes raving mad—over his thwarted love). Ariosto's poem, however, is far superior to Boiardo's in every way.

Because the plot of *Orlando Furioso* is incredibly complex—with an impressive array of characters, with numerous interweaving subplots that continually submerge and reemerge, sometimes after a considerable hiatus, and with many interpolated tales—it would take pages merely to give an outline of the events in their original sequence. Here, only a few of the major plot elements can be discussed.*

The basic situation is the confrontation of Christians and Moors in Europe. When *Orlando Furioso* begins, the Moors are masters of Provence and are capable of besieging Paris. The personal derring-do of Rodomonte, king of Algiers (whose braggadocio has given us the English word rodomontade) almost makes this siege successful, but Rodomonte's own romantic problems, and the opportune arrival of troops enlisted in Britain by the Christian hero Rinaldo, foil Moorish plans. The Mohammedans are driven out of France in southward-moving thrusts. Meanwhile, another Christian warrior, Astolfo, has led a pincers movement across the Sahara from Ethiopia. Moorish strongholds in North Africa are successfully besieged, and then the Moorish refugee fleet is wiped out. A total Christian victory—but not the end of the poem.

Another basic strand, as we have already seen, is the enormous sexual attraction exerted by the aloof Angelica. The poem begins with several knights in pursuit of her. Eluding them all, she falls into the deceitful hands of a pious-looking hermit who proves to be a lustful sorcerer. His unwanted attentions finally cause Angelica to be exposed on a sea cliff as a morsel for an insatiable marine monster. She is rescued by the

*This plot summary, as well as the picture captions in the present edition, are based on the reliable Italian text in the four triple volumes in the Biblioteca Universale Rizzoli (1955). The original Italian form is retained for all personal names, with the exception of Charlemagne and the Byzantine monarchs Constantine and Leo (Carlo, Costantino and Leone, respectively, in the Italian); for names of real places, the modern English form is used. Several English translations of *Orlando Furioso* are currently available for those who have not yet had the pleasure of reading it.

Moorish knight Ruggiero. (Orlando eventually kills the monster on a later occasion.) Angelica keeps escaping from men until she herself is suddenly smitten by the handsome Moorish boy Medoro. During their tender honeymoon as the guests of some shepherds, the couple scratch their entwined names onto every rock and tree in the neighborhood; after a few more adventures, Angelica makes it back safely to India and reigns there with Medoro.

On his wanderings, the enormously strong Orlando (who does something noble and magnificent every time he appears, but rarely anything that moves the plot along) comes across the commemorative trees and rocks that prove that Angelica is no longer a virgin. He immediately goes mad and rips off his clothes. For most of the rest of the poem he is a menace to society, killing people indiscriminately, uprooting trees, etc. Finally, the same Astolfo who conquers Africa for Christianity is escorted by St. John the Evangelist to the moon, which is a repository for all things lost on earth; he bottles Orlando's lost reason in the form of a vapor and makes Orlando inhale it when their paths cross. (Rinaldo also needs a special cure, in the form of a religious retreat, to get Angelica off his mind.)

Although the poem is almost too fragmented to have a single heroine and a single hero, the couple who come closest to filling those roles are Bradamante and Ruggiero (rescuer of Angelica). Bradamante, sister of Rinaldo, usually wears armor and is more than a match for any adversary, even the redoubtable Rodomonte, but never sacrifices her womanliness; toward the end of the poem, when her wedding day approaches, she becomes more and more passive and demure. Ruggiero fights on the Islamic side; he would gladly convert for Bradamante's sake, but cannot desert his old comrades in wartime—until a technicality finally allows him to do so with honor.

Many of the events in the poem also take place *because of* Ruggiero. The solicitous sorcerer Atlante fears for the young man's life and is constantly whisking him away out of danger. First Atlante imprisons Ruggiero, then, when Bradamante releases him, has Ruggiero carried off by the hippogriff (a horse-griffin hybrid) to Alcina's never-never-land of love play. When Bradamante's right-hand sorceress, Melissa, gets him out of *that* entanglement, Atlante constructs a palace of illusions to entrap him; and so on. But Ruggiero gets to do his share of hard fighting and eventually, against enormous odds, wins Bradamante's hand. Thus, all the prophecies made in the poem can be fulfilled, and Ruggiero and Bradamante can become the ancestors of the Este family, Ariosto's patrons. At the very end of the poem, Rodomonte reappears and Ruggiero must undergo a final combat with that most valiant of all the Moors.*

Doré's illustrations for Ariosto were first published in a single folio volume by the Librairie Hachette in Paris in 1879 (some bibliographical works give 1878) with the title *Arioste. Roland furieux, poème héroïque, traduit par A.-J. du Pays et illustré par Gustave Doré.* Besides the frontispiece and the 81 full-page plates, there were 536 (some sources give 550) text illustrations of all sizes. In the case of many of the smaller pictures, Doré was able here for the first time to present his wiry and exuberant pen style directly to the public without recourse to the intermediate services of his team of wood-engravers. The reproductive process used for the pictures in question was *gillotage,* a zinc-engraving technique invented by Firmin Gillot (1820–1872).

Several foreign editions quickly followed the French first edition. The extremely well printed source of the reproductions in the present volume is the Breslau edition published by S. Schottlaender, *Ariost's Rasender Roland. Illustrirt von Gustave Doré. Metrisch übersetzt von Hermann Kurz, durchgesehen und herausgegeben von Paul Heyse.* The two folio volumes of this edition, which lack a printed date, were issued in 1880 and 1881.

The present volume includes the full-page frontispiece (the castle depicted is said to represent Warwick Castle, where Doré had been a guest of the Earl of Warwick), all the original full-page plates, a number of illustrations that originally appeared along with text but here fill a page alone, and a generous sampling of the smaller, zinc-engraved pictures.

Some severe critics have felt that this last major work by Doré adds nothing new to his creative production, and that in this case the artist's imagination did not soar as high as his author's. Doré devotees will nevertheless find much to enjoy and admire. An incomparable feeling of metaphysical gloom pervades many of the scenes. The settings, both interior and exterior, often seem to overwhelm the tiny human figures, who thus appear to be helpless pawns of destiny. The actual events sometimes occur in the middle ground or background of a spacious outdoor setting. Architecture and architectural ornament, both Neo-Gothic and Neo-Moorish, fascinate the artist here. Some of his best draftsmanship and most interesting compositions for *Orlando Furioso* occur in the L-shaped headpieces to the cantos (the opening of the text originally filled the missing corner); the challenge of the unusual shape was obviously a salutary one. Doré's early talent for cartooning still has echoes in this late work in such studies as Drusilla's servant (page 118, top left, in the present volume) and Anselmo's astrologer friend (page 139, top left).

A few of the illustrations are not only memorable but haunting. The use of deep perspective and mirrored action in the palace of illusions scene (page 39) creates a highly effective image of existential bewilderment; the long corridor and the woman mysteriously seated on the low wall call to mind the passage to the underworld in Cocteau's film version of *Orphée.* The scene at Rodomonte's narrow bridge (page 92) is a chilling nightmare full of Freudian overtones. All in all, this group of illustrations is well worth careful attention and repeated revisits.

*The captions in the present volume cover the action more specifically. They also refer to canto and stanza numbers of the original Italian in the form 25:72 (Canto 25, stanza 72).

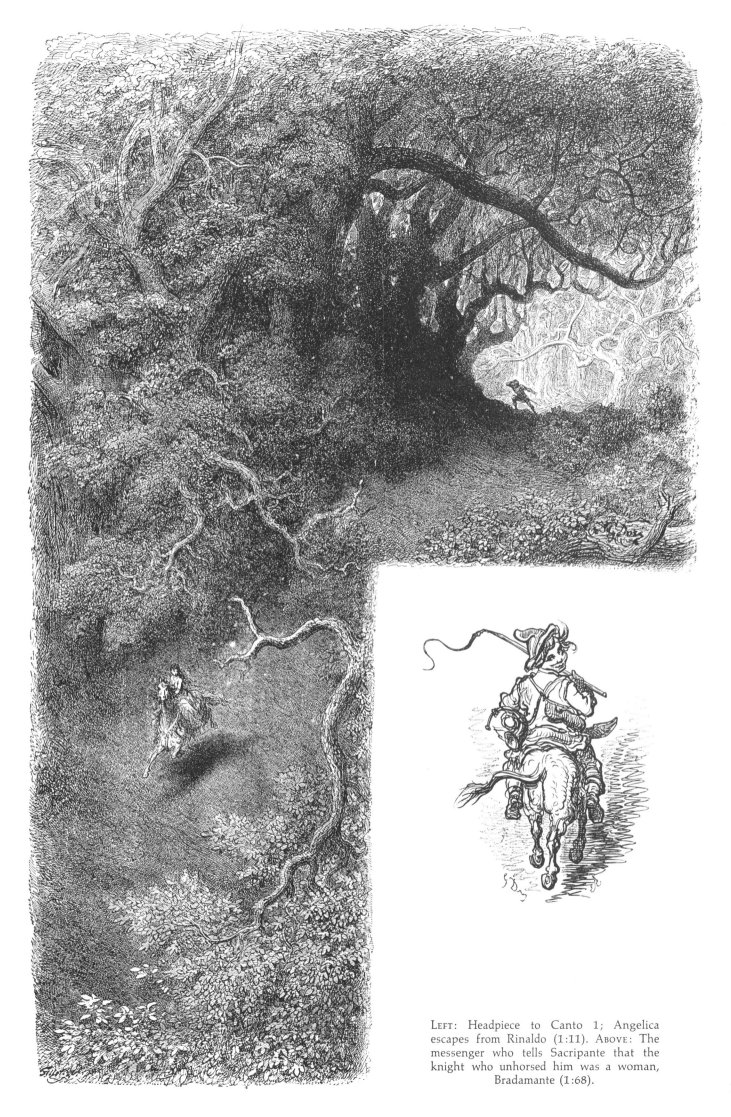

LEFT: Headpiece to Canto 1; Angelica escapes from Rinaldo (1:11). ABOVE: The messenger who tells Sacripante that the knight who unhorsed him was a woman, Bradamante (1:68).

1

Top: Angelica flees as Rinaldo fights with Ferraù (1:17). Bottom: Sacripante attempts to seize Rinaldo's horse Baiardo (1:74).

Angelica consoles Sacripante after the unknown knight has unseated him (1:67).

Angelica encounters a hermit riding a donkey (2:12).

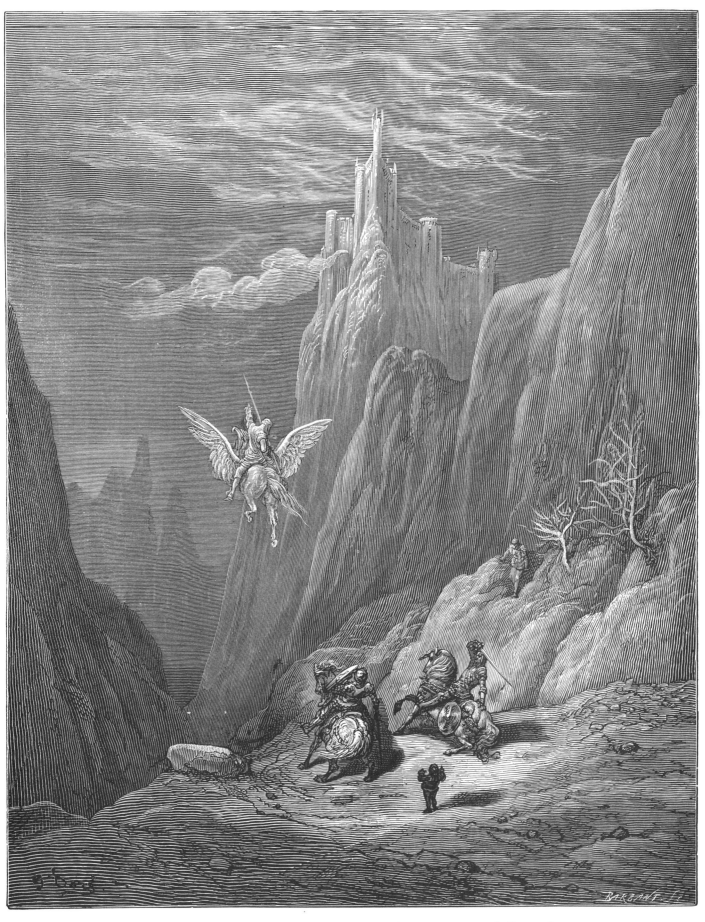

The rider of the hippogriff battles Gradasso and Ruggiero as Pinabello watches
(2:53)

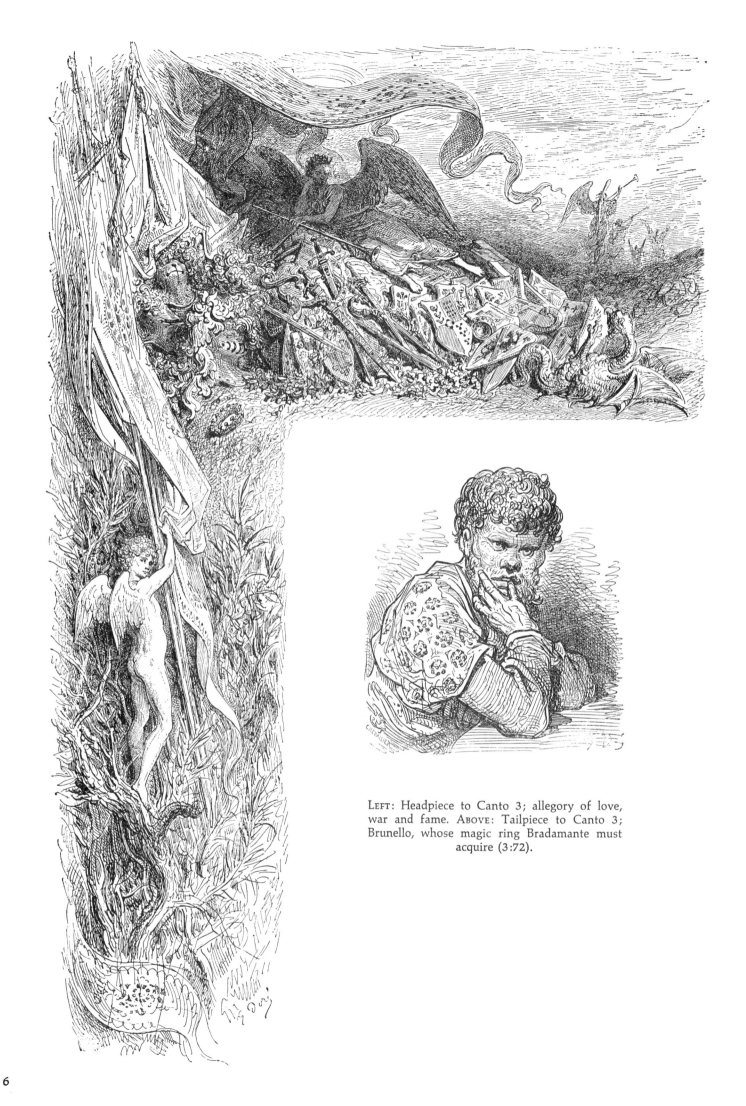

LEFT: Headpiece to Canto 3; allegory of love, war and fame. ABOVE: Tailpiece to Canto 3; Brunello, whose magic ring Bradamante must acquire (3:72).

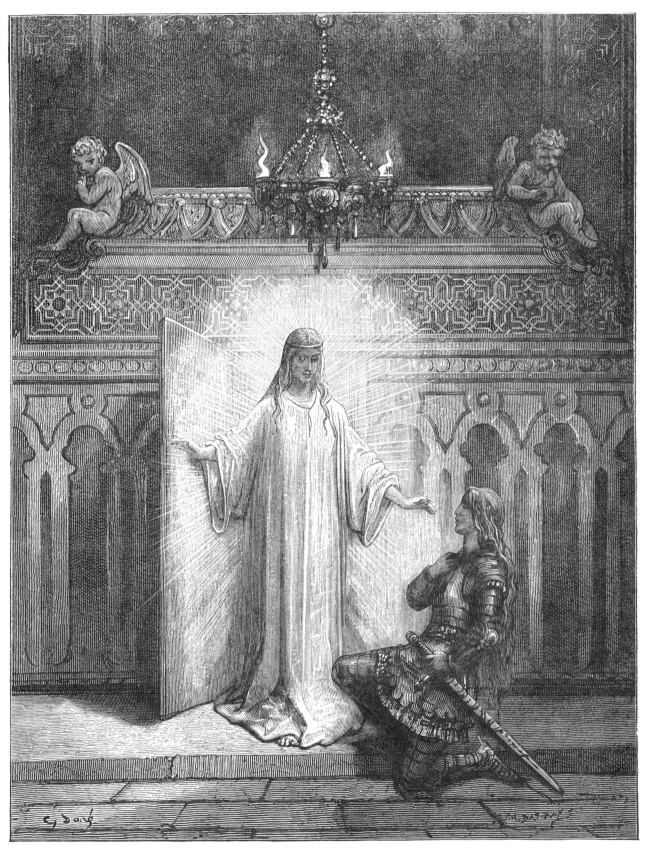

In Merlin's cave, Bradamante is greeted by the beneficent sorceress Melissa (3:9).

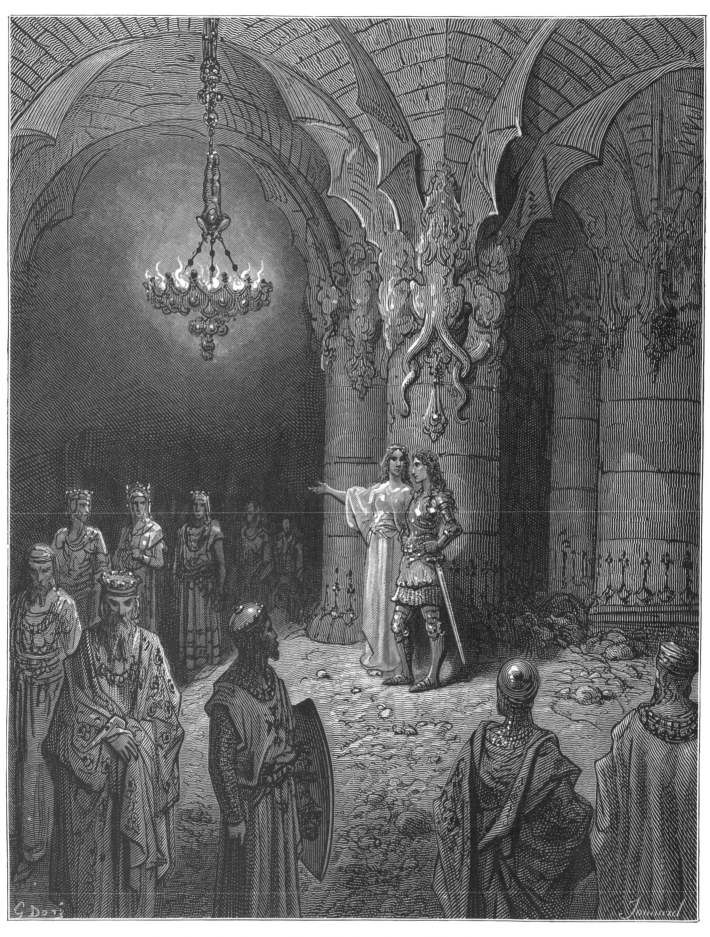

Melissa shows Bradamante the noble descendants of her future union with Ruggiero (3:24).

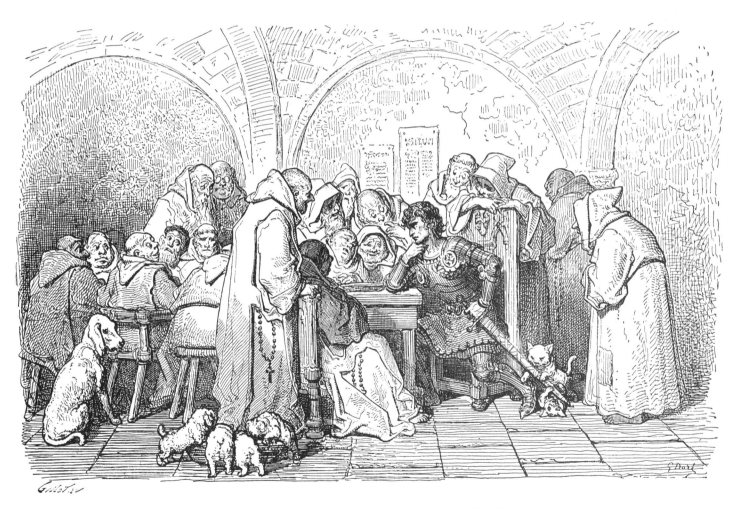

Top: Outside Bradamante's inn, everyone looks up at the hippogriff (4:4).
Bottom: Rinaldo is made welcome at the abbey (4:55).

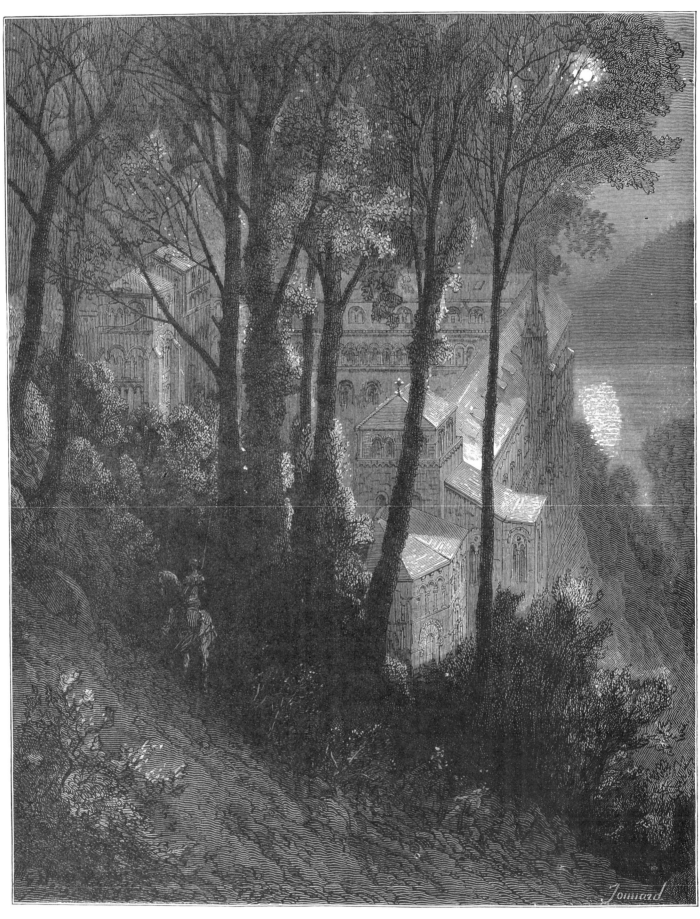

Rinaldo, traveling through a great forest in Scotland, approaches an abbey (4:54).

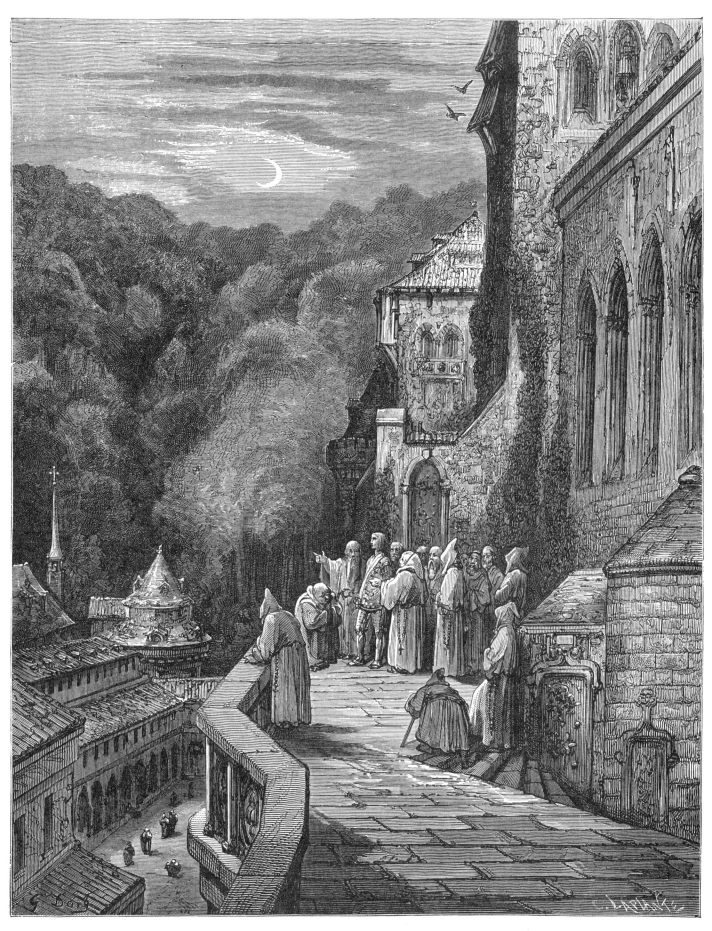

The monks tell Rinaldo where he can find adventures (4:56).

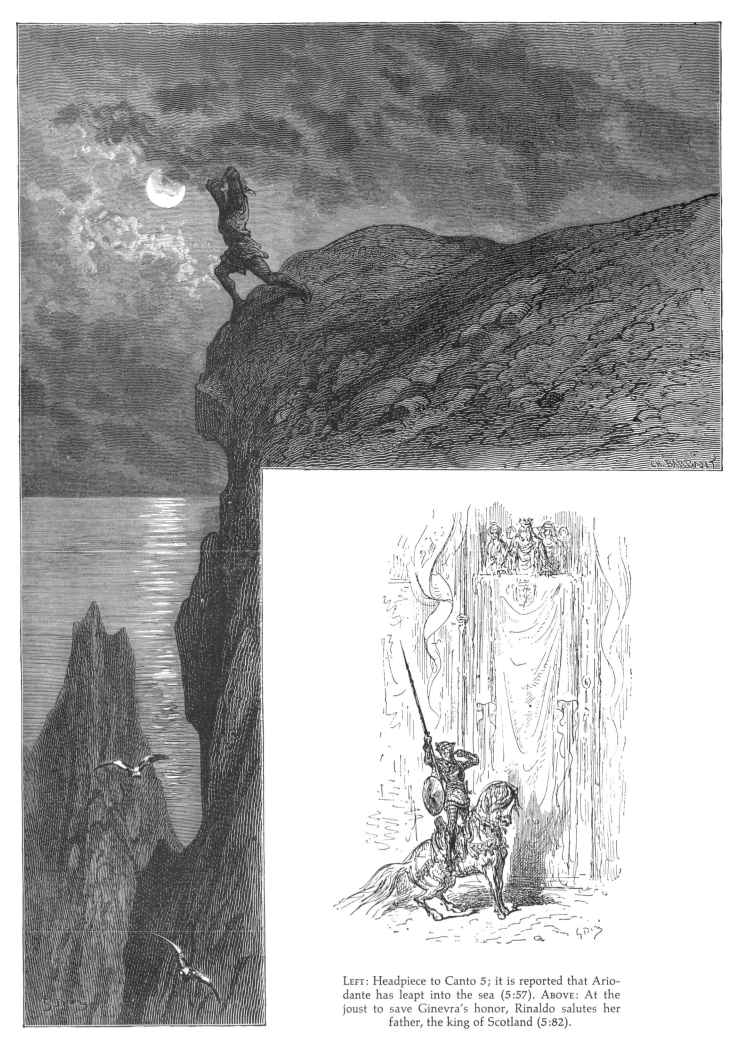

LEFT: Headpiece to Canto 5; it is reported that Ario-
dante has leapt into the sea (5:57). ABOVE: At the
joust to save Ginevra's honor, Rinaldo salutes her
father, the king of Scotland (5:82).

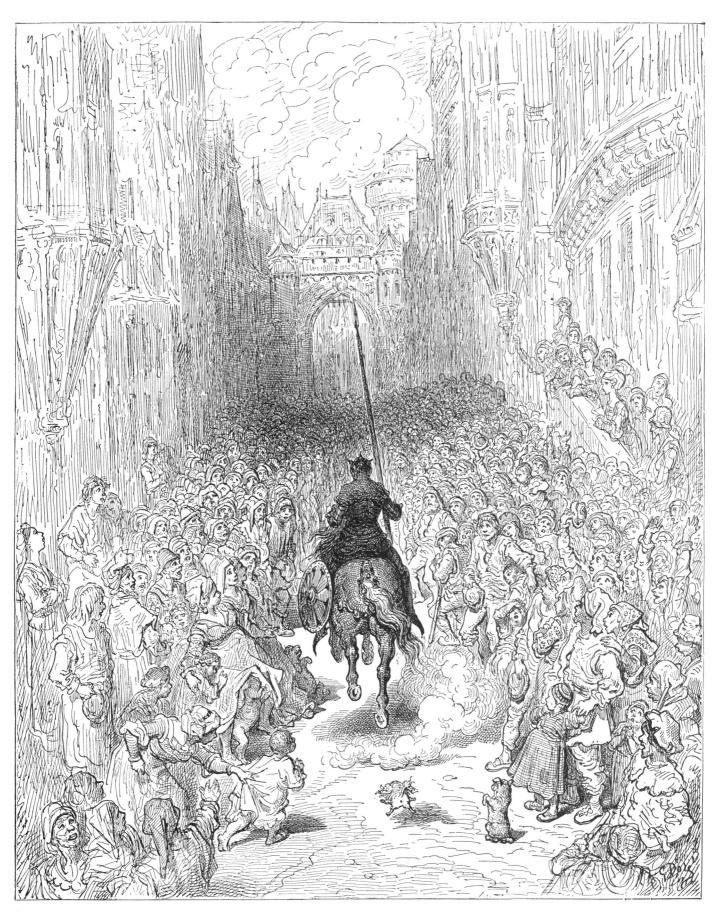

Rinaldo making his way to the joust (5:82).

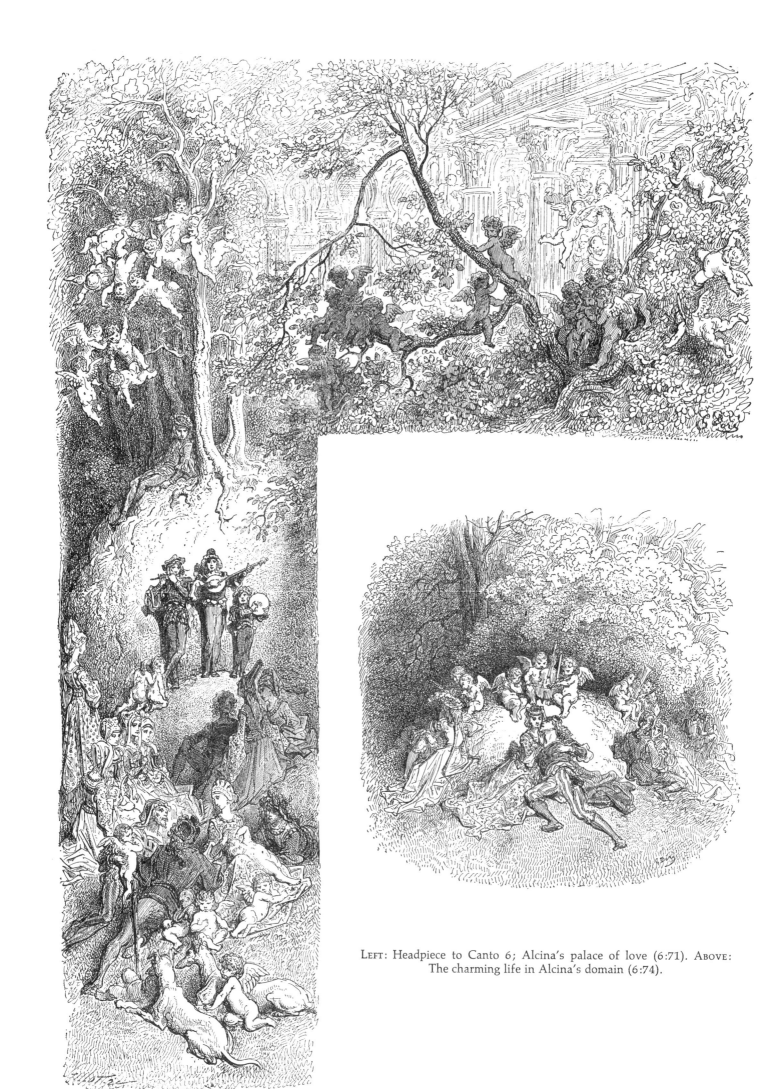

LEFT: Headpiece to Canto 6; Alcina's palace of love (6:71). ABOVE:
The charming life in Alcina's domain (6:74).

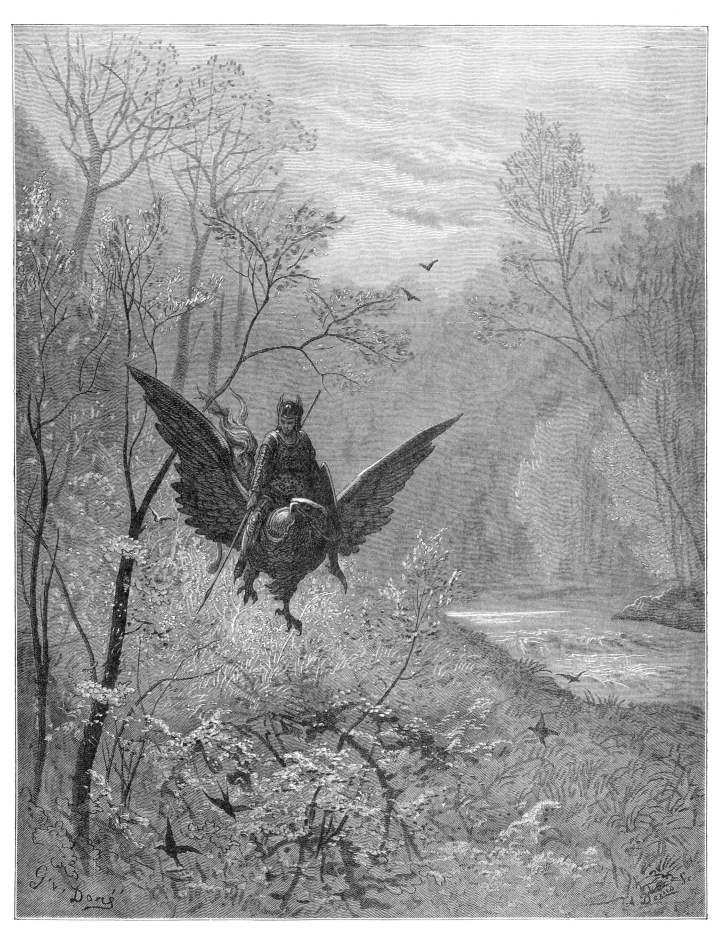

The hippogriff, which had flown off with Ruggiero, finally lands in a pleasant
region (6:20).

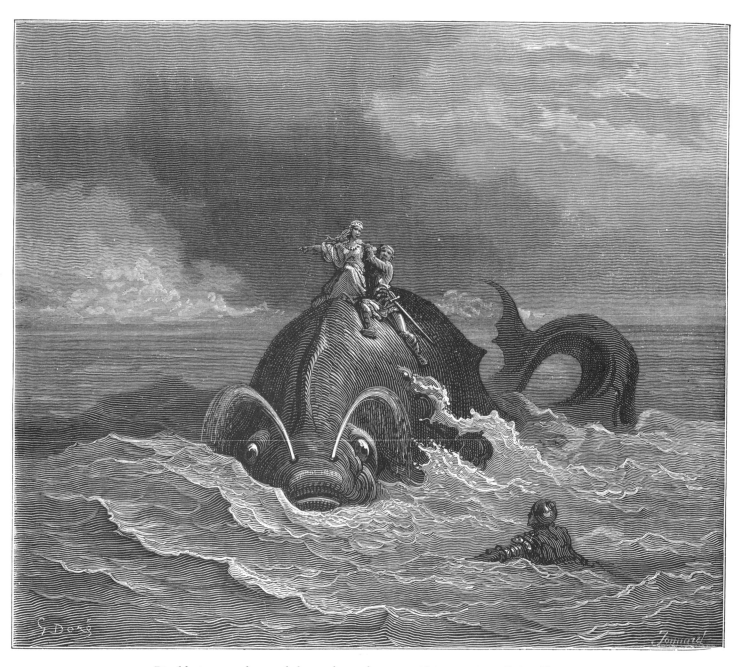

Rinaldo is powerless to help as the enchantress Alcina carries off Astolfo on a whale (6:42).

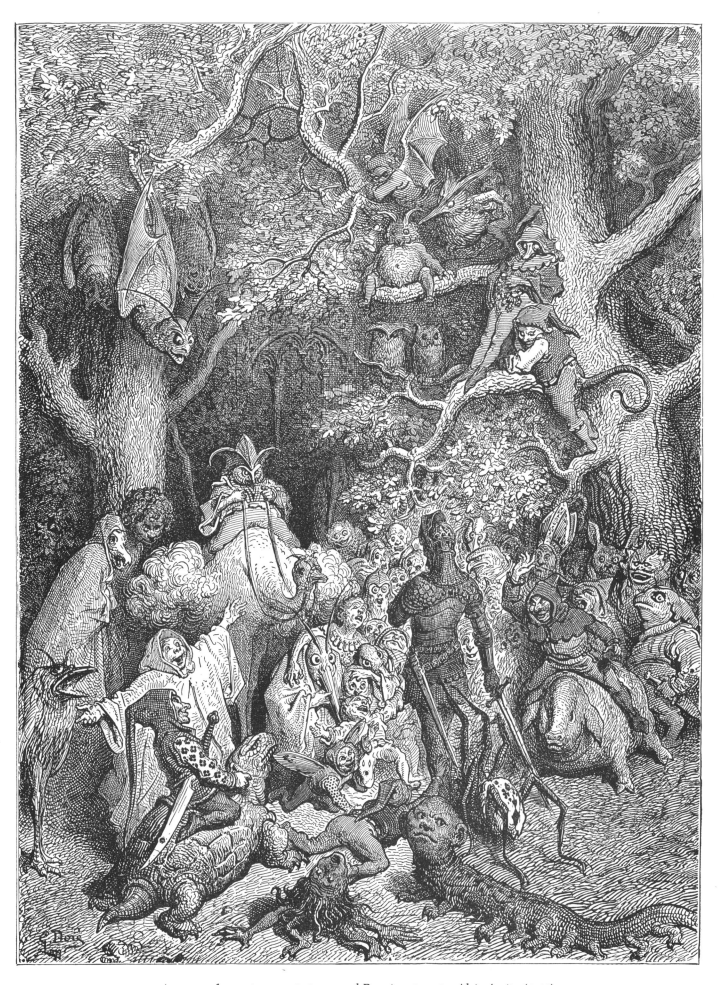

A group of monsters wants to compel Ruggiero to enter Alcina's city (6:60).

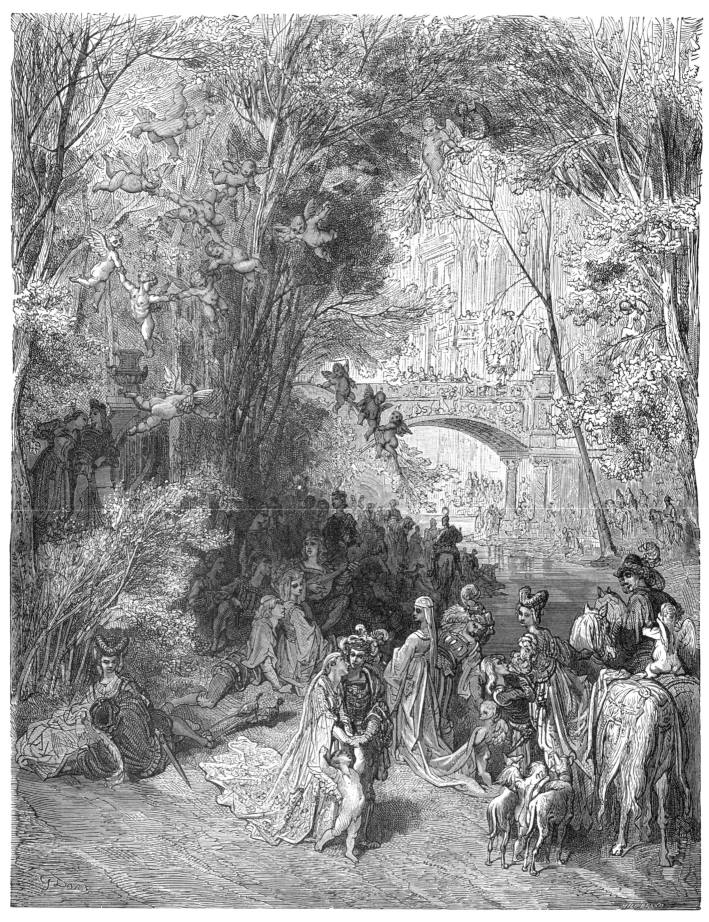

More of the delights in Alcina's realm (6:74).

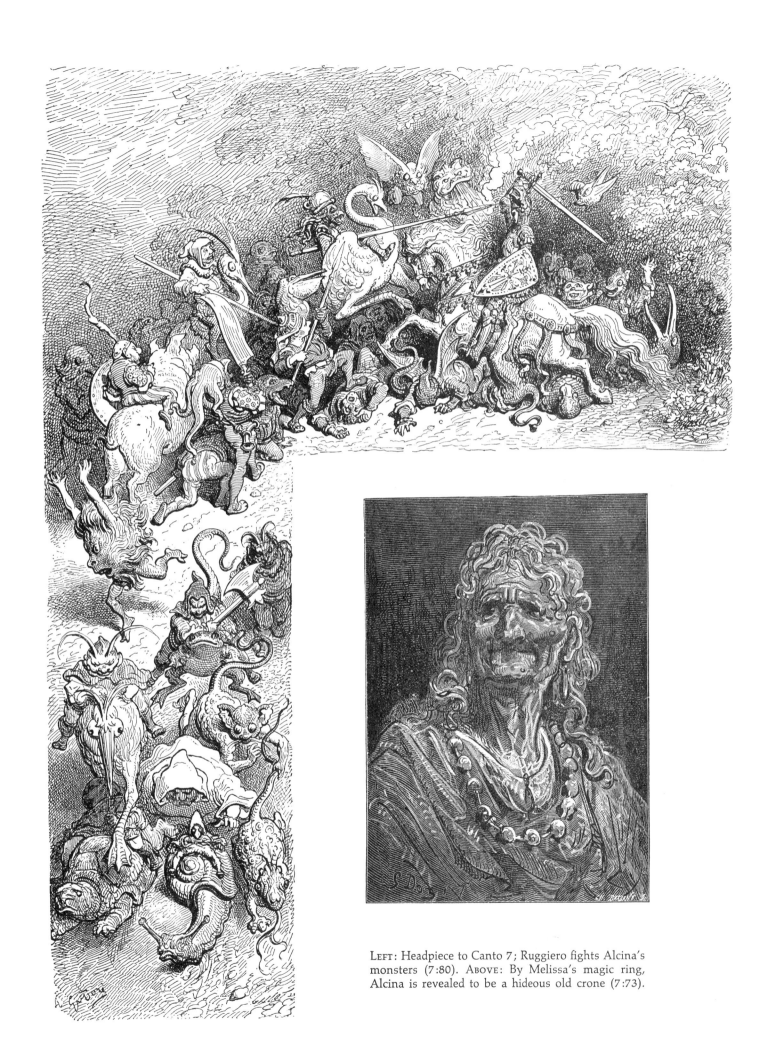

LEFT: Headpiece to Canto 7; Ruggiero fights Alcina's monsters (7:80). ABOVE: By Melissa's magic ring, Alcina is revealed to be a hideous old crone (7:73).

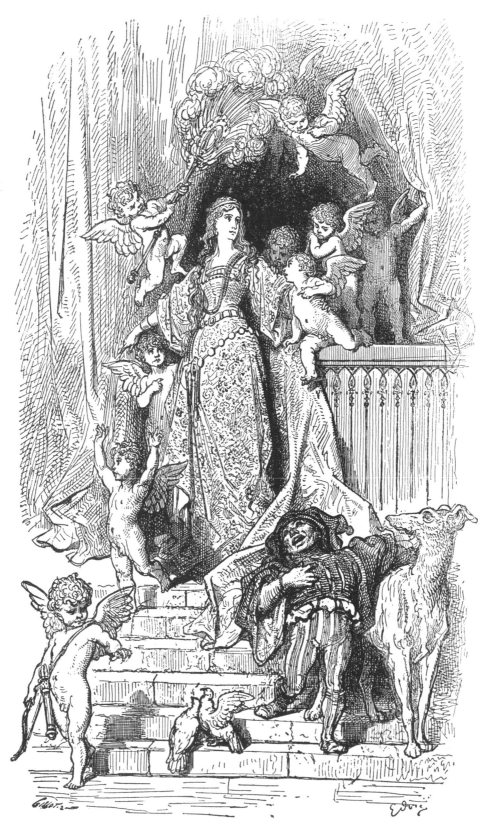

Alcina in all her glory (7:11).

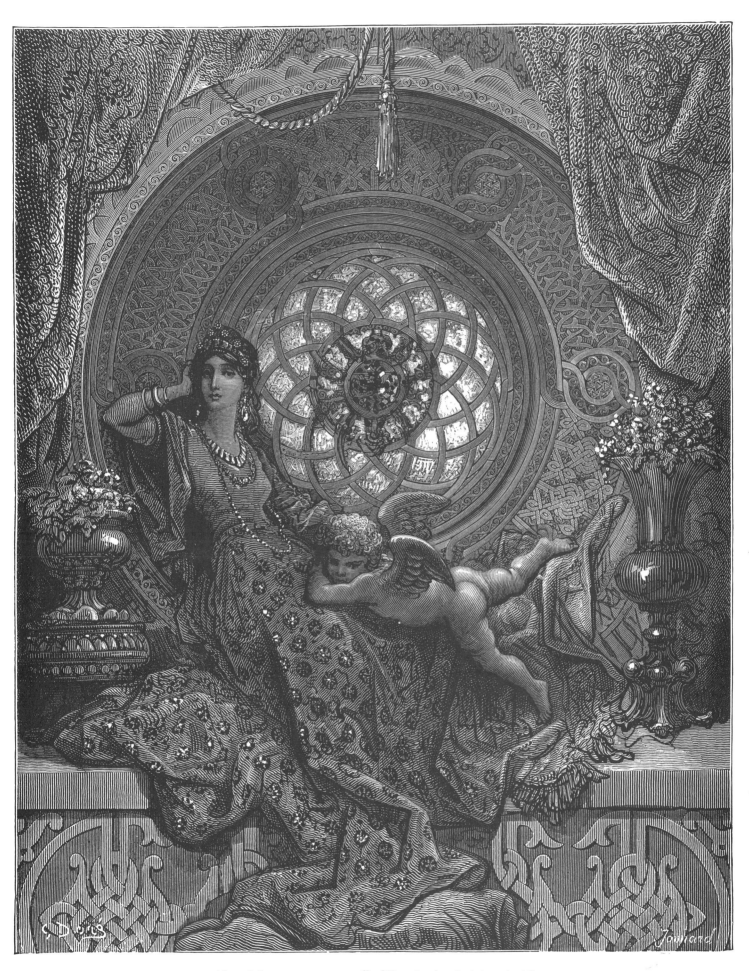

Alcina's beauty overcomes all of Ruggiero's misgivings (7:16).

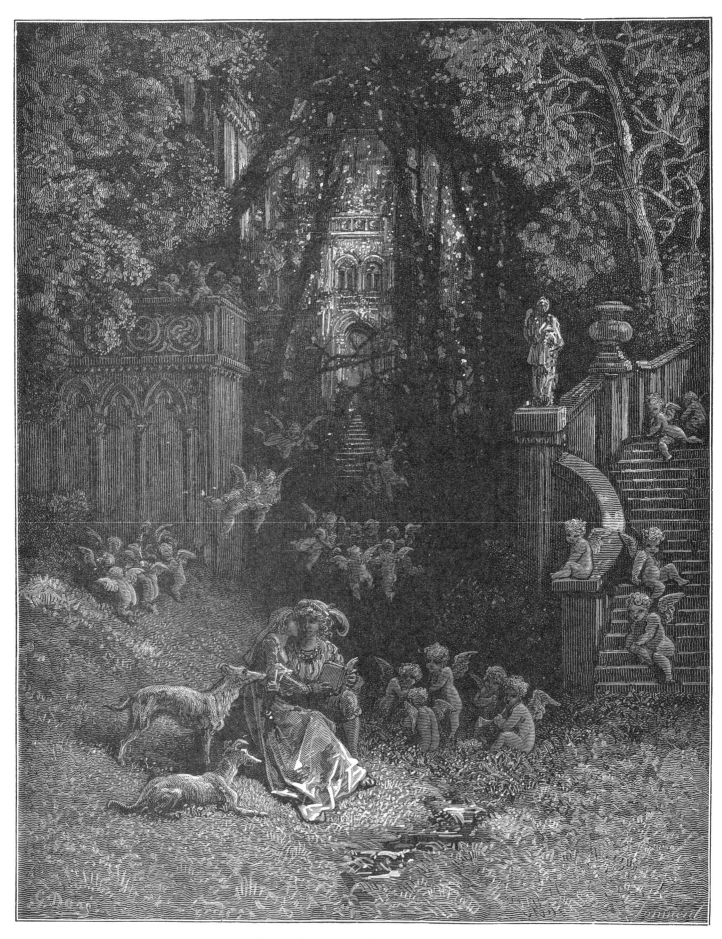

Alcina and Ruggiero as happy lovers (7:31).

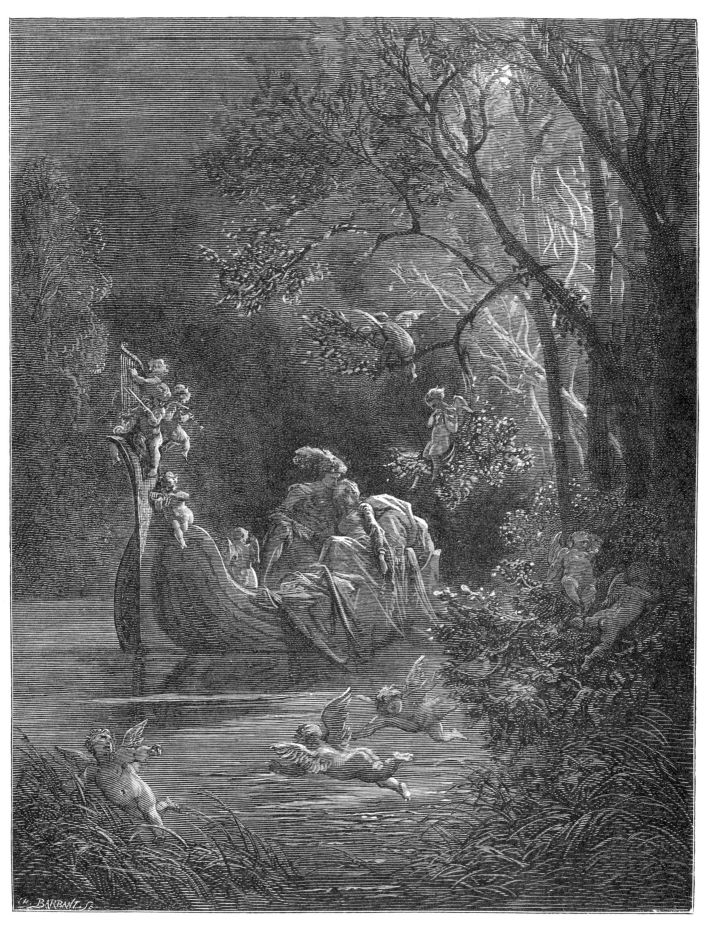

Alcina and Ruggiero out fishing (7:32).

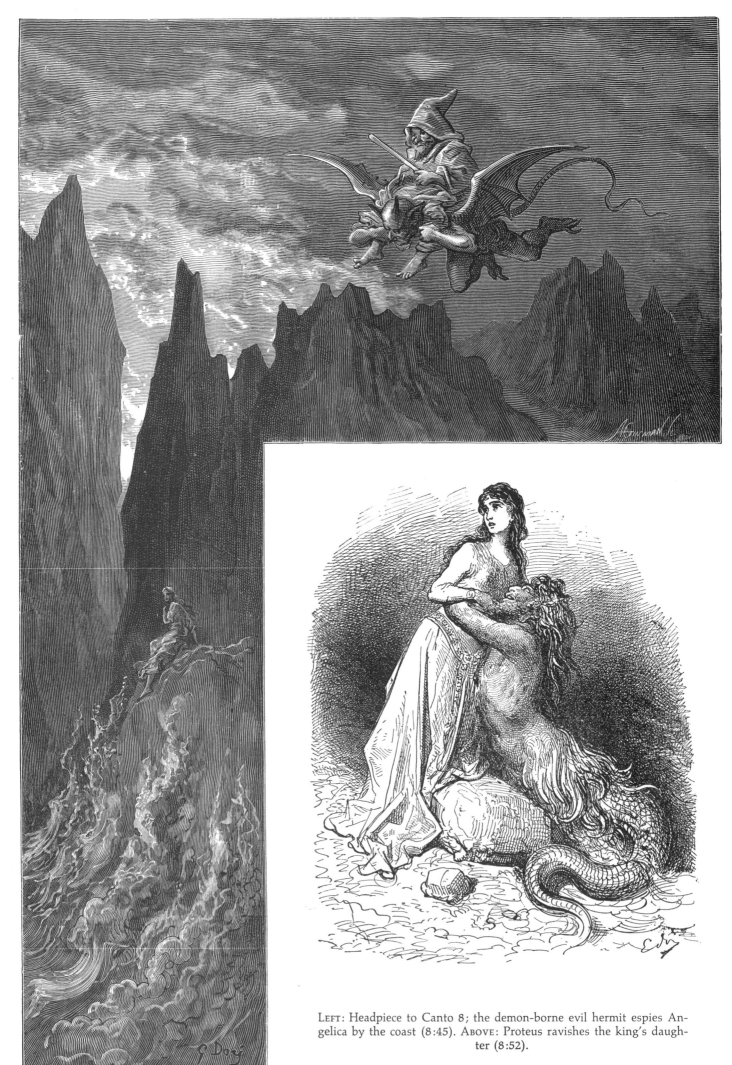

LEFT: Headpiece to Canto 8; the demon-borne evil hermit espies Angelica by the coast (8:45). ABOVE: Proteus ravishes the king's daughter (8:52).

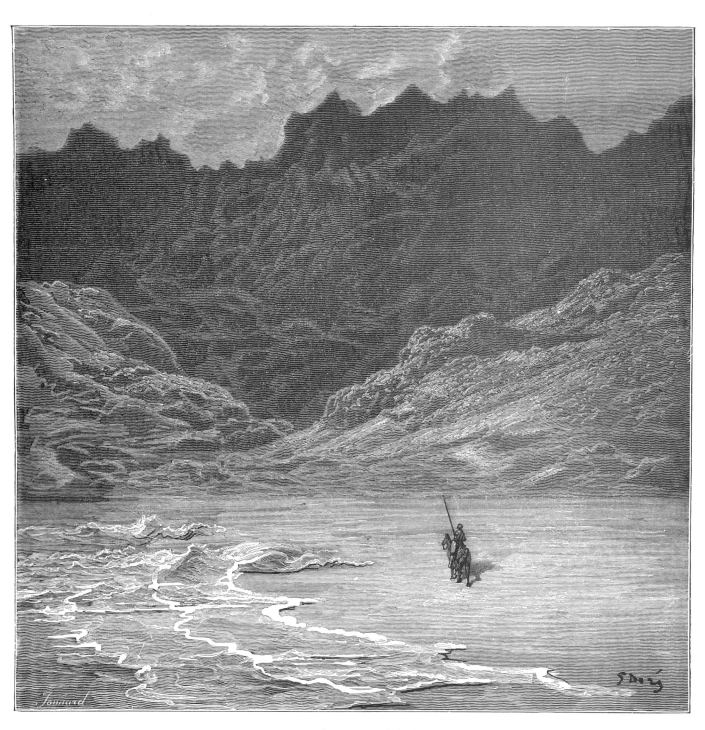

Ruggiero arrives at a barren, sun-baked beach (8:19).

Angelica is abandoned on a rugged coast (8:39).

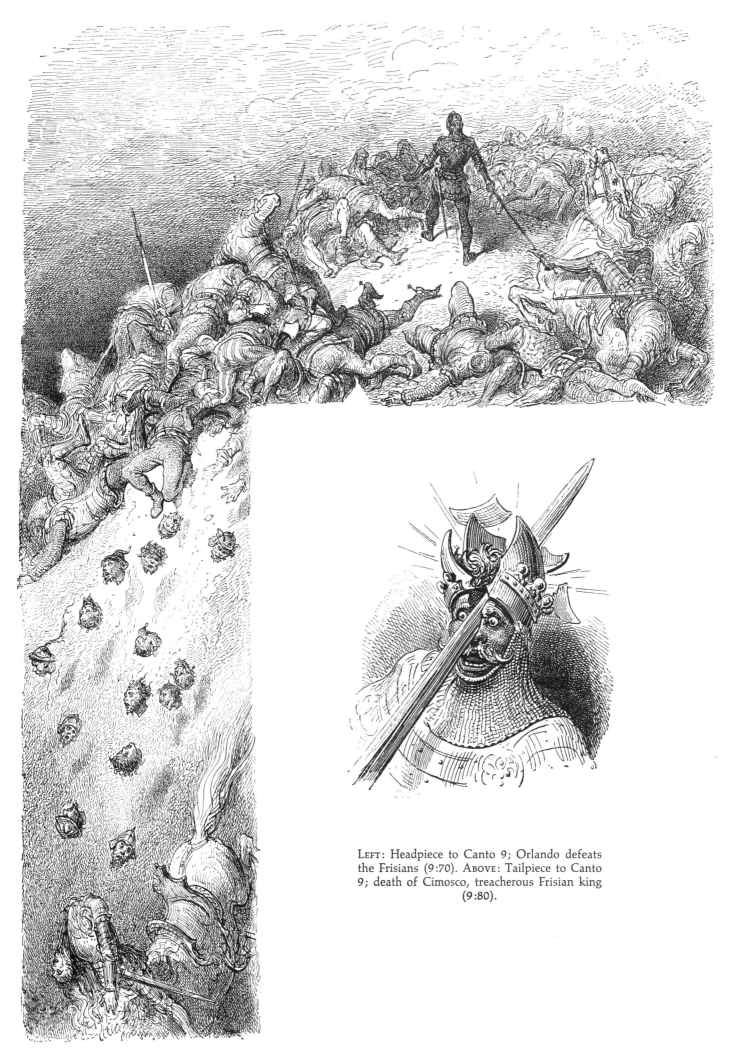

LEFT: Headpiece to Canto 9; Orlando defeats the Frisians (9:70). ABOVE: Tailpiece to Canto 9; death of Cimosco, treacherous Frisian king (9:80).

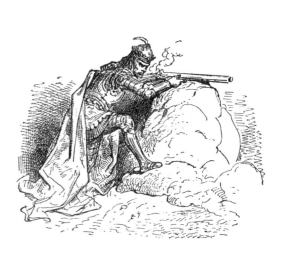

Top: Orlando skewers several Frisians on his lance (9:68). Bottom left: Orlando pursues Cimosco (9:72). Bottom right: Cimosco fires his gun—a remarkable invention ahead of its time—at Orlando (9:74).

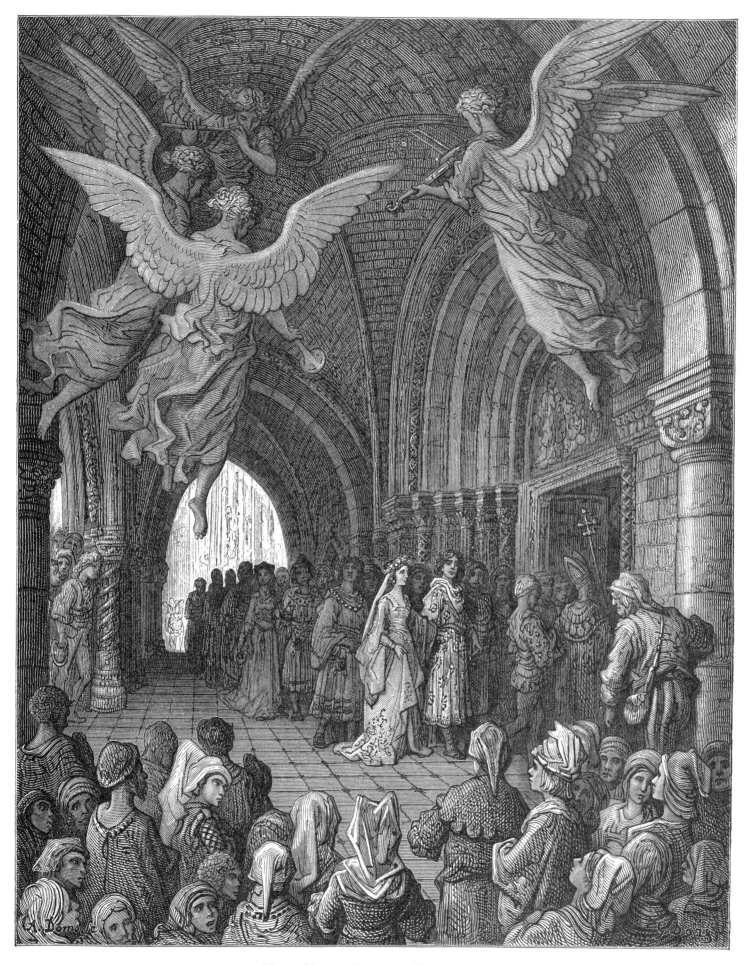

The wedding of Olimpia and Bireno (9:94).

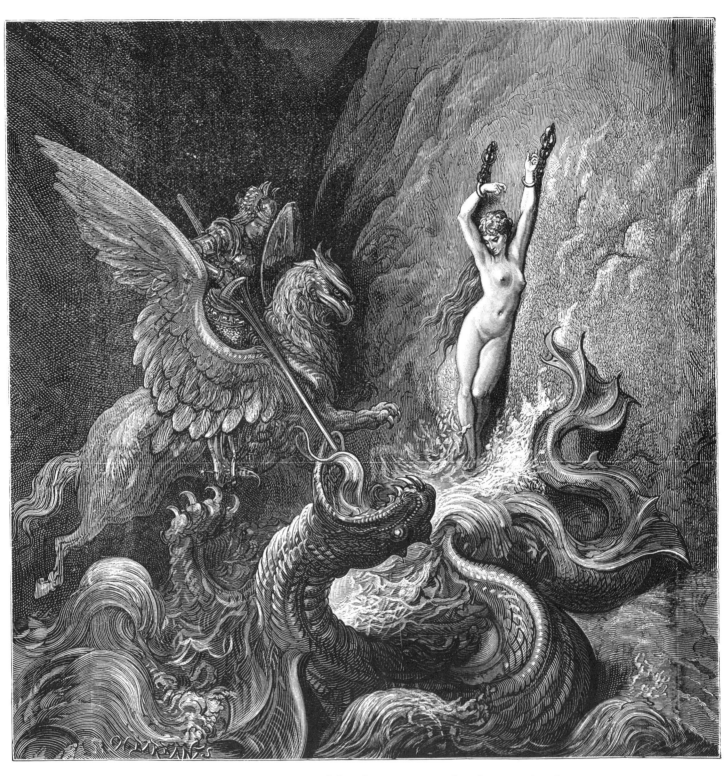

Headpiece to Canto 10; Ruggiero fights the sea monster that threatens Angelica
(10:104).

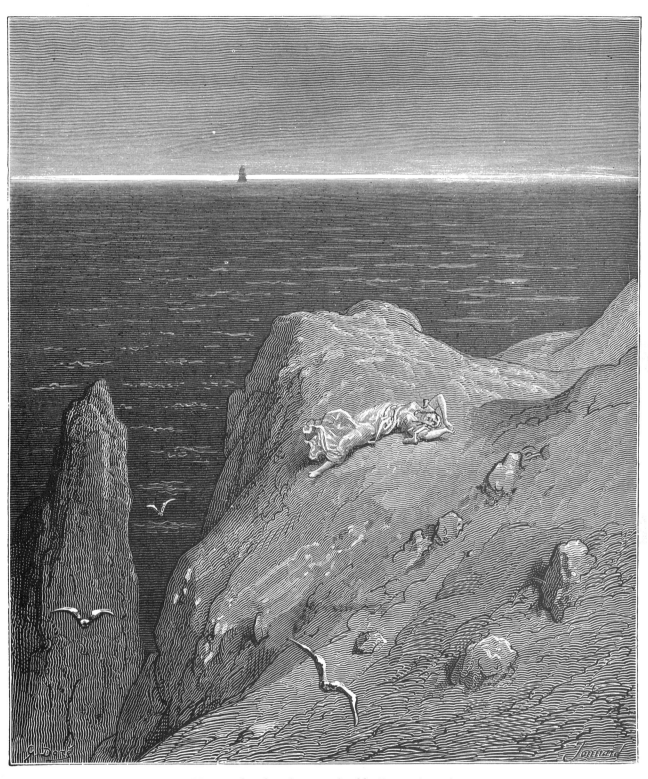

Olimpia abandoned on an island by Bireno (10:34).

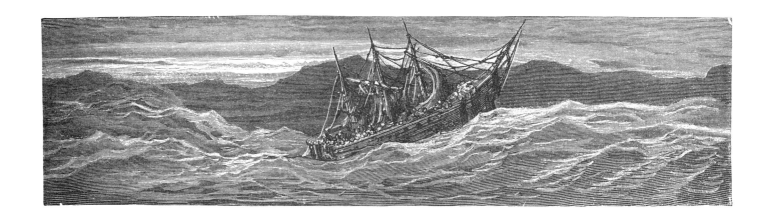

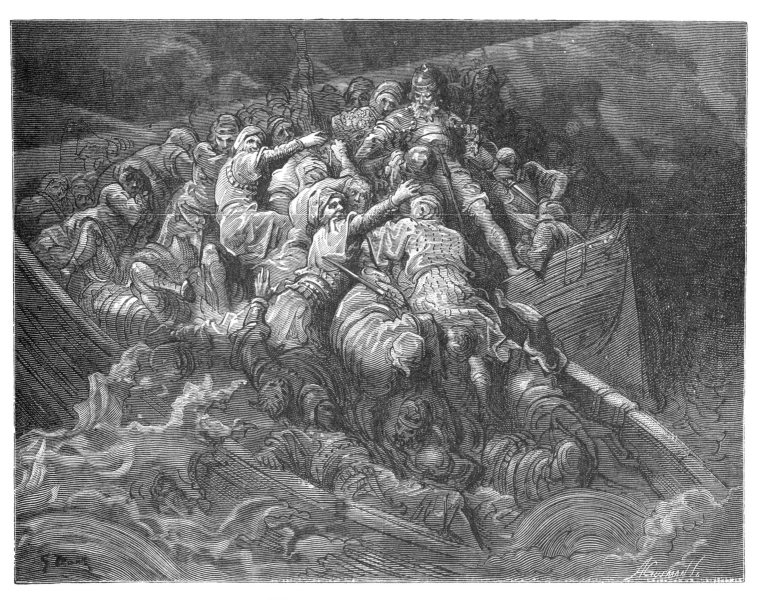

TOP: A strong wind blows Olimpia and Bireno off course (10:16). BOTTOM: Alcina's sailors are blinded by the glare from Ruggiero's magic shield (10:50).

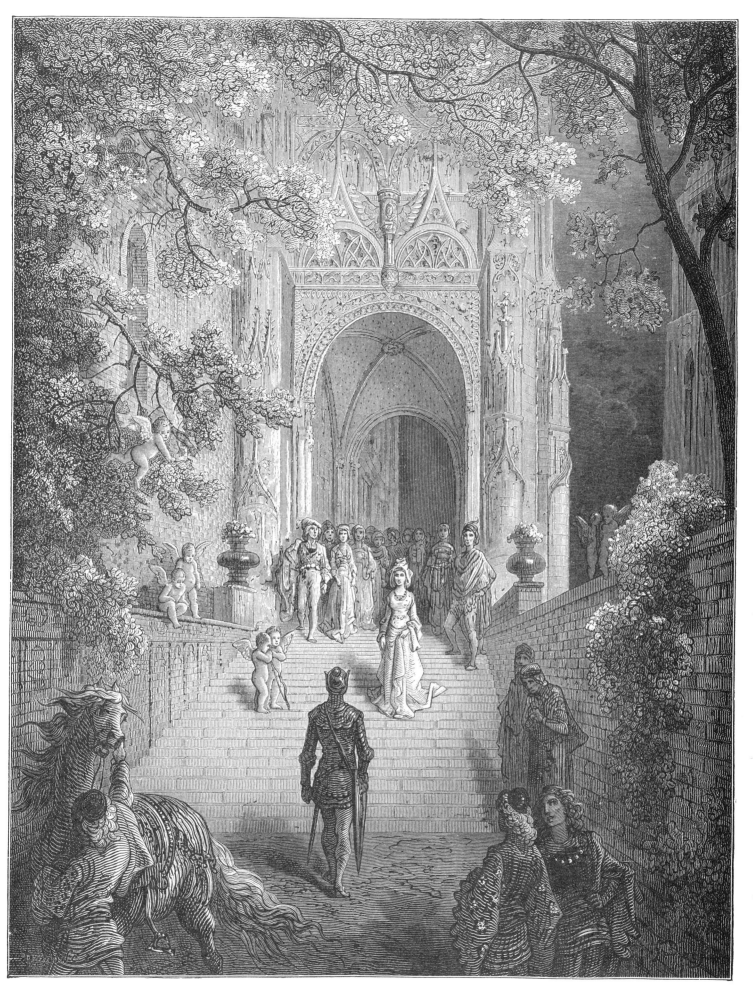

Ruggiero arrives at the court of Logistilla (10:64).

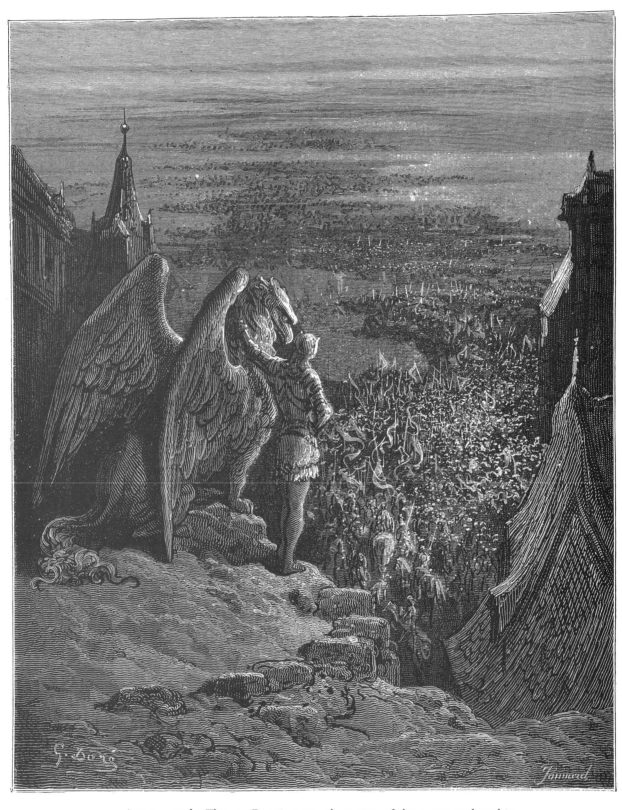

Arriving at the Thames, Ruggiero sees the review of the troops gathered in
Britain by Rinaldo (10:75).

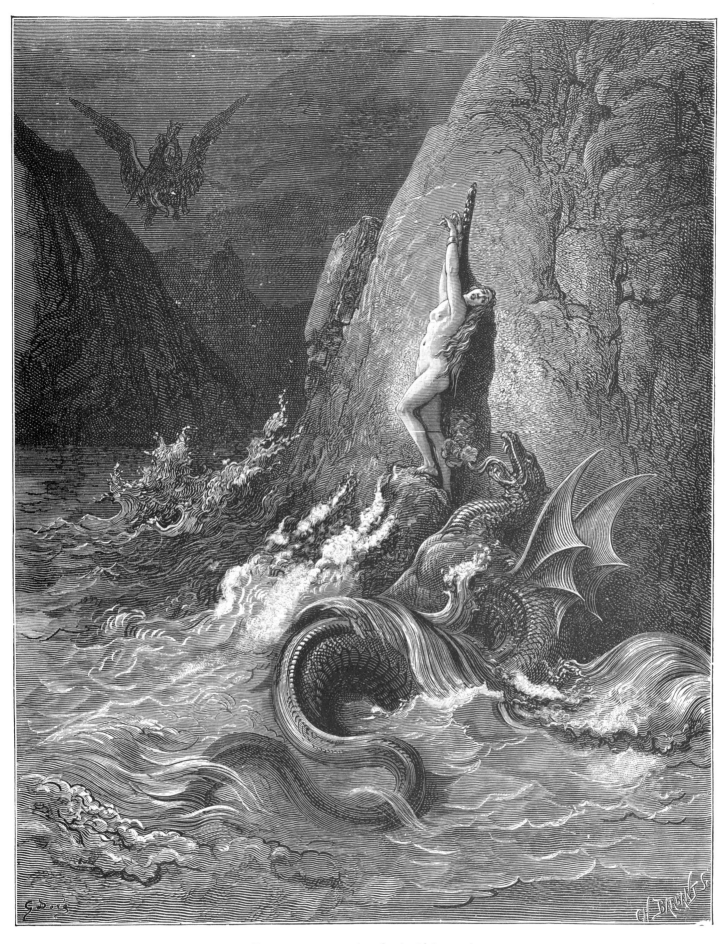

Ruggiero comes to Angelica's aid (10:100).

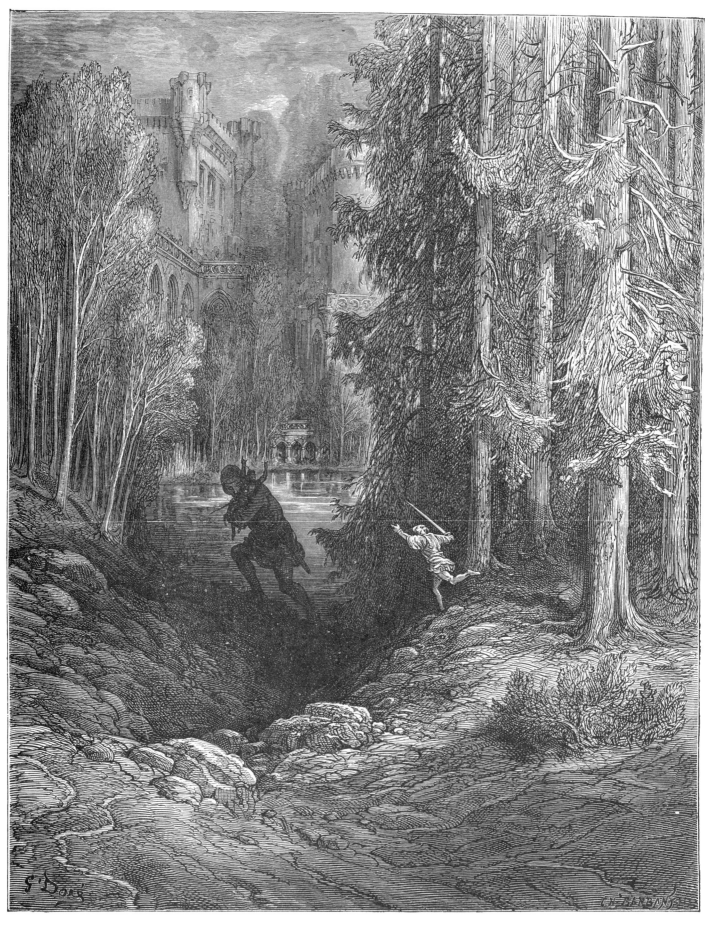

Ruggiero pursues the giant who is carrying off Bradamante (11:20).

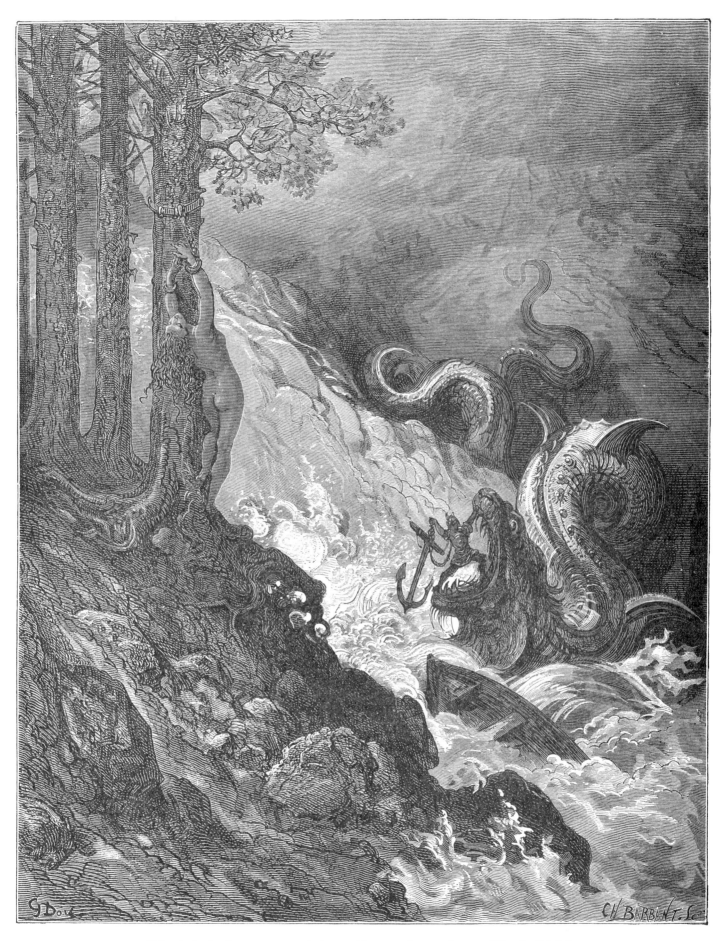

Orlando locks the sea monster's jaws with an anchor, and saves Olimpia (11:37).

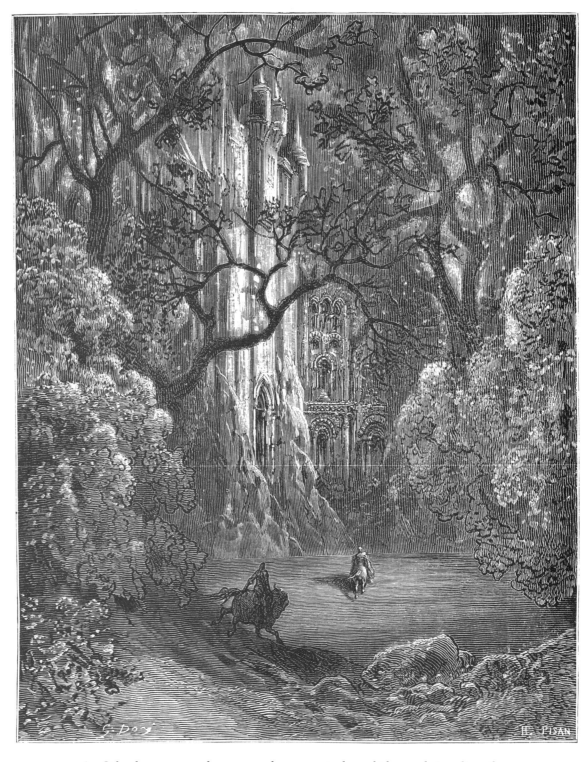

As Orlando pursues a horseman who seems to have kidnapped Angelica, they
reach a great palace (12:7).

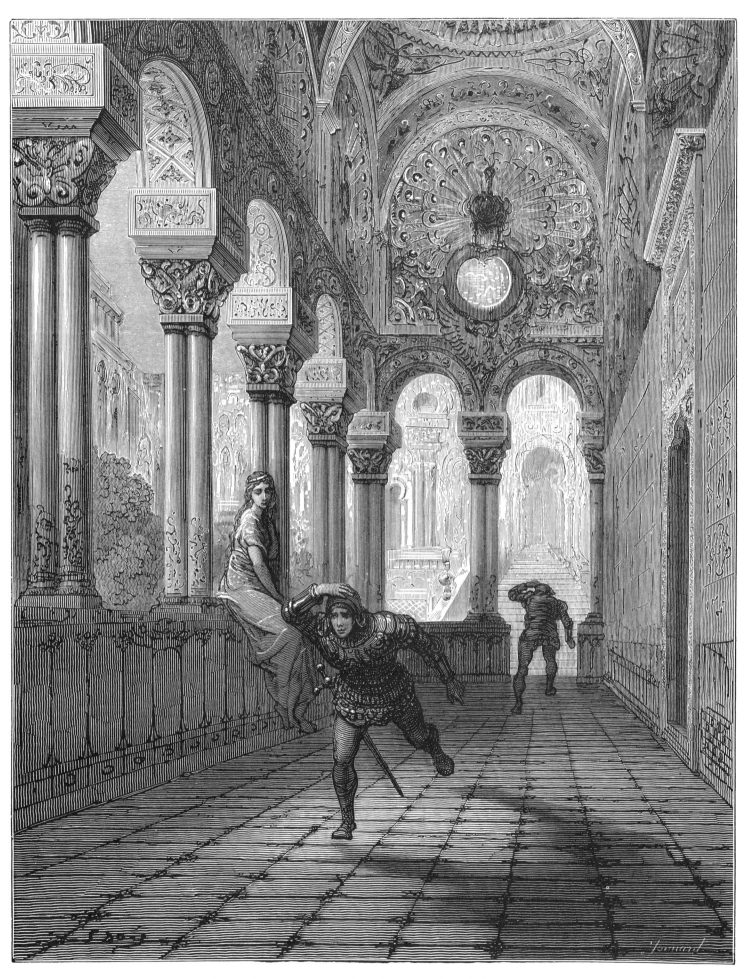

The palace is full of famous knights who constantly seek their host in vain
(12:11).

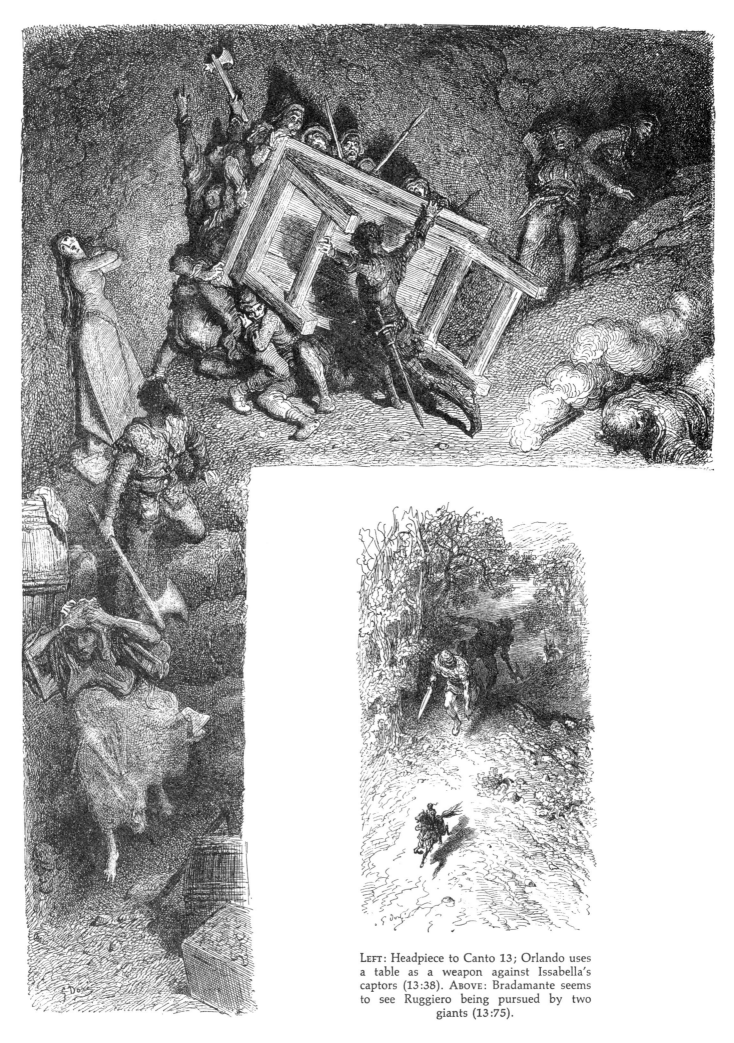

LEFT: Headpiece to Canto 13; Orlando uses a table as a weapon against Issabella's captors (13:38). ABOVE: Bradamante seems to see Ruggiero being pursued by two giants (13:75).

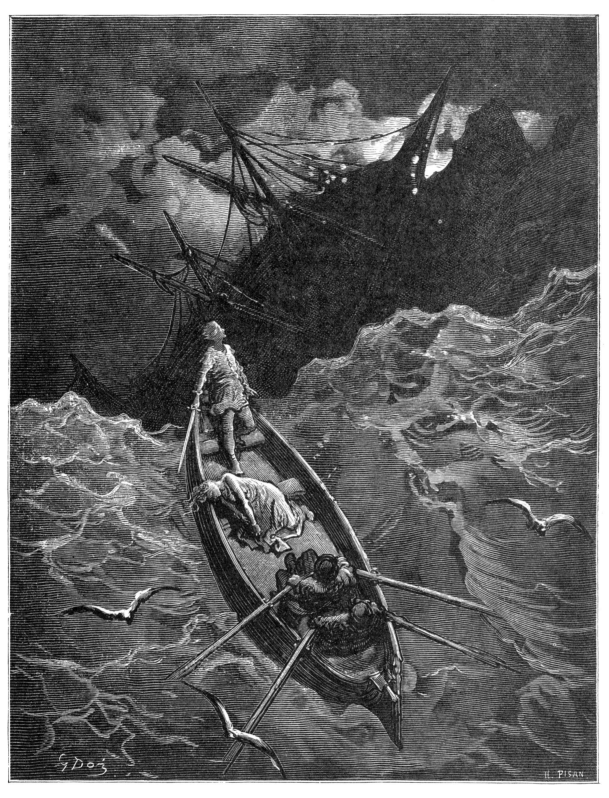

Issabella and the false Odorico escape the wreck of their ship (13:17).

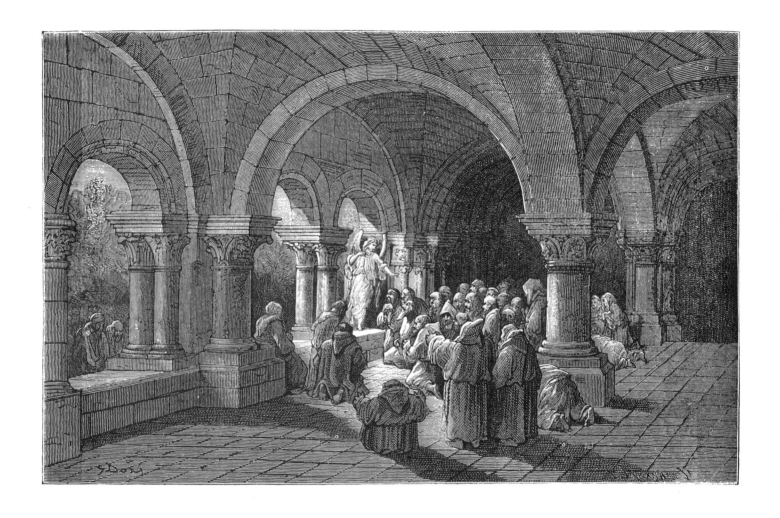

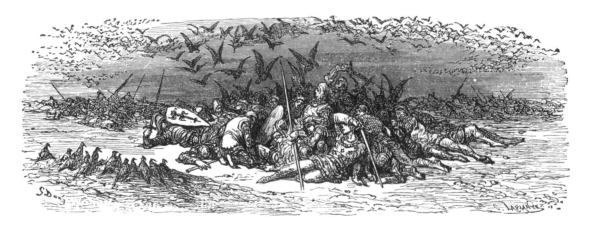

TOP: Headpiece to Canto 14; the archangel Michael in a monastery (14:80).
BOTTOM: Moorish warriors defeated by Orlando (14:36).

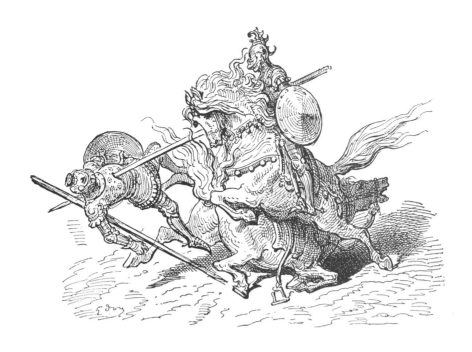

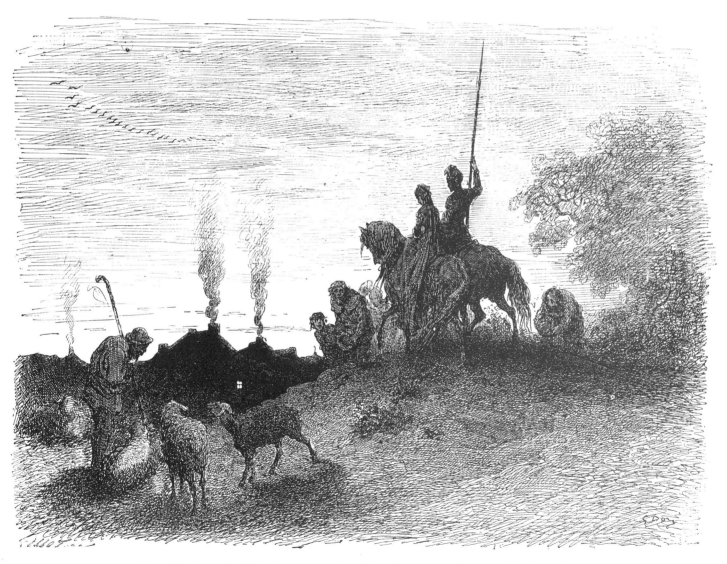

Top: Mandricardo kills the captain from Granada (14:42). Bottom: Mandricardo and Doralice find lodgings with some shepherds (14:61).

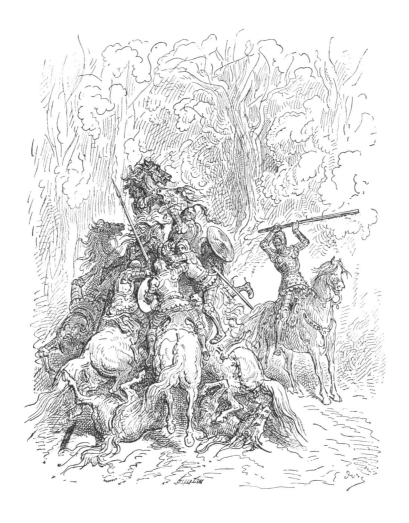

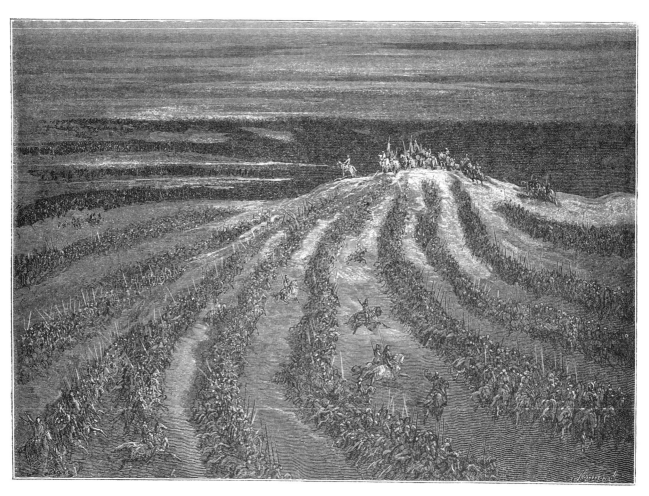

Top: Mandricardo massacres the whole troop from Granada (14:45). Bottom:
The Moors gather, preparing to besiege Paris (14:66).

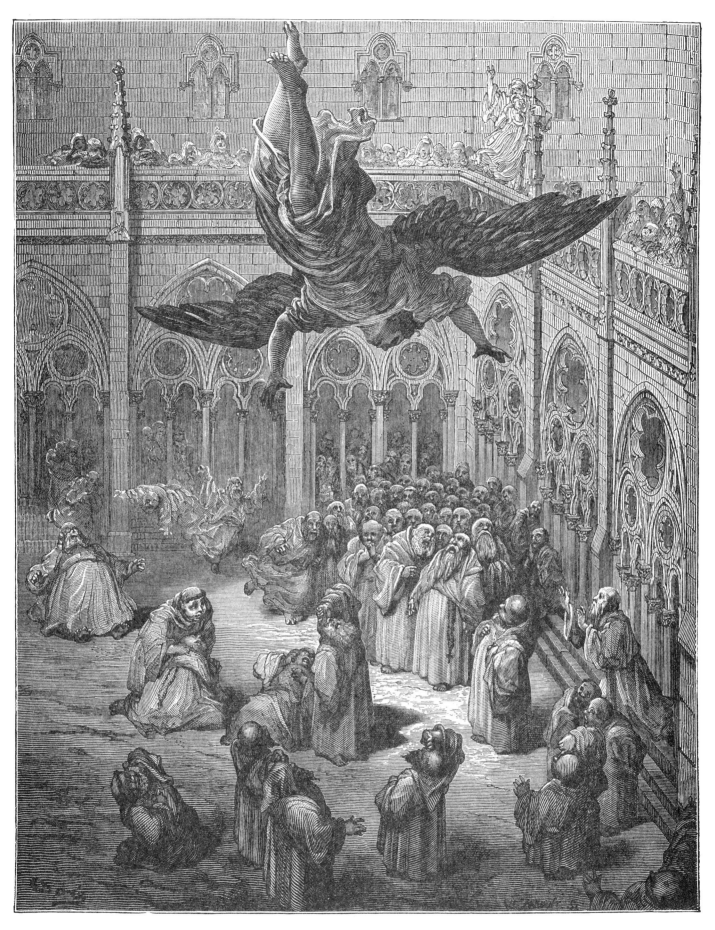

The archangel Michael, commanded to find Silence, tries in vain in monasteries
(14:80).

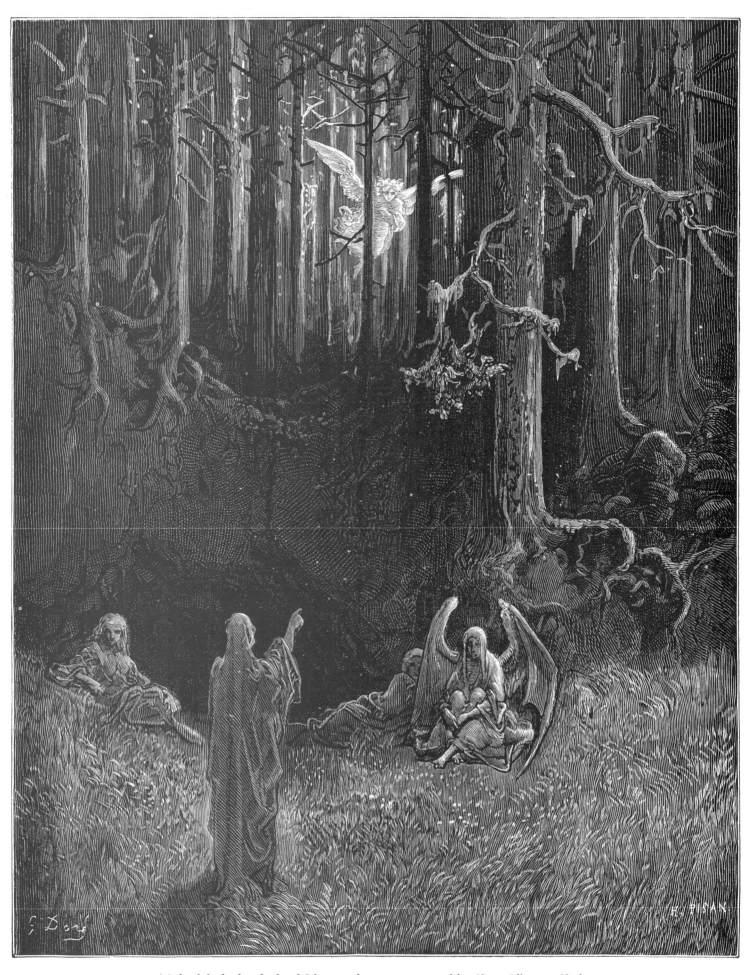

Michael finds the abode of Silence, who is accompanied by Sleep, Idleness, Sloth
and Forgetfulness (14:93).

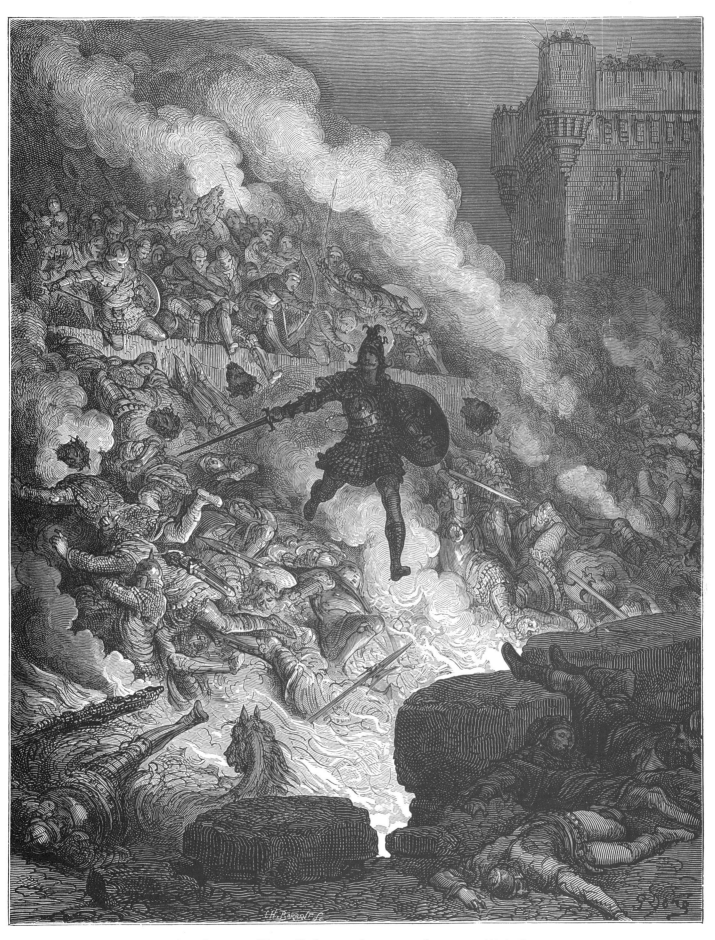

At the siege of Paris, Rodomonte leaps over a huge moat (14:130).

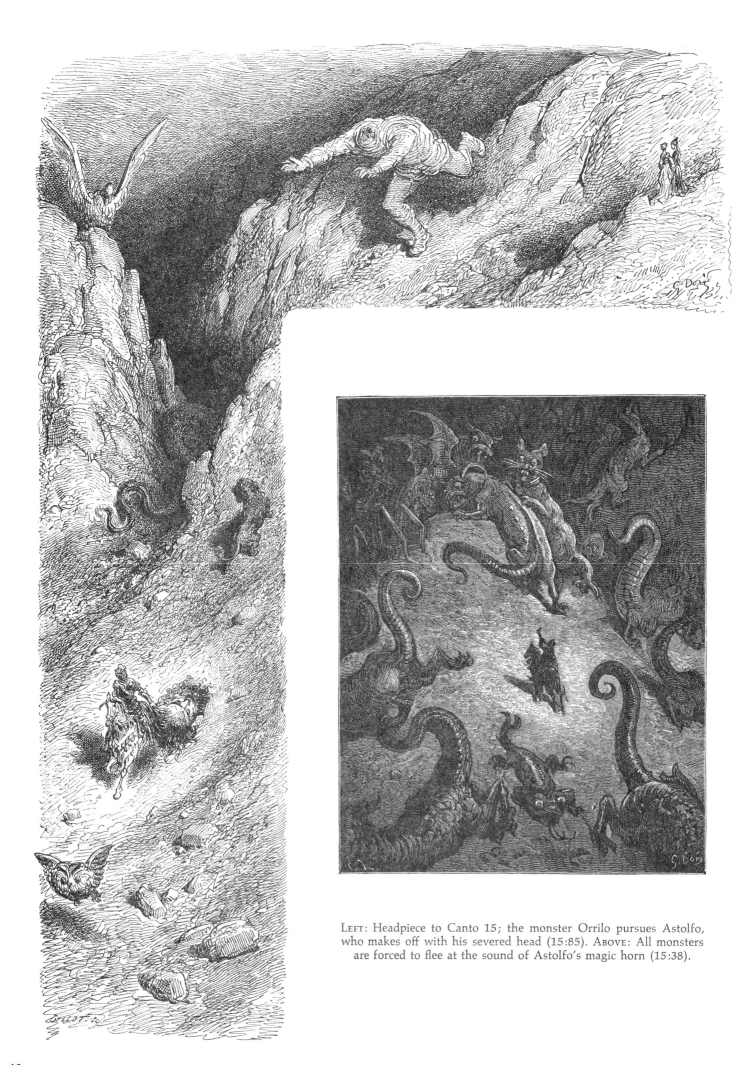

Left: Headpiece to Canto 15; the monster Orrilo pursues Astolfo, who makes off with his severed head (15:85). Above: All monsters are forced to flee at the sound of Astolfo's magic horn (15:38).

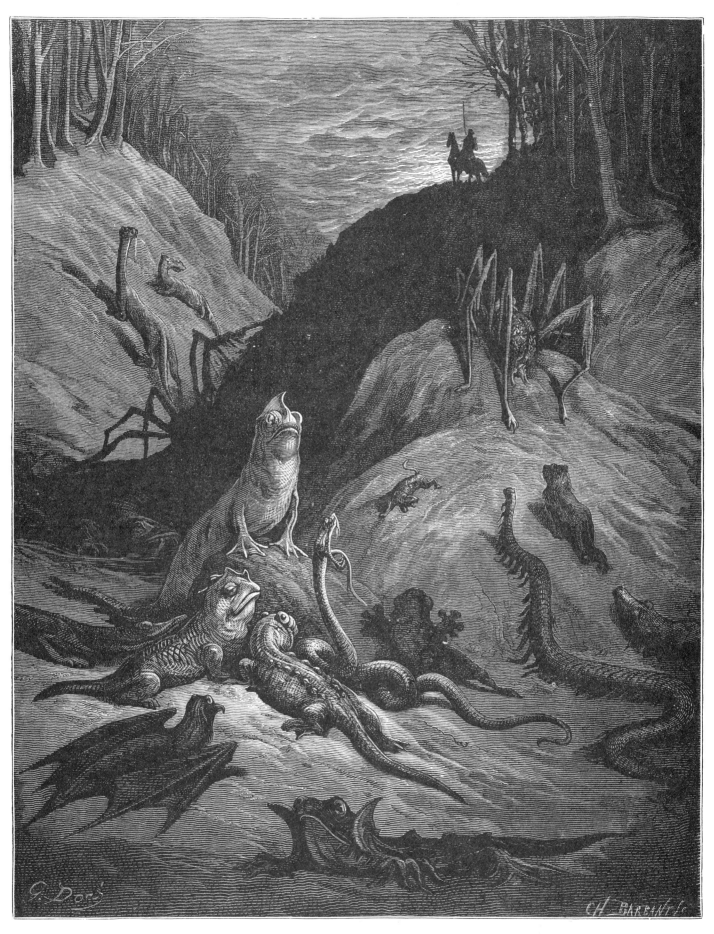

Monsters in Astolfo's path (15:38).

Top: Amid the Nile swamps, Astolfo faces the giant Caligorante (15:52). Bottom: Astolfo and his companions reach the Holy Land (15:94).

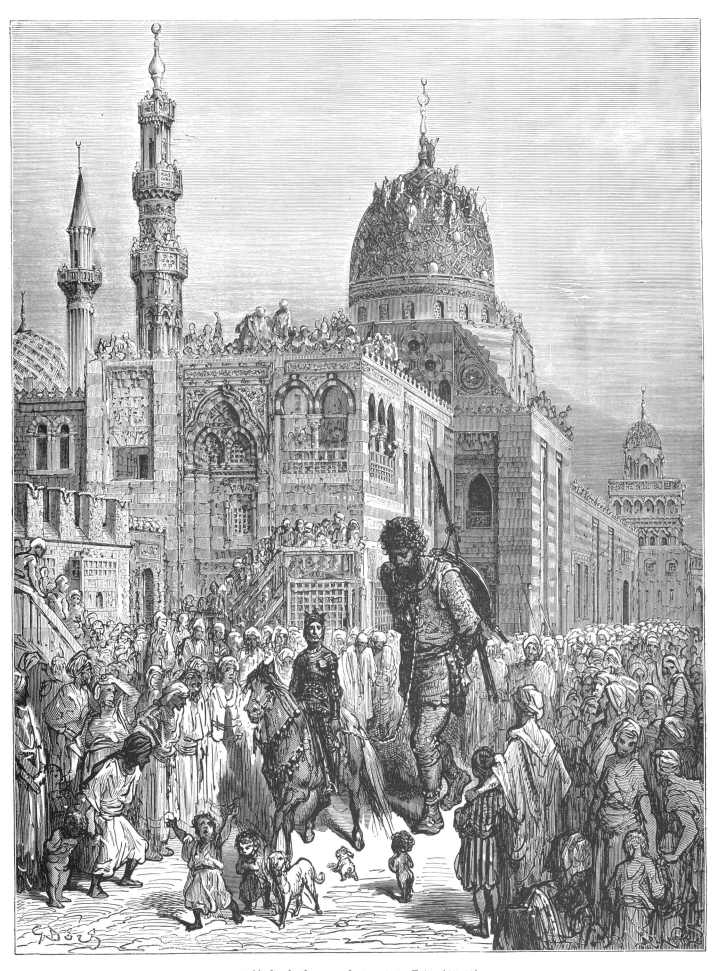

Astolfo leads the tamed giant into Cairo (15:62).

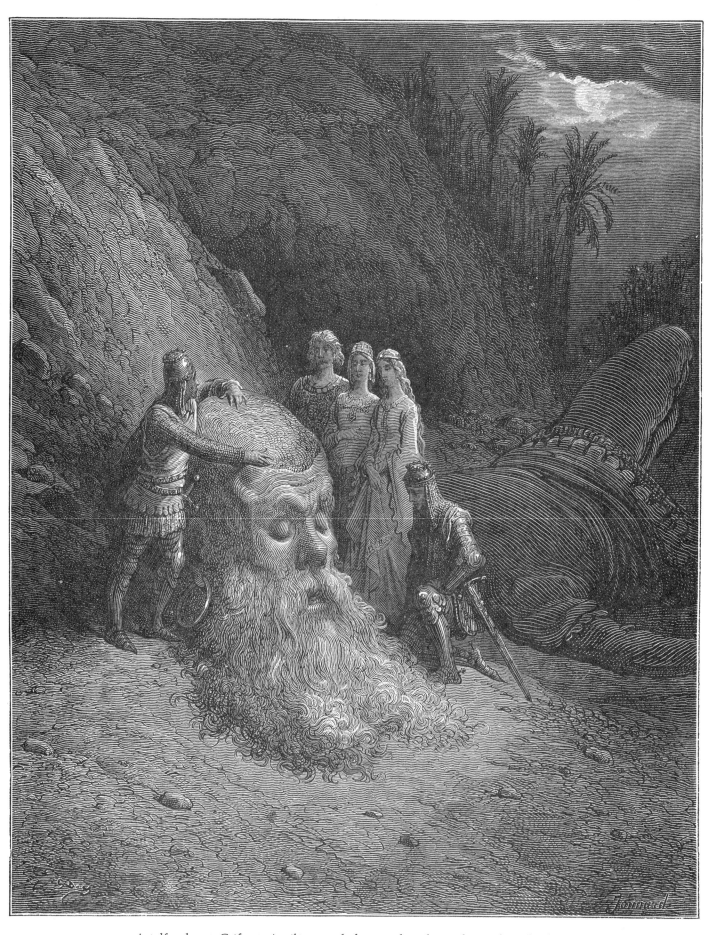

Astolfo shows Grifone, Aquilante and the two beneficent fairies how he has
slain Orrilo by removing the enchanted hair from his head (15:88).

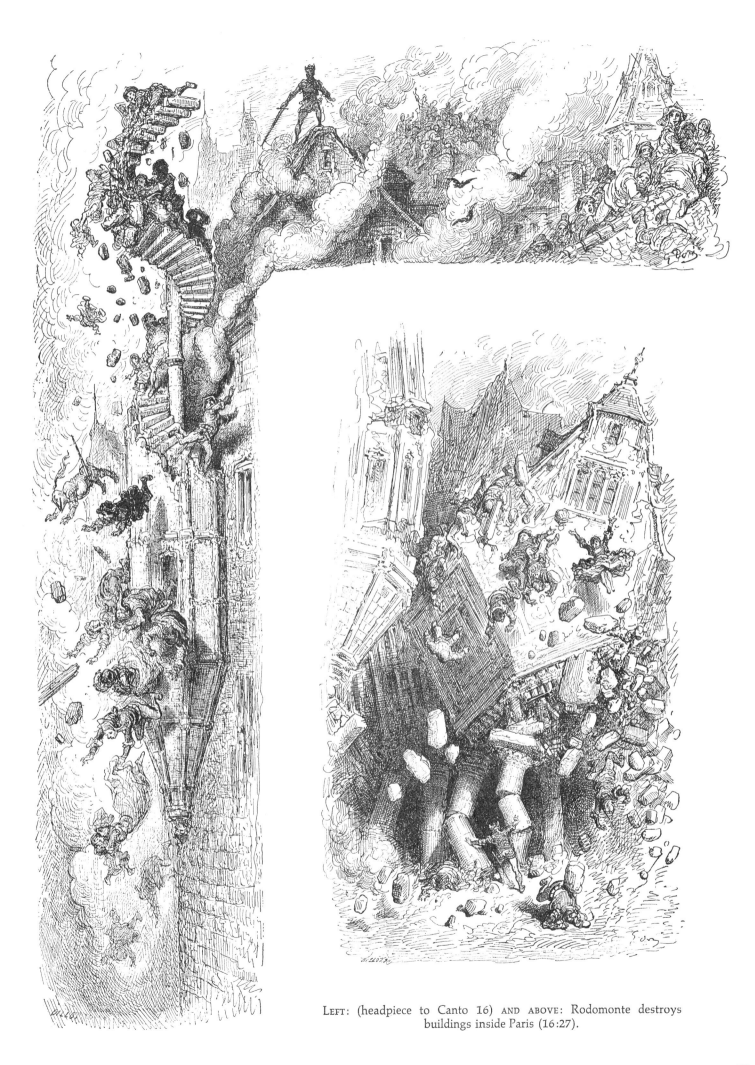

LEFT: (headpiece to Canto 16) AND ABOVE: Rodomonte destroys buildings inside Paris (16:27).

53

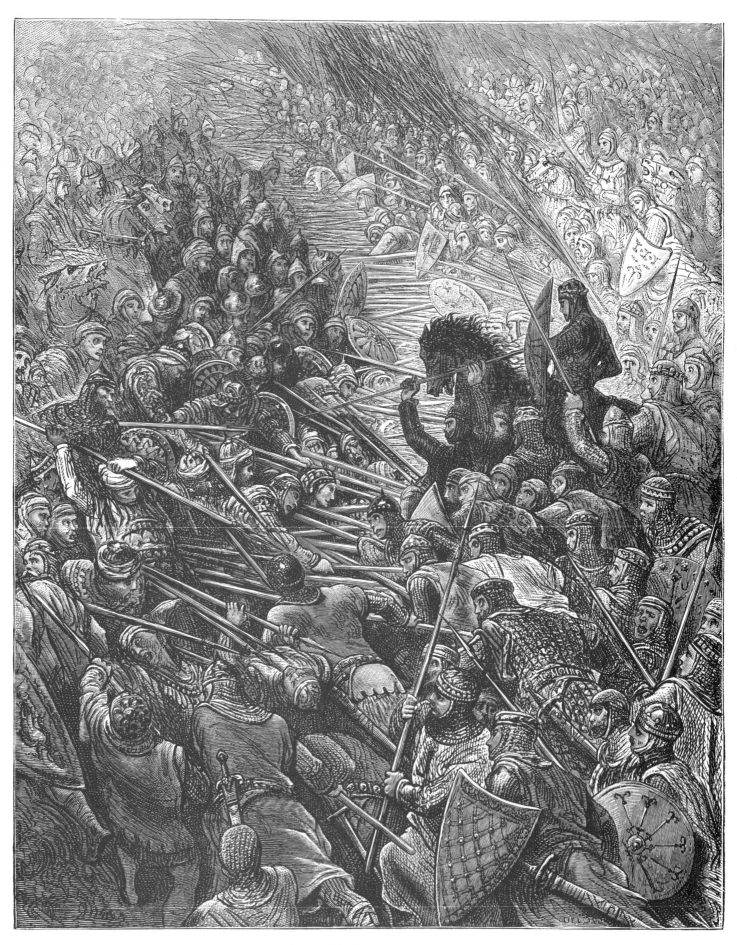

The great battle at Paris (16:19).

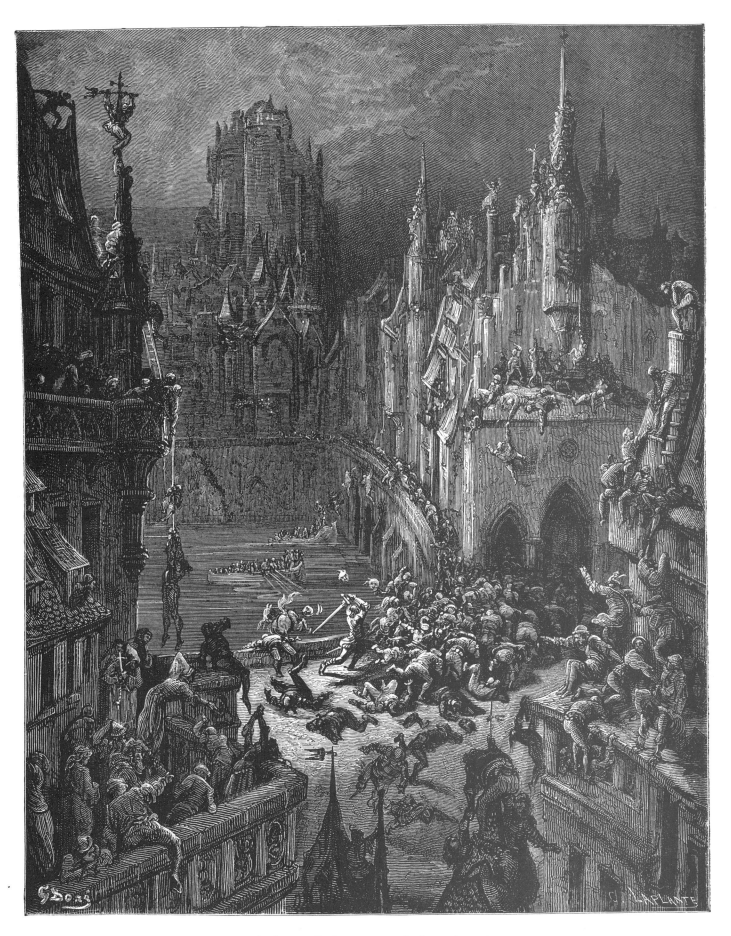

Inside the city, Rodomonte wreaks havoc (16:24).

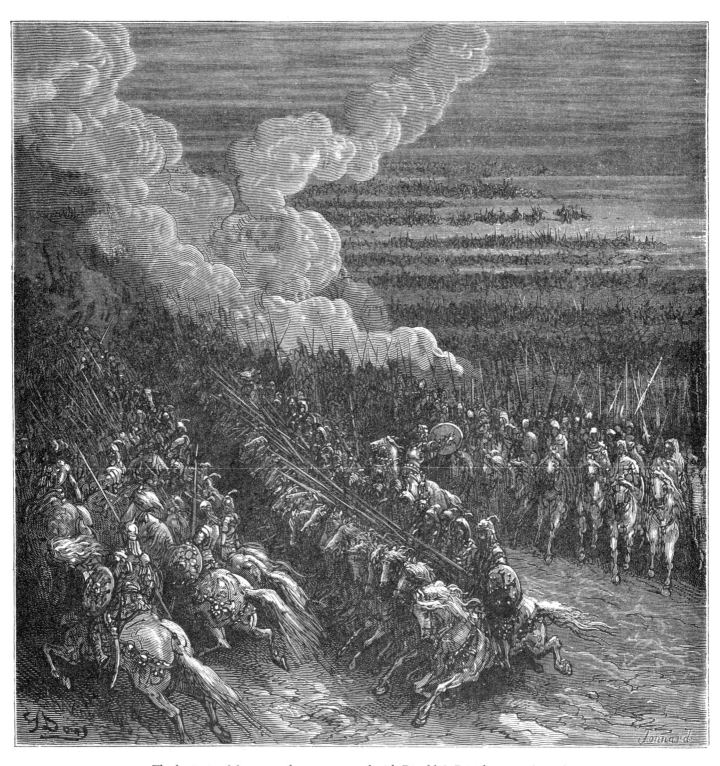

The besieging Moors now have to contend with Rinaldo's British troops (16:57).

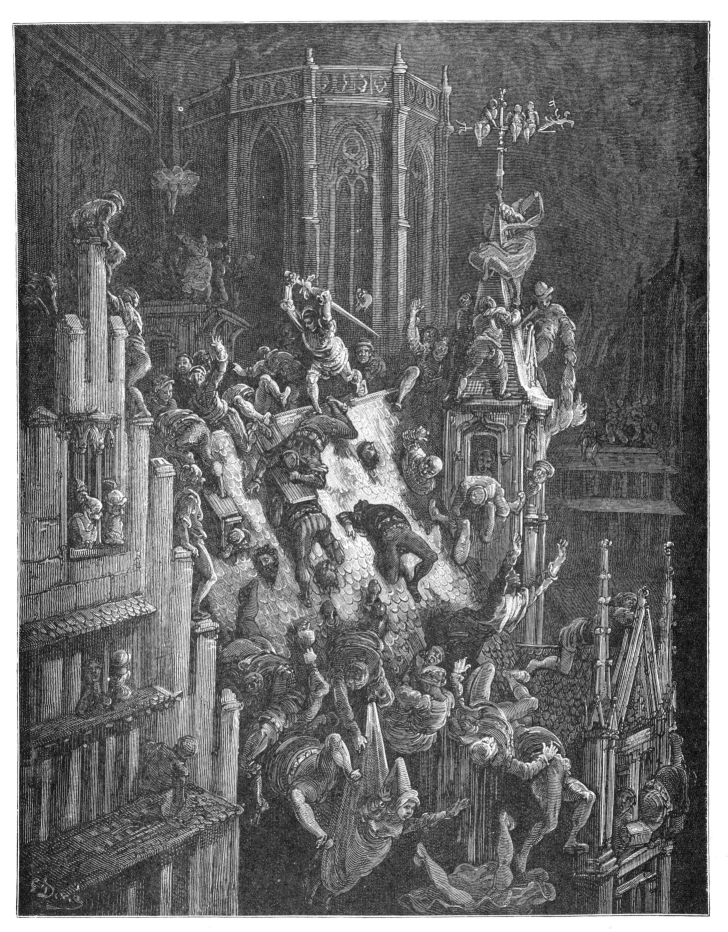

Rodomonte continues his vandalism in Paris (16:85).

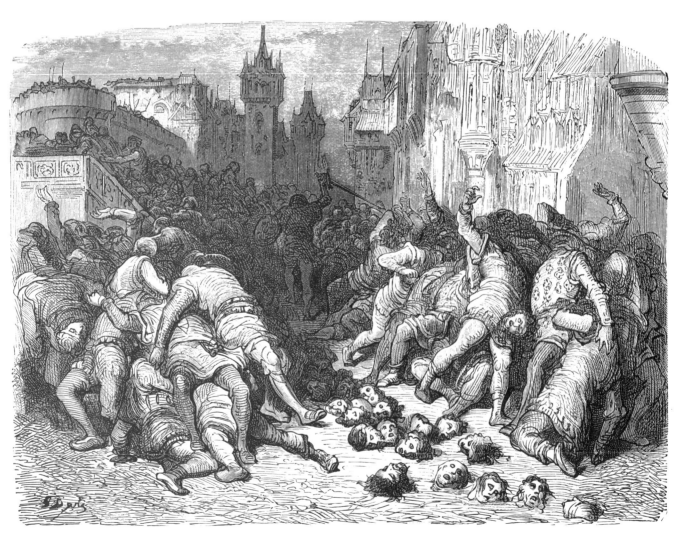

Top: Charlemagne exhorts his warriors to vanquish Rodomonte (17:14). Bottom: Rodomonte's swath of destruction (17:8).

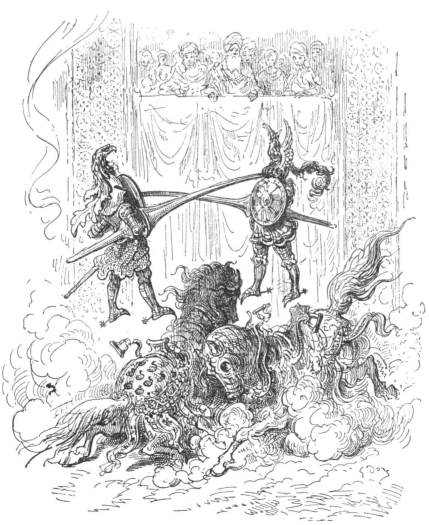

TOP LEFT: The blind man-eating monster captures Norandino's companions (17:32). TOP RIGHT: He eats a few (17:35). BOTTOM: At the tournament in Damascus, Grifone kills Salinterno (17:98).

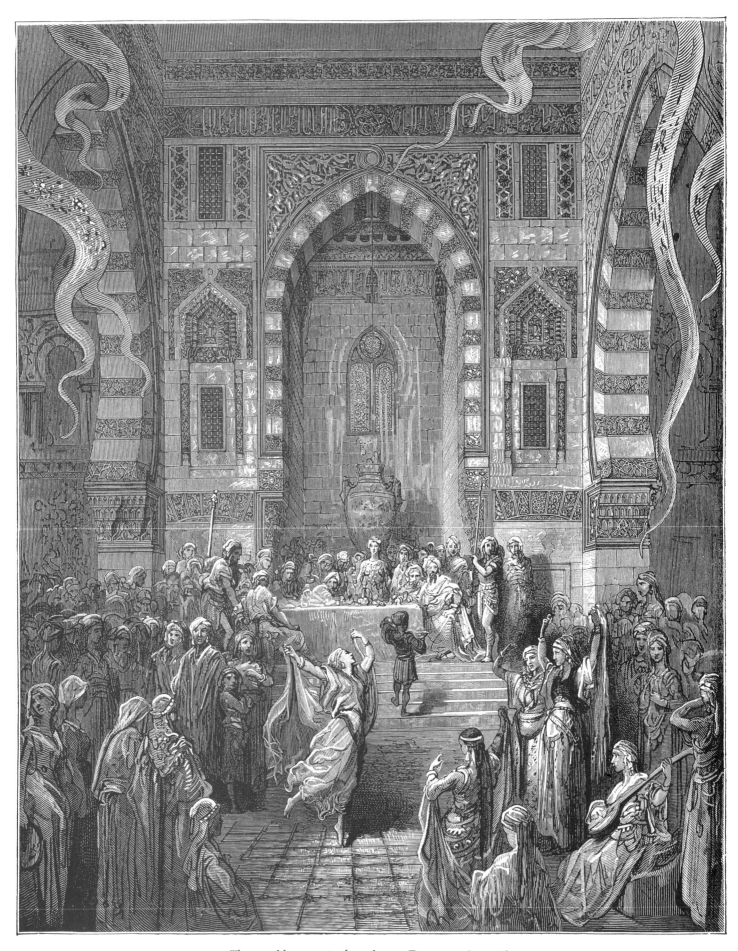

The royal banquet in the palace at Damascus (17:119).

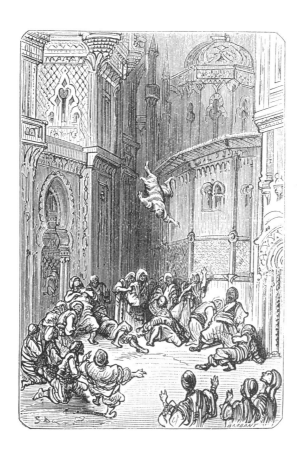

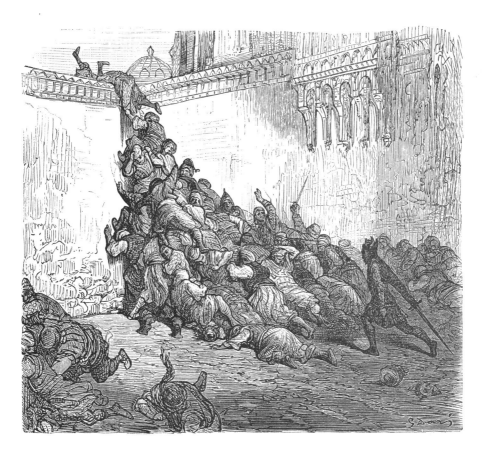

Top: Grifone throws a Damascene over the city wall (18:6). Bottom: Grifone avenges himself on the Damascenes for the insult to his honor (18:4).

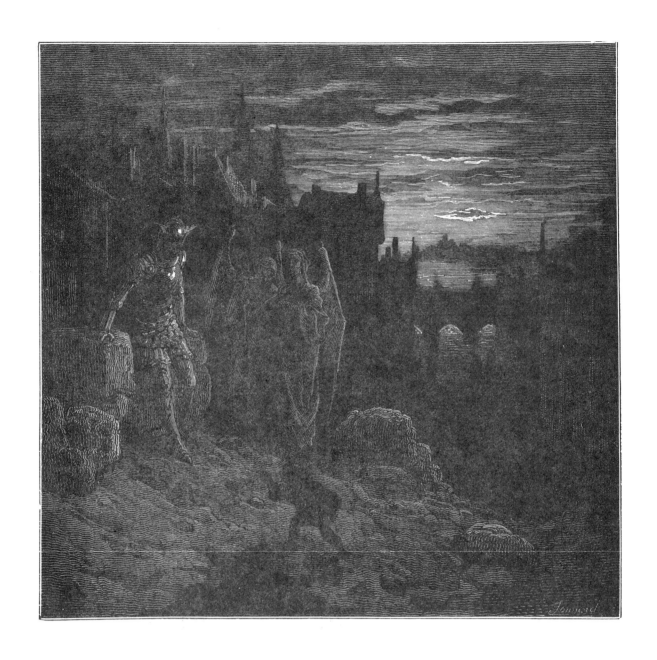

TOP: Doralice's dwarf tells Rodomonte that she has gone off with Mandricardo; Discord and Jealousy stand by (18:32). BOTTOM: The aftermath of a battle in France; the Christians are now on the offensive (18:162).

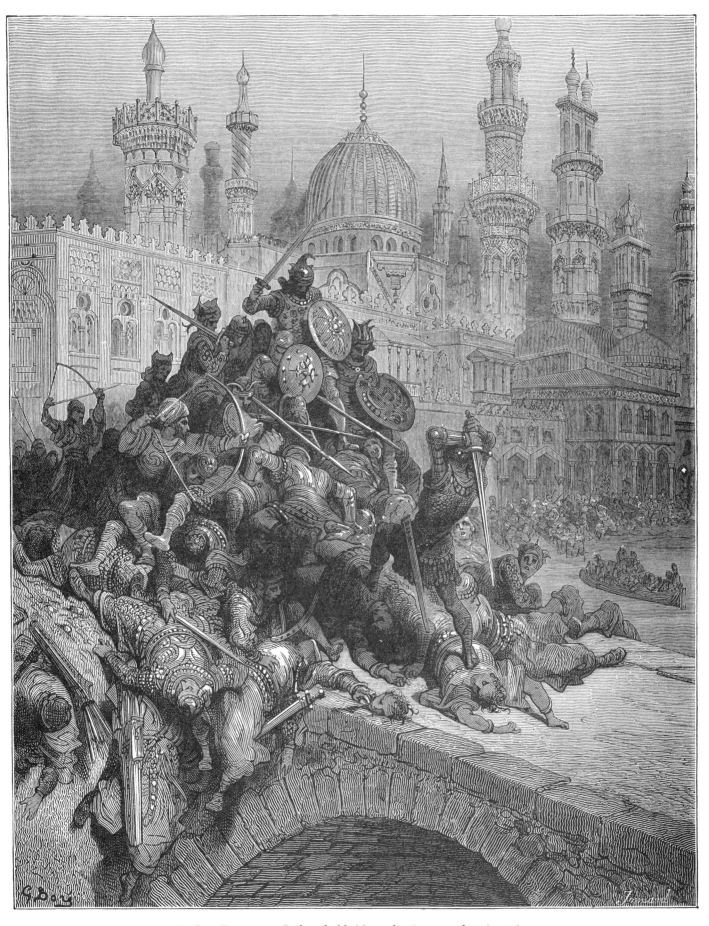

Back in Damascus, Grifone holds Norandino's men at bay (18:63).

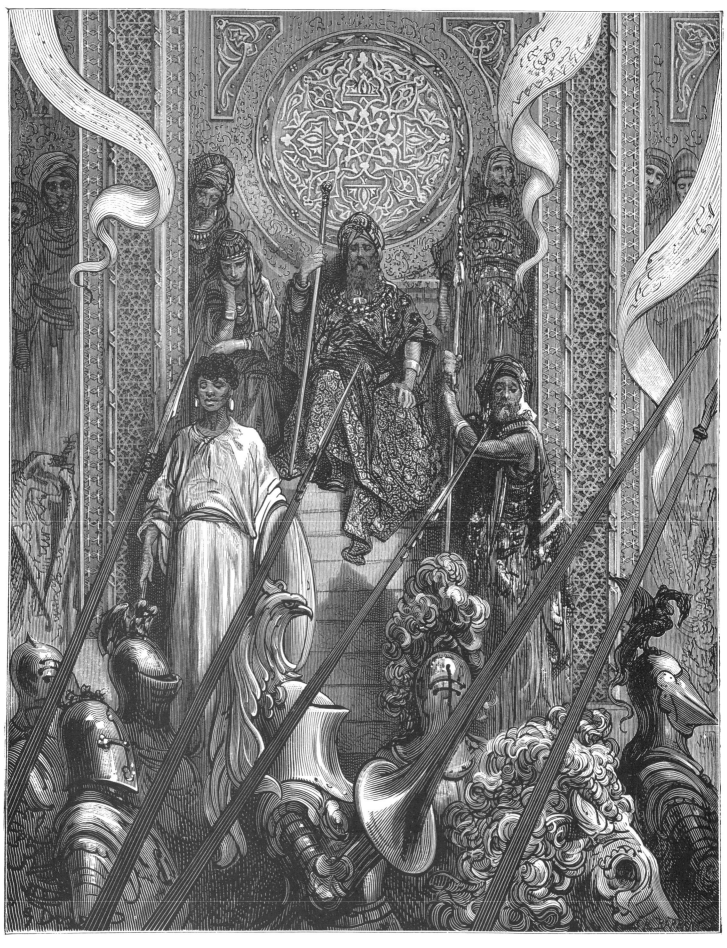

Norandino presides over a new tournament (18:104).

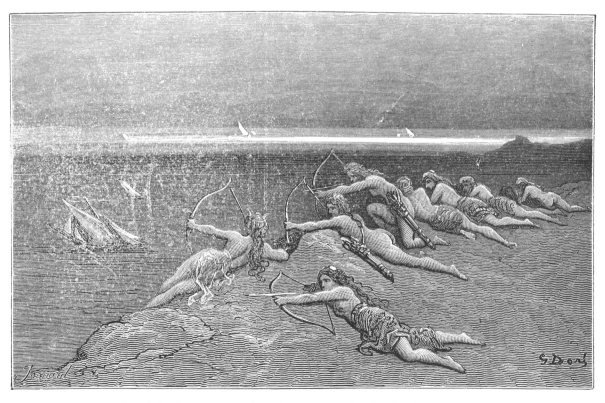

TOP: The idyll of Angelica and Medoro among the shepherds (19:33). BOTTOM:
The warlike man-hating women of Laiazzo (Iskenderun) (19:65).

Angelica and Medoro write their names on every surrounding tree (19:36).

Angelica and Medoro travel along the coast of Catalonia (19:41).

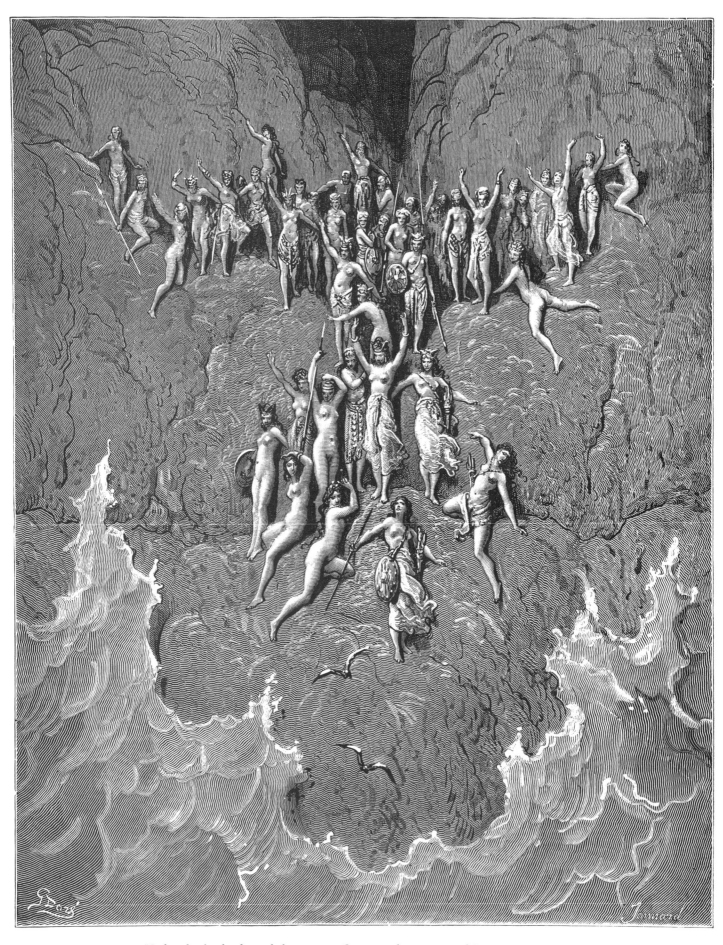

Under the leadership of their queen Orontea, the women of Laiazzo prey upon voyagers (20:28).

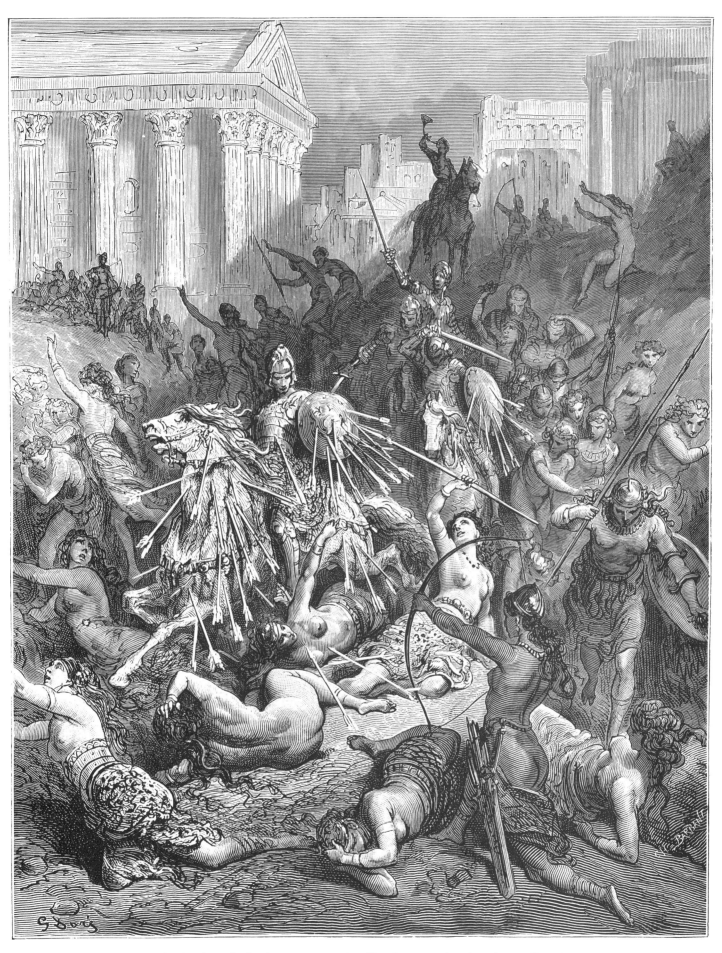

In the battle with the fierce women, Astolfo's horn terrifies friend as well as foe
(20:93).

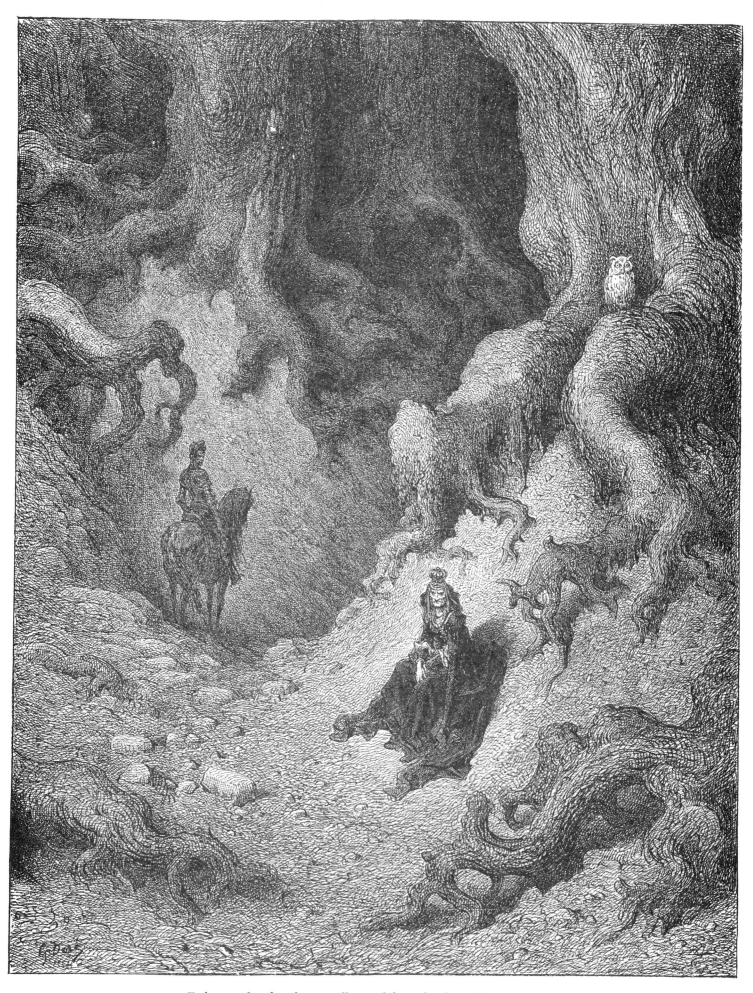

Zerbino undertakes the surveillance of the malevolent Gabrina (21:70).

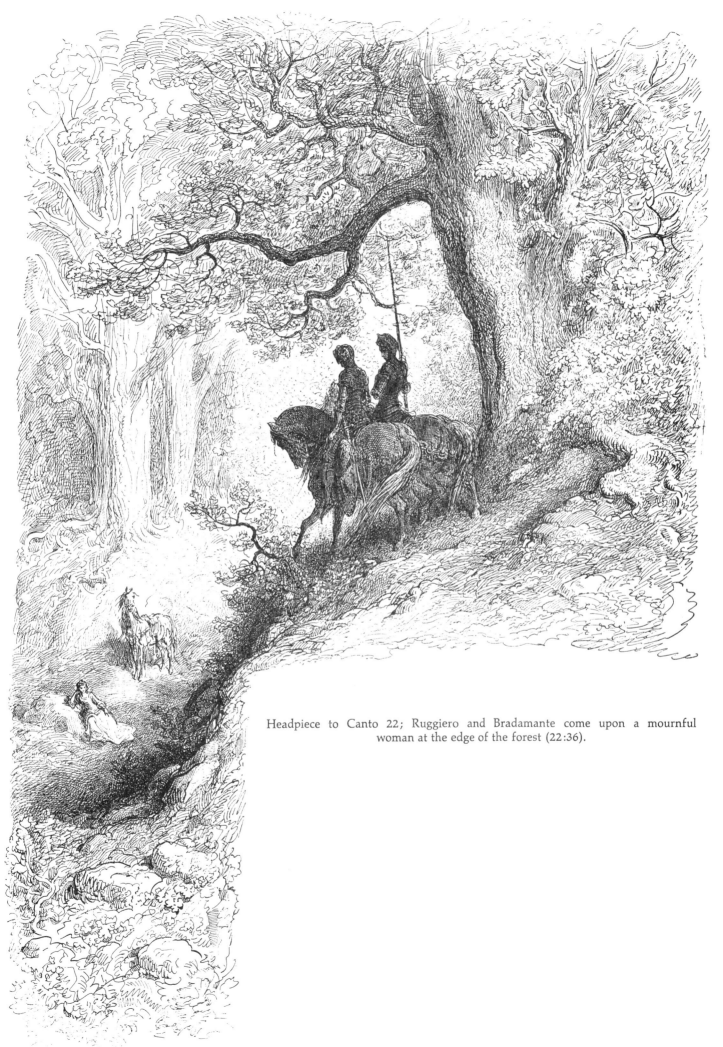

Headpiece to Canto 22; Ruggiero and Bradamante come upon a mournful woman at the edge of the forest (22:36).

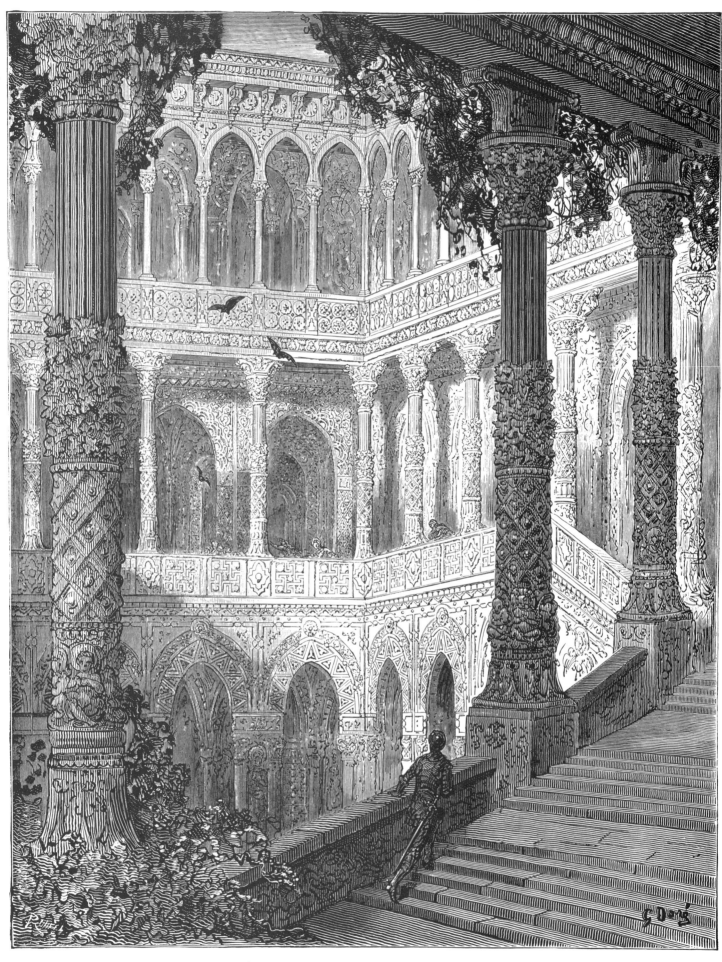

Astolfo in his turn is lured to Atlante's palace of illusions (22:15).

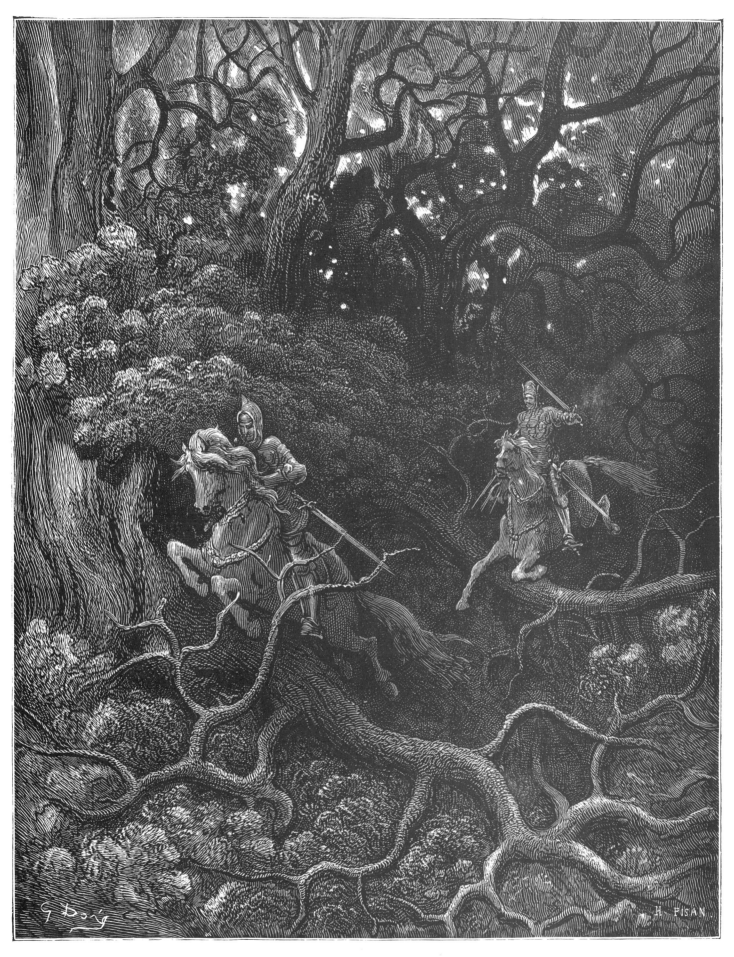

The sorcerer flees the destruction of his palace (22:61).

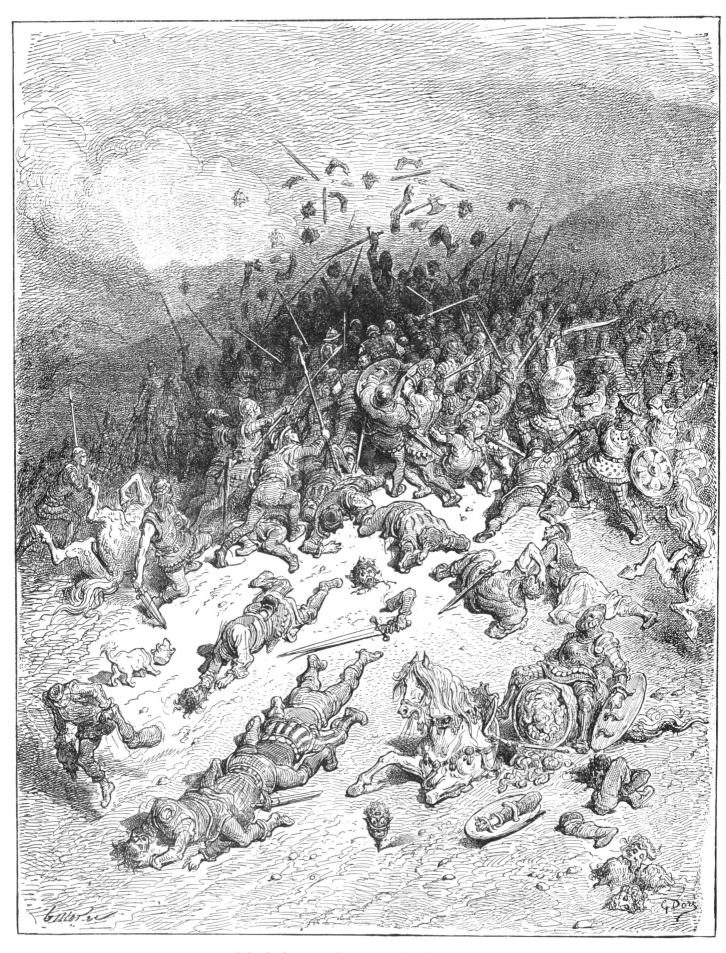

Orlando decimates the captors of Zerbino (23:61).

Orlando approaches the site of Angelica's honeymoon (23:100).

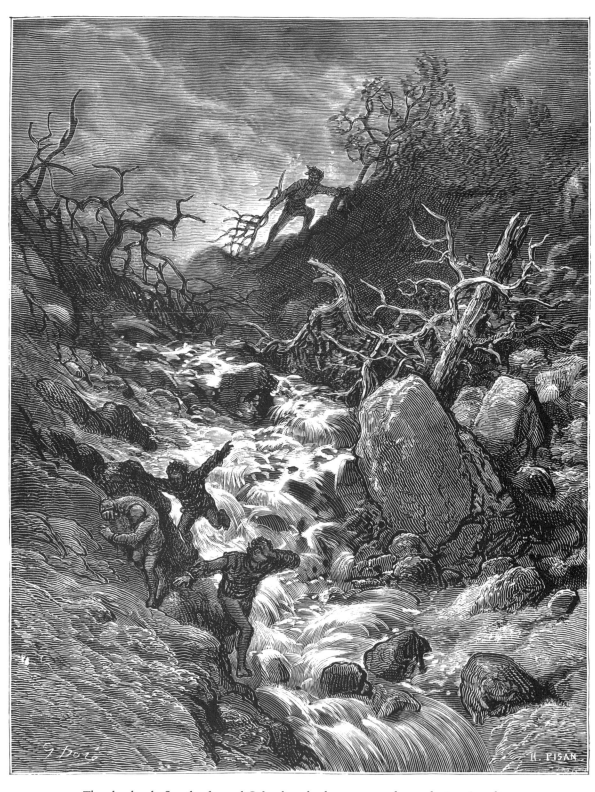

The shepherds flee the fury of Orlando, who has gone mad over losing Angelica
(24:4).

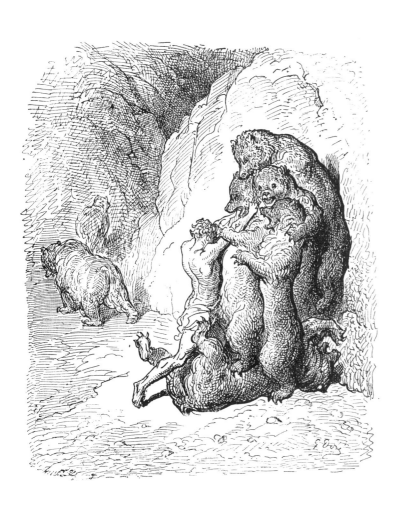

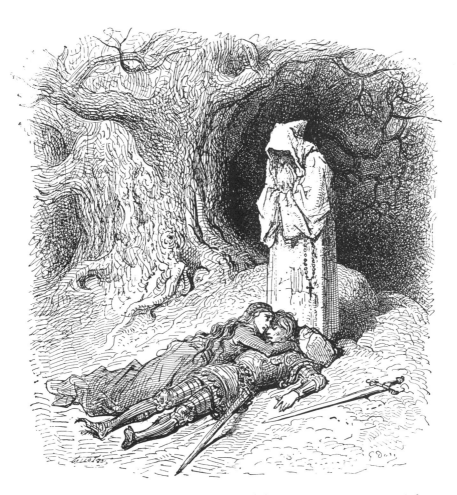

TOP LEFT: In his madness Orlando battles with bears (24:13). TOP RIGHT: Gabrina is treacherously hanged by Odorico, to whom Zerbino entrusted her (24:45). BOTTOM: A pious hermit arrives as Issabella bewails the dead Zerbino (24:87).

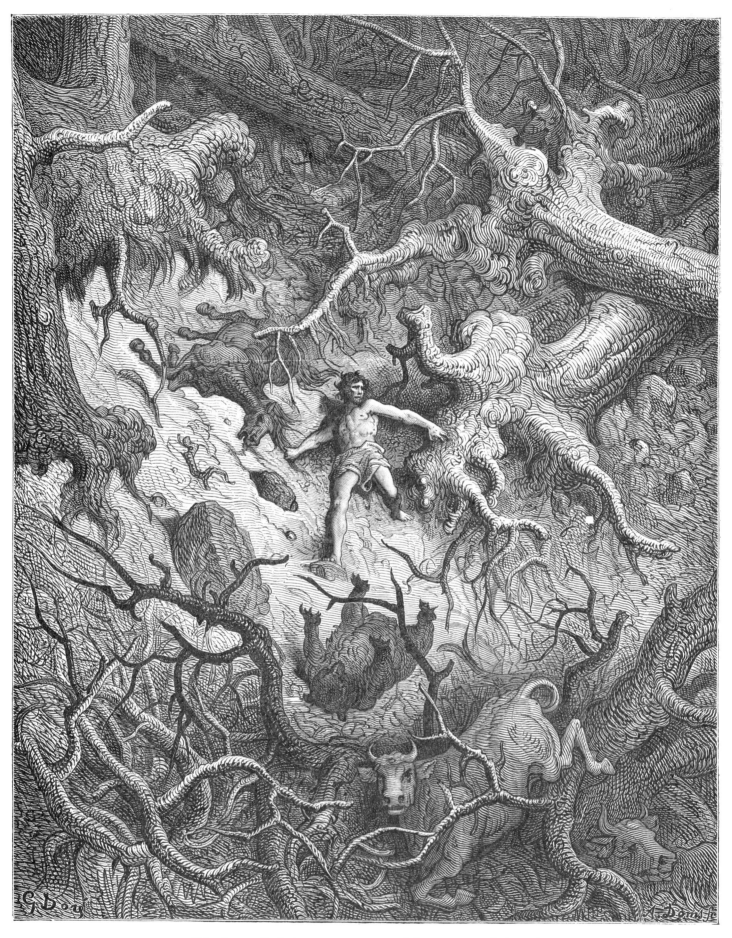

Orlando, totally *furioso,* uproots trees and destroys animals (24:13).

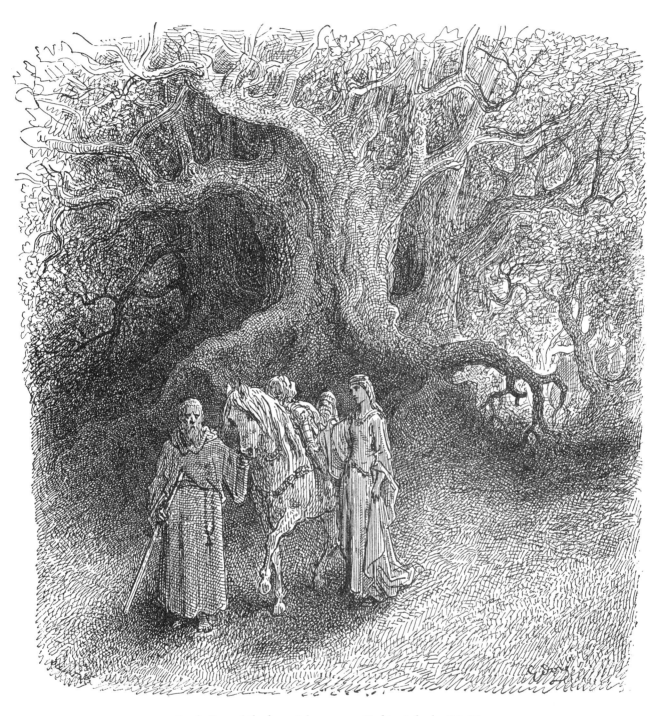

Issabella and the hermit bear away Zerbino's body (24:90).

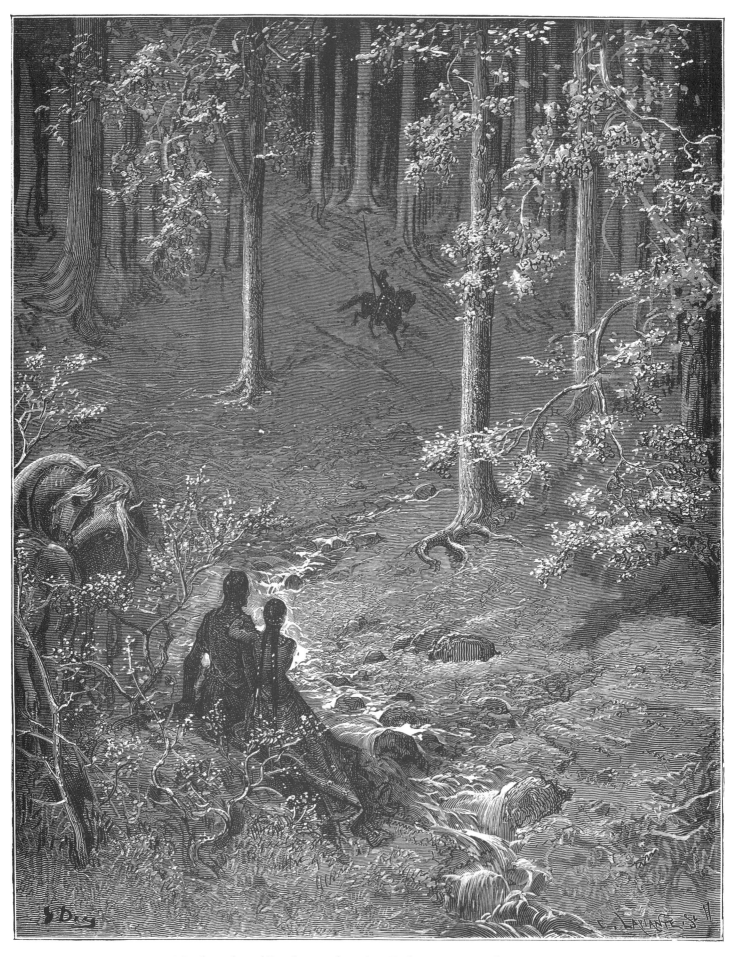

Mandricardo and Doralice see the jealous Rodomonte approaching (24:95).

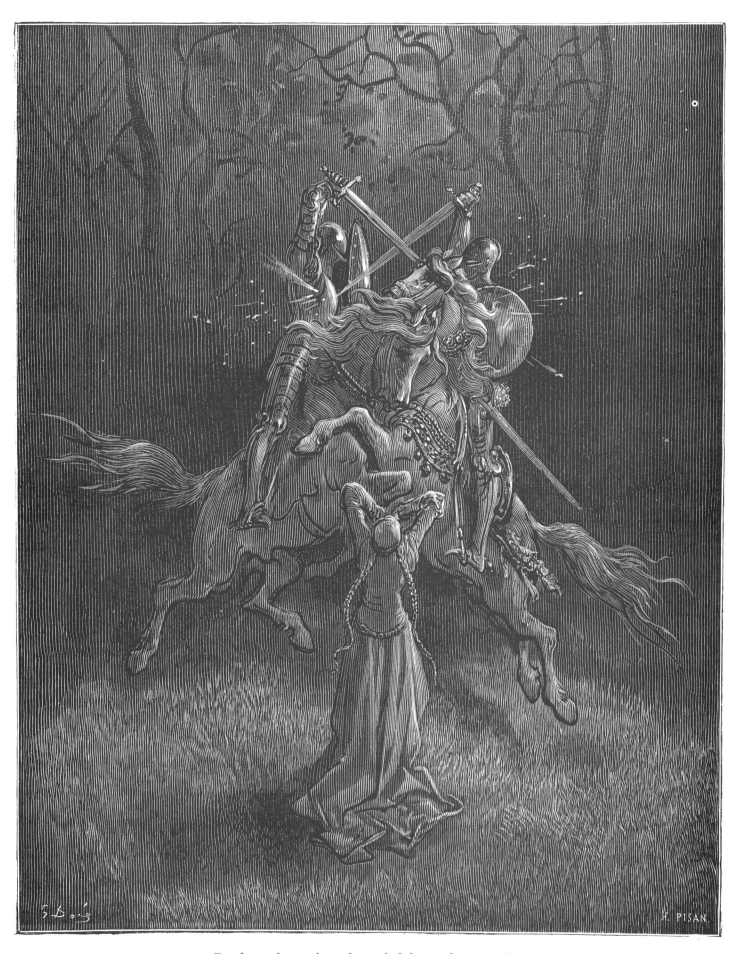

Doralice is distraught as the rivals fight over her (24:100).

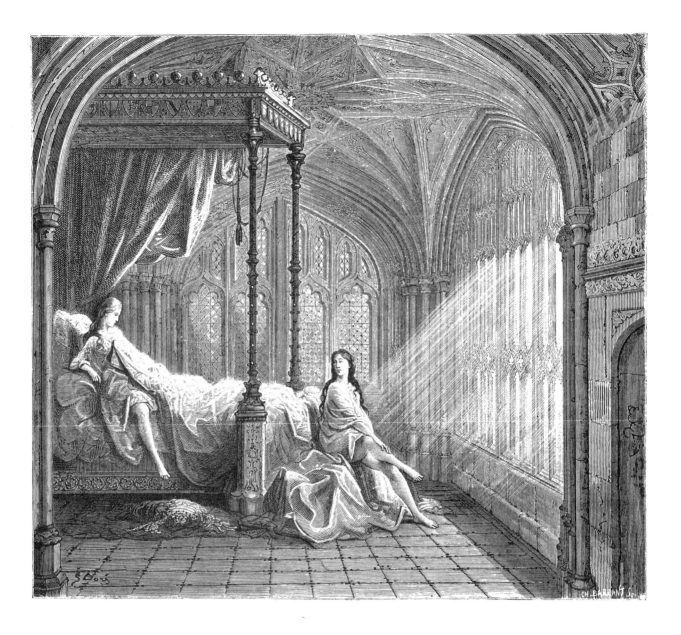

TOP: Fiordispina is hopelessly in love with Bradamante even though they are both women (25:42). BOTTOM: The satyr who has captured a nymph (25:60).

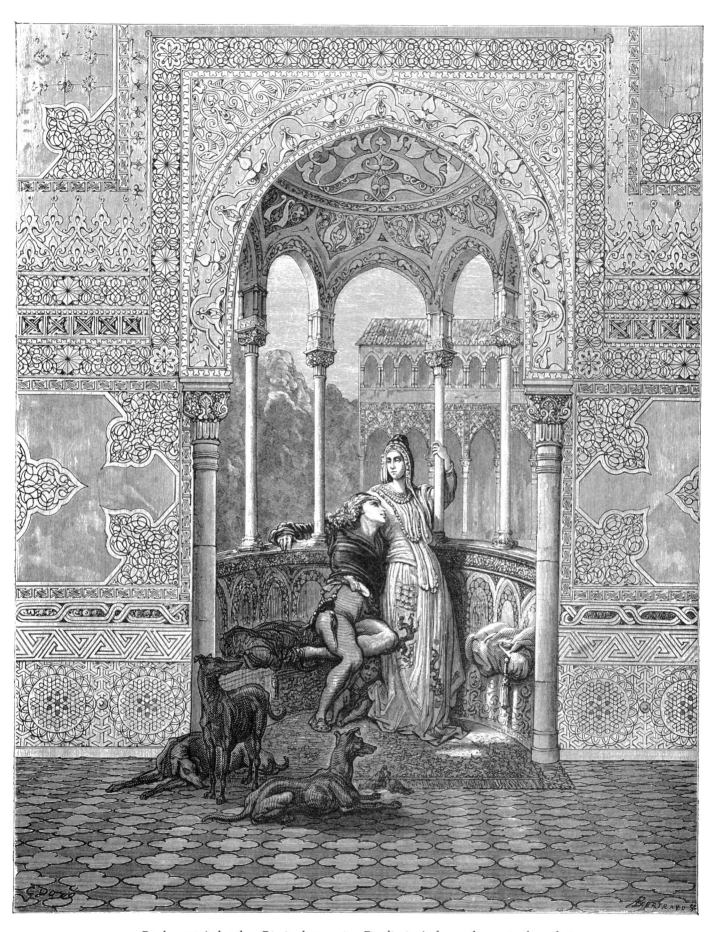

Bradamante's brother Ricciardetto gains Fiordispina's favors by pretending that
he is his sister, who has experienced a change of sex (25:70).

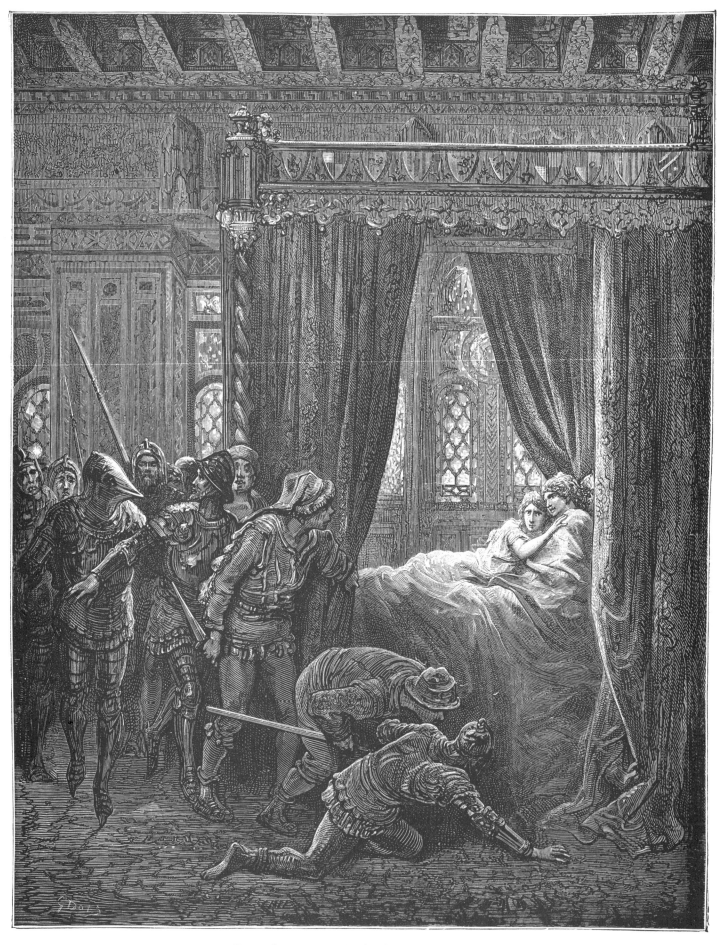

Ricciardetto's ruse is finally discovered (25:70).

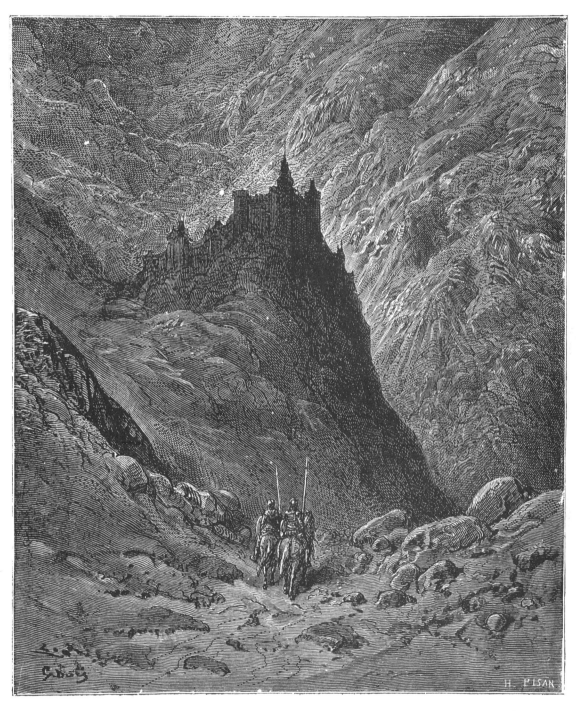

Ruggiero and Ricciardetto arrive at the castle called Agrismonte (25:71).

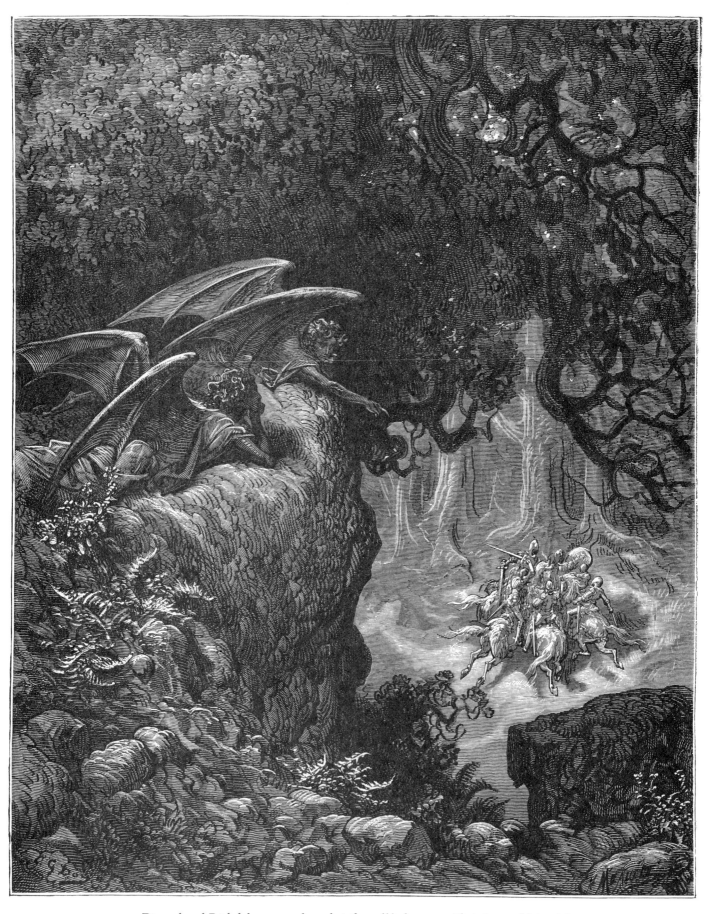

Discord and Pridefulness are pleased at the mêlée between Christian and Moorish
heroes (26:122).

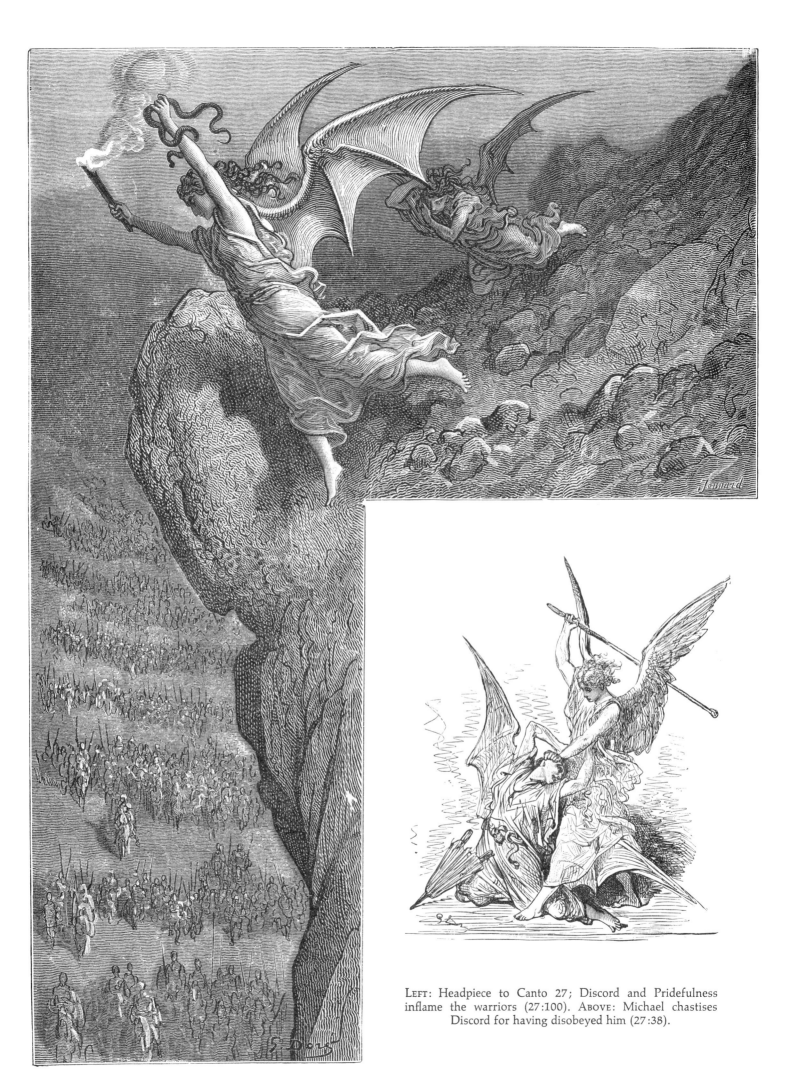

LEFT: Headpiece to Canto 27; Discord and Pridefulness
inflame the warriors (27:100). ABOVE: Michael chastises
Discord for having disobeyed him (27:38).

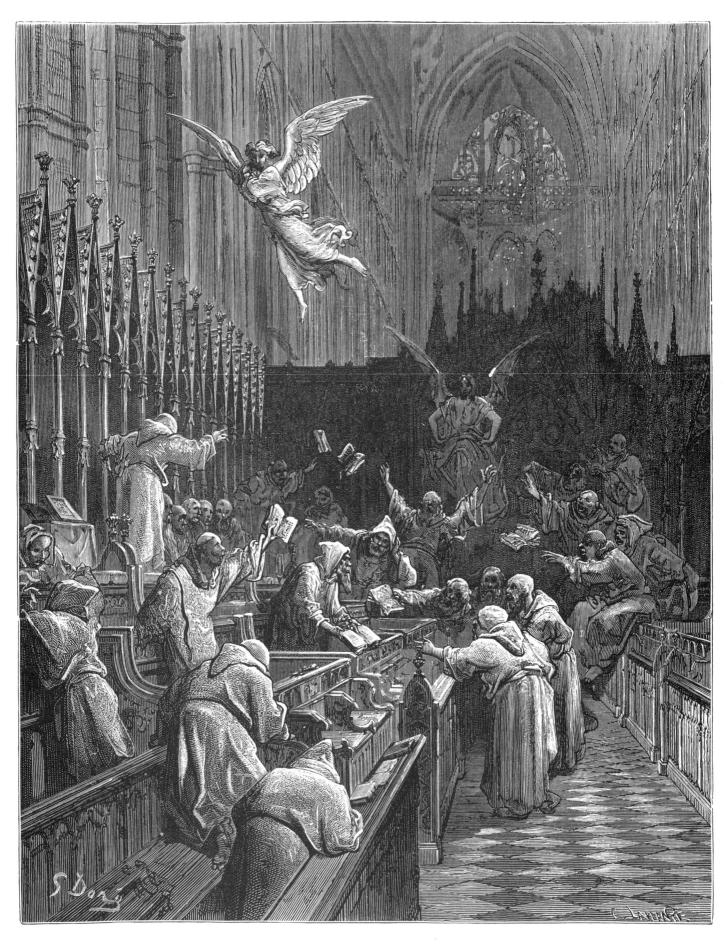

Michael finds Discord presiding over an election in the monastery (27:37).

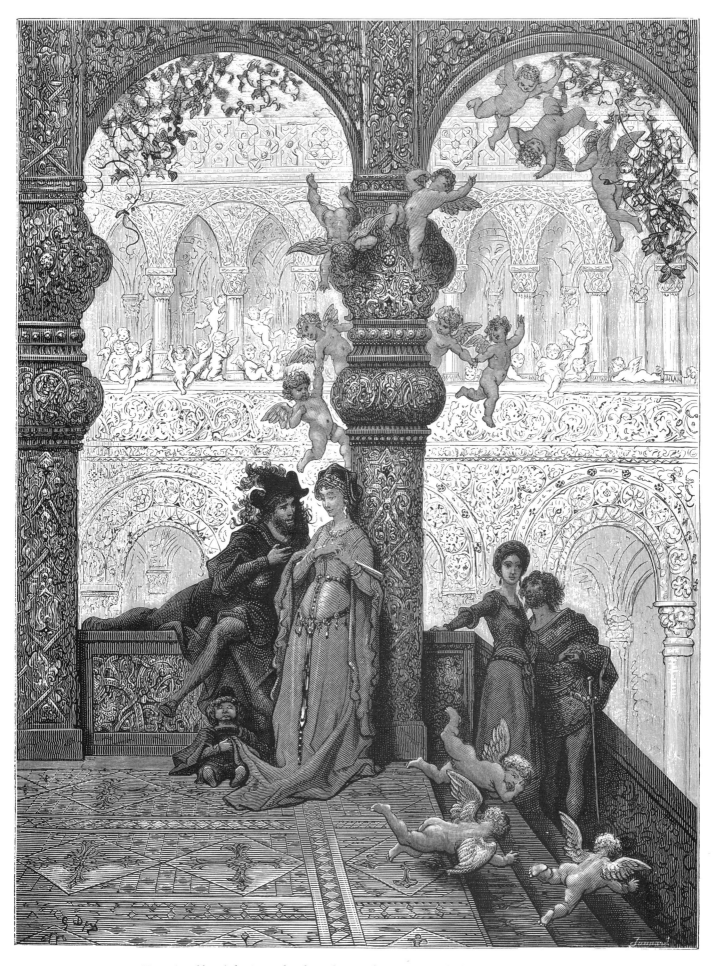

King Astolfo of the Langobards and Iocondo Latini travel all over Europe incognito, making love to beautiful women (28:48).

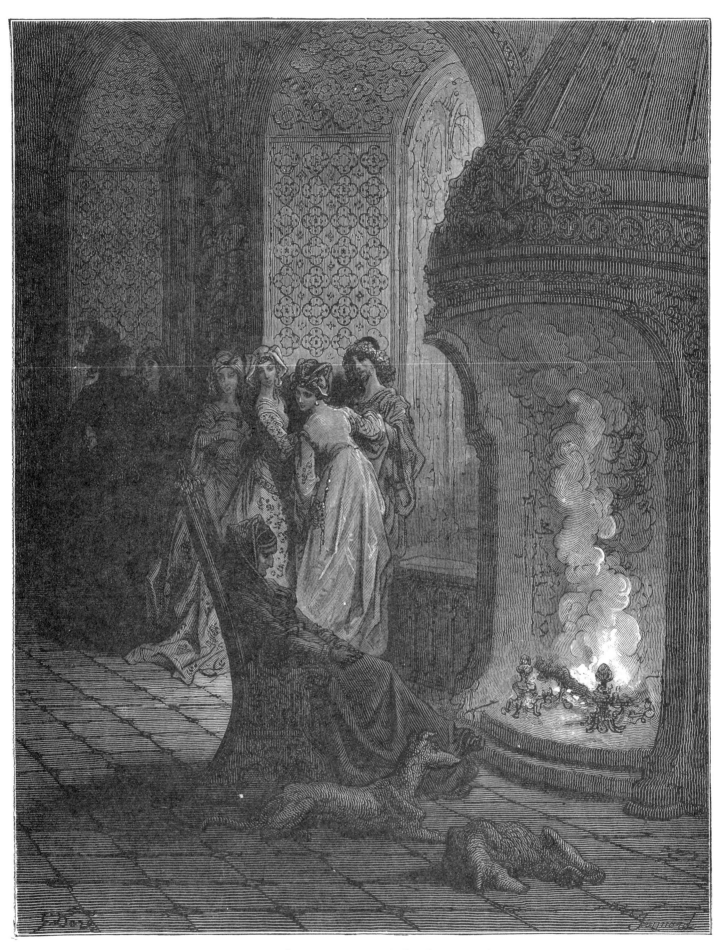

Amorous adventures in women's chambers (28:49).

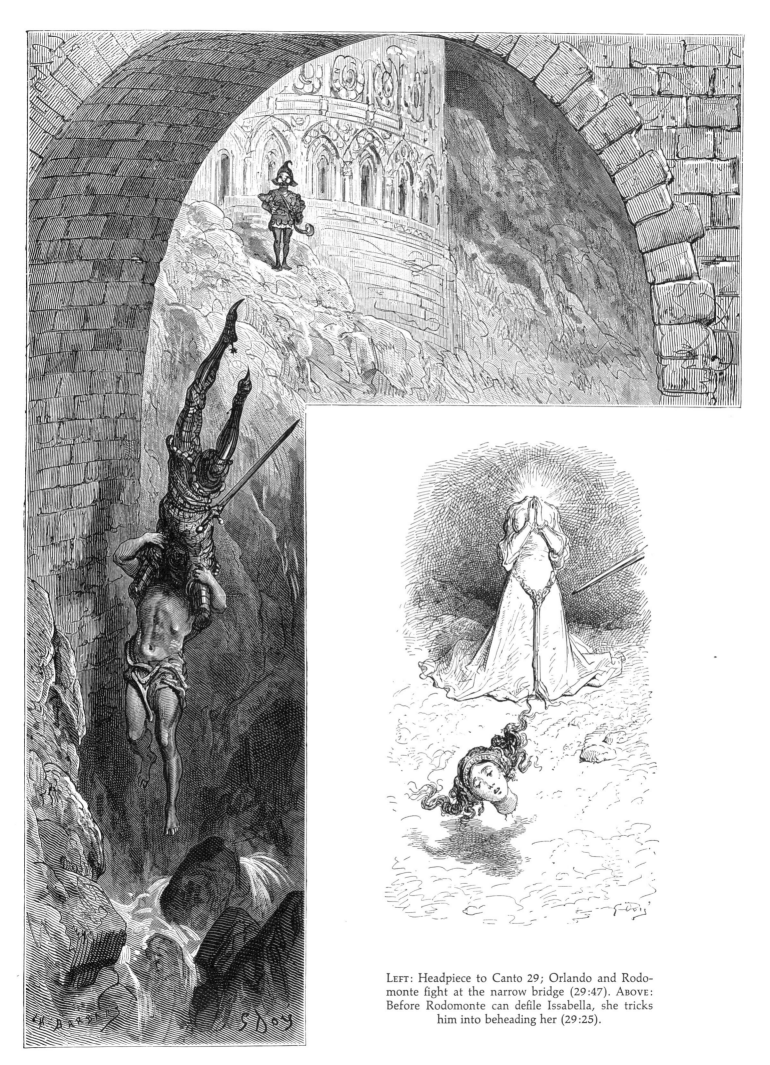

LEFT: Headpiece to Canto 29; Orlando and Rodo-
monte fight at the narrow bridge (29:47). ABOVE:
Before Rodomonte can defile Issabella, she tricks
him into beheading her (29:25).

91

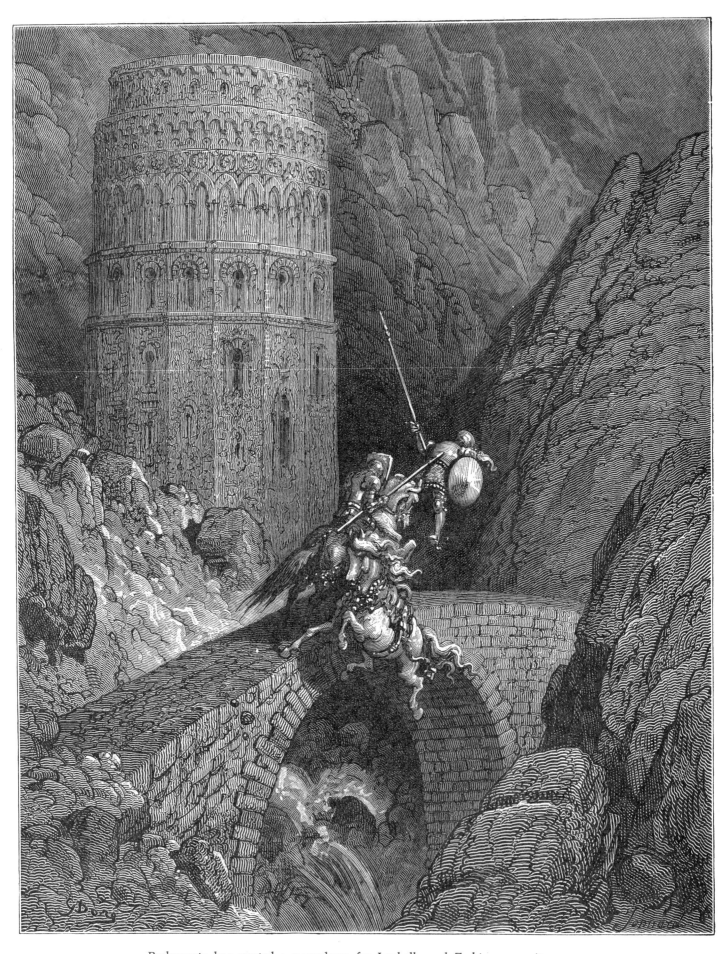

Rodomonte has erected a mausoleum for Issabella and Zerbino; near it, on a
narrow bridge over a river he combats all wayfaring knights (29:36).

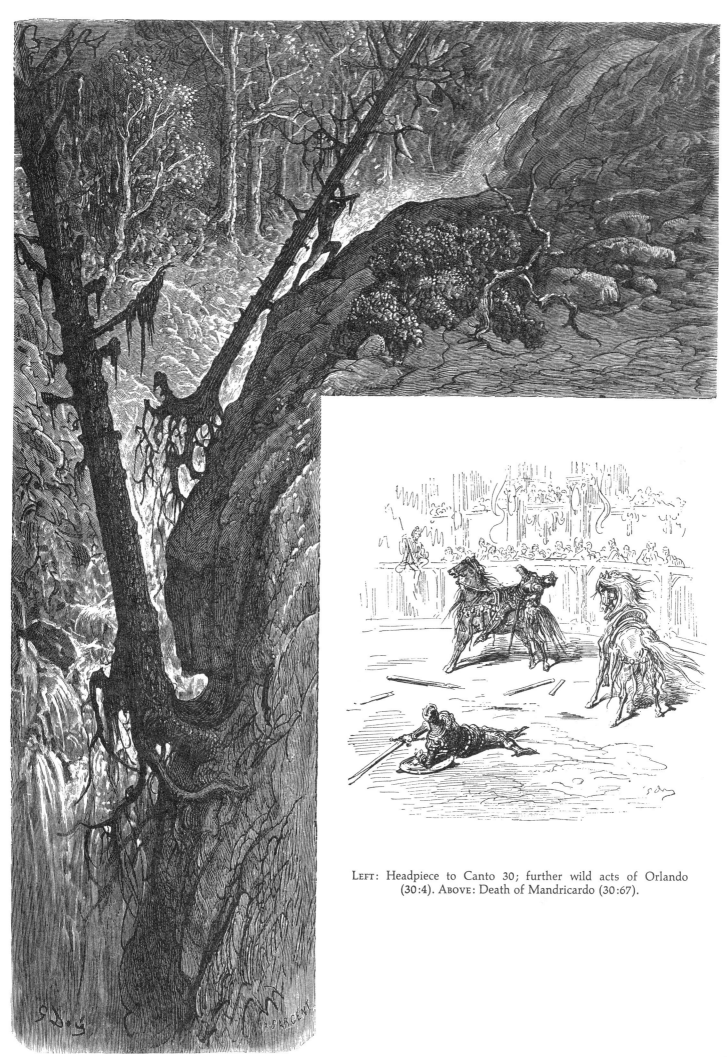

LEFT: Headpiece to Canto 30; further wild acts of Orlando (30:4). ABOVE: Death of Mandricardo (30:67).

Mad Orlando continues to drag a dead horse after him as he wanders (30:4).

Angelica and Medoro escape happily to India (30:16).

Doralice tries to keep Mandricardo from his duel with Ruggiero (30:45).

Rinaldo and his men meet a strange knight with a lady (31:8).

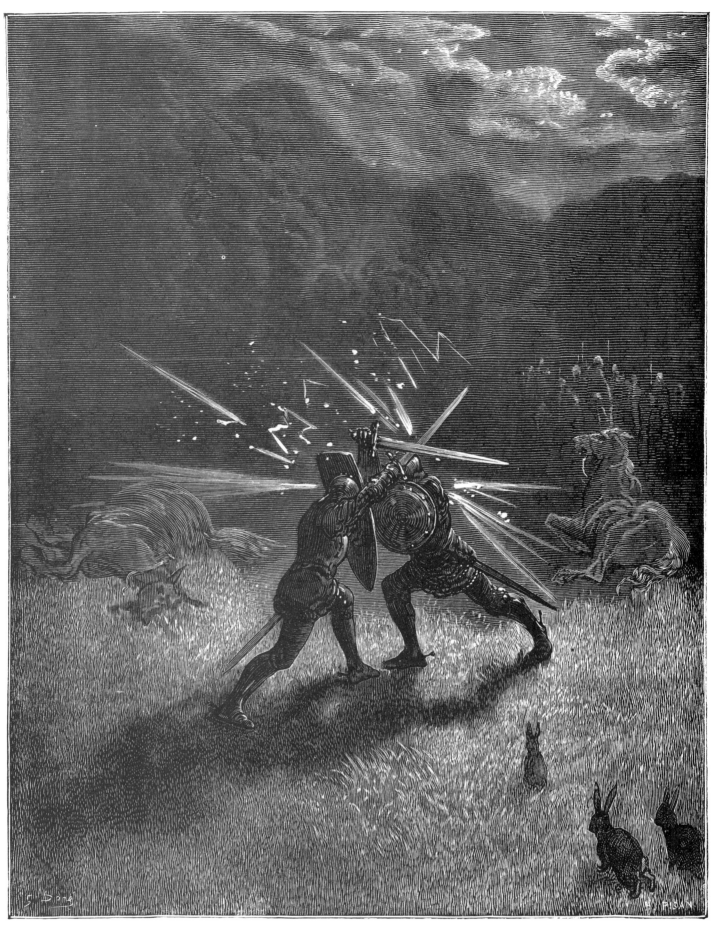

Rinaldo fights the strange knight, who proves to be his own half-brother
Guidone Selvaggio (31:22).

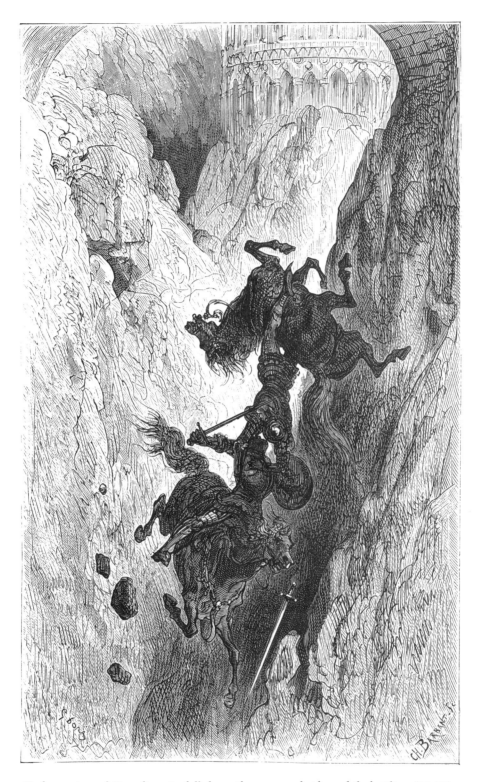

Rodomonte and Brandimarte fall from the narrow bridge while battling (31:70).

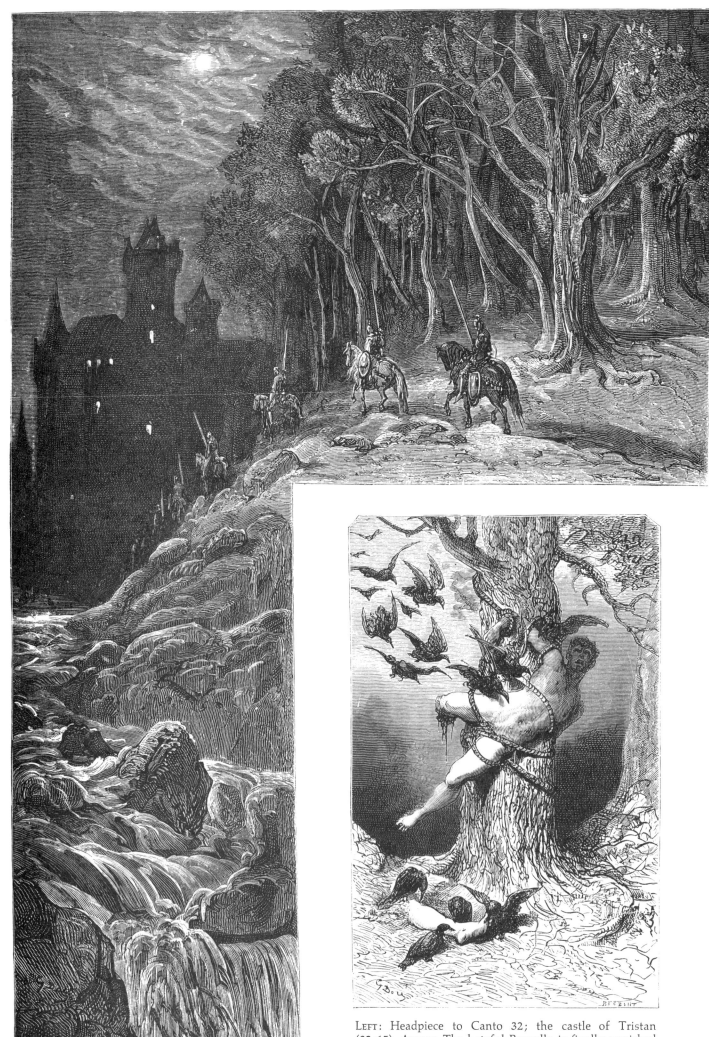

LEFT: Headpiece to Canto 32; the castle of Tristan (32:65). ABOVE: The hateful Brunello is finally punished for his crimes (32:9).

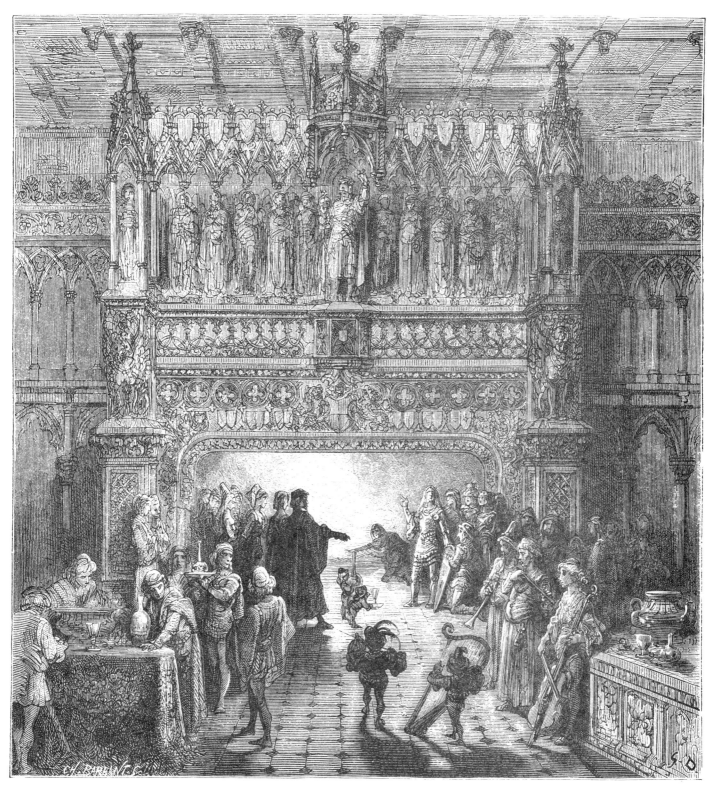

Bradamante is welcomed at the castle of Tristan (32:81).

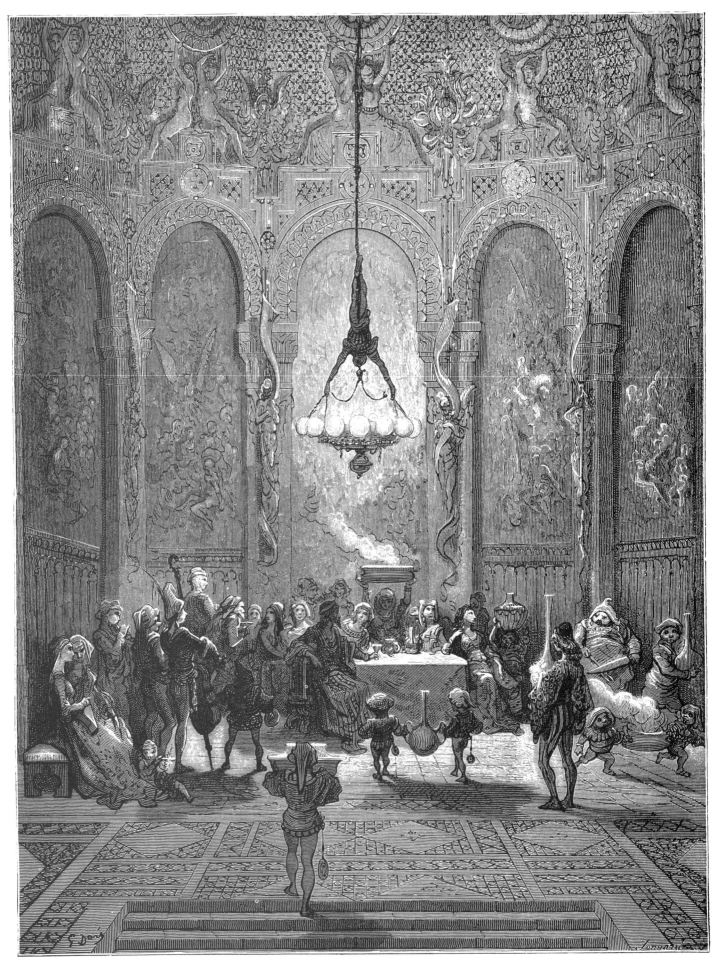

The richly decorated great hall of the castle (32:95).

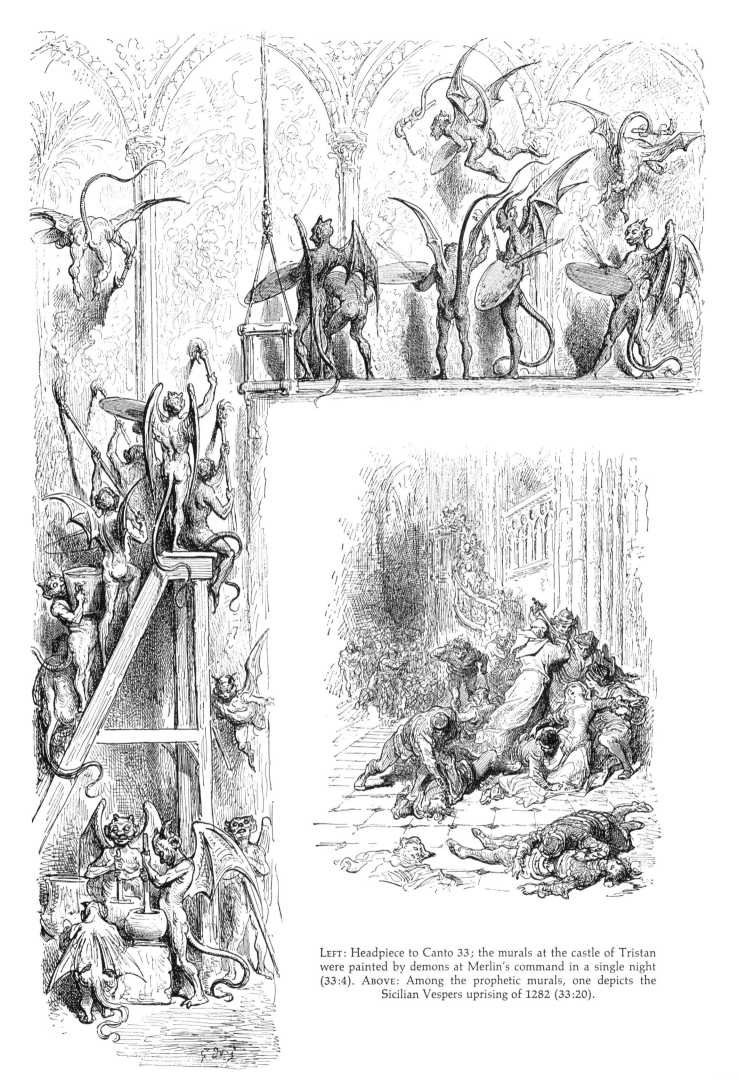

LEFT: Headpiece to Canto 33; the murals at the castle of Tristan were painted by demons at Merlin's command in a single night (33:4). ABOVE: Among the prophetic murals, one depicts the Sicilian Vespers uprising of 1282 (33:20).

Two scenes from the prophetic murals: the warfare in northern Italy in Ariosto's own day (33:40, 41).

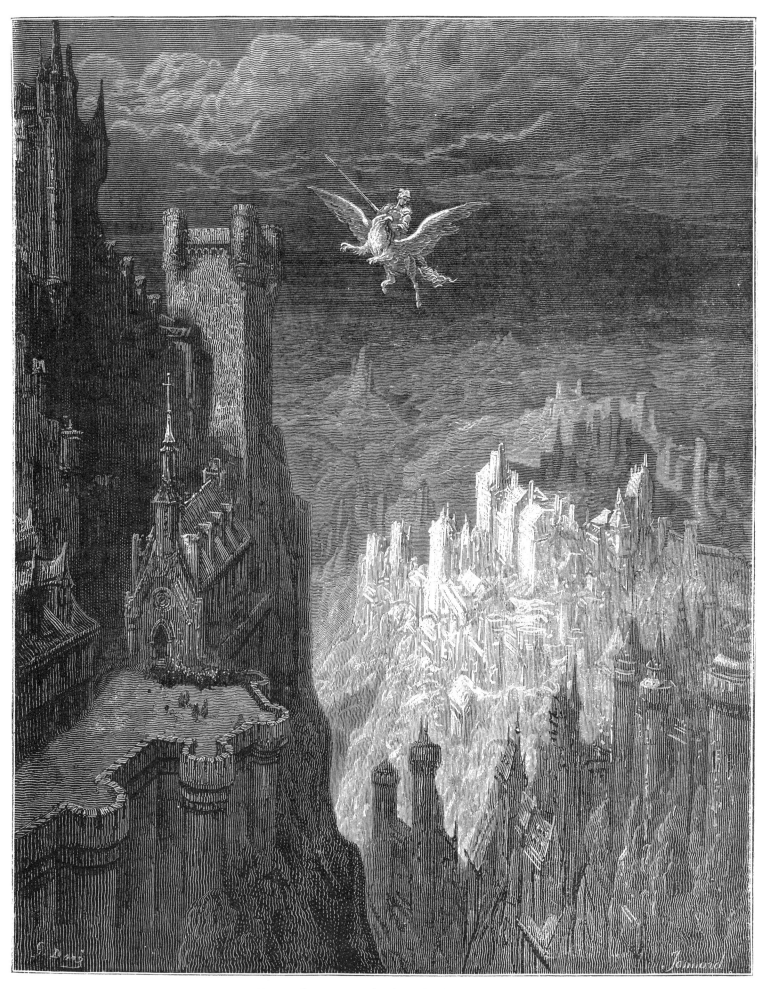

Astolfo travels over many lands on the hippogriff (33:96).

TOP: Astolfo on his travels (33:96). BOTTOM: Astolfo chases the harpies to the entrance of the underworld (33:127).

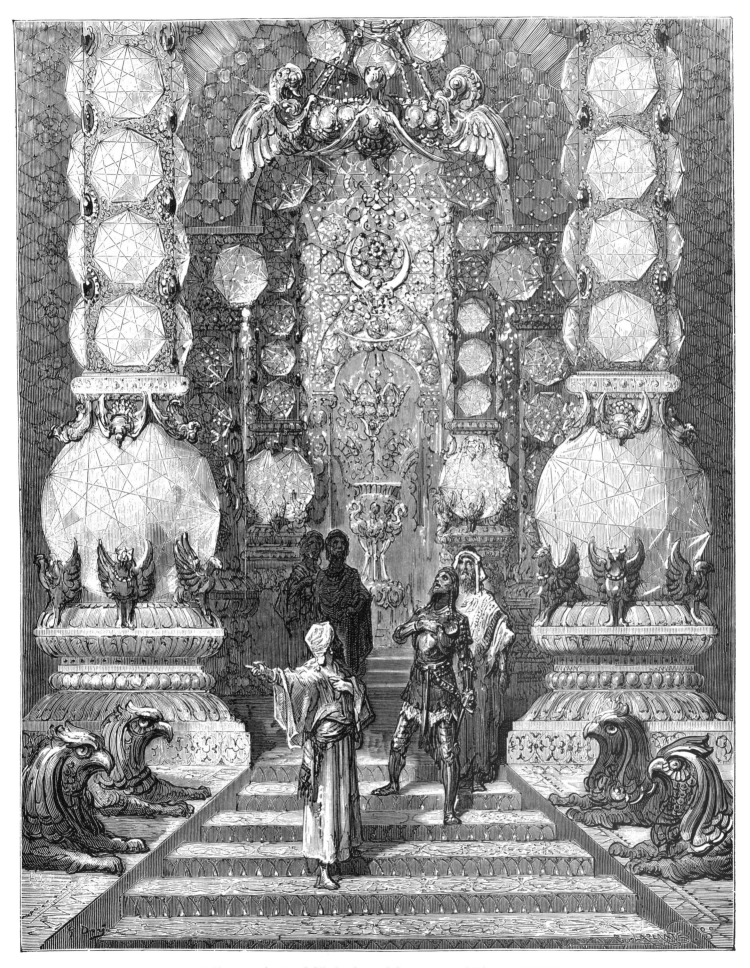

Astolfo visits the jewel-filled palace of the emperor of Ethiopia (33:104).

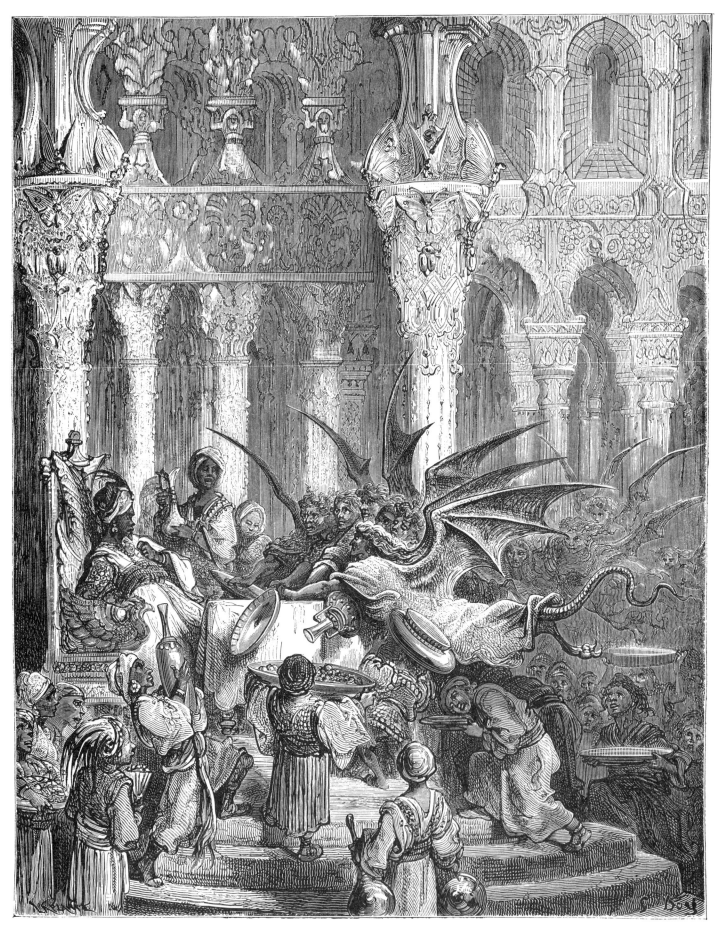

Attacking harpies prevent the emperor from enjoying any meal (33:108).

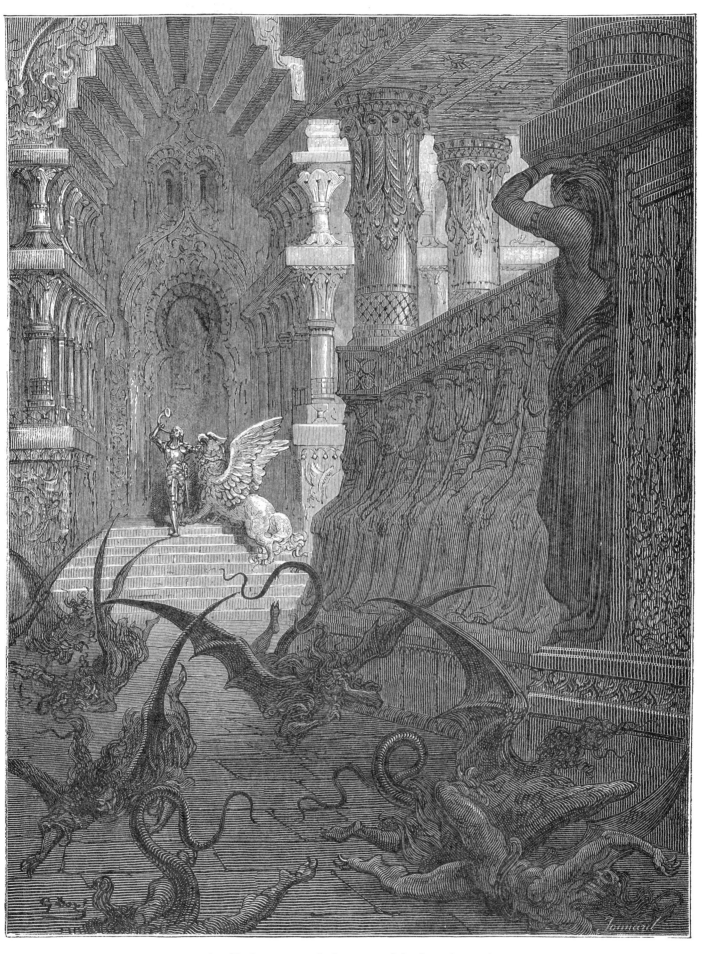

Astolfo drives away the harpies with his horn (33:125).

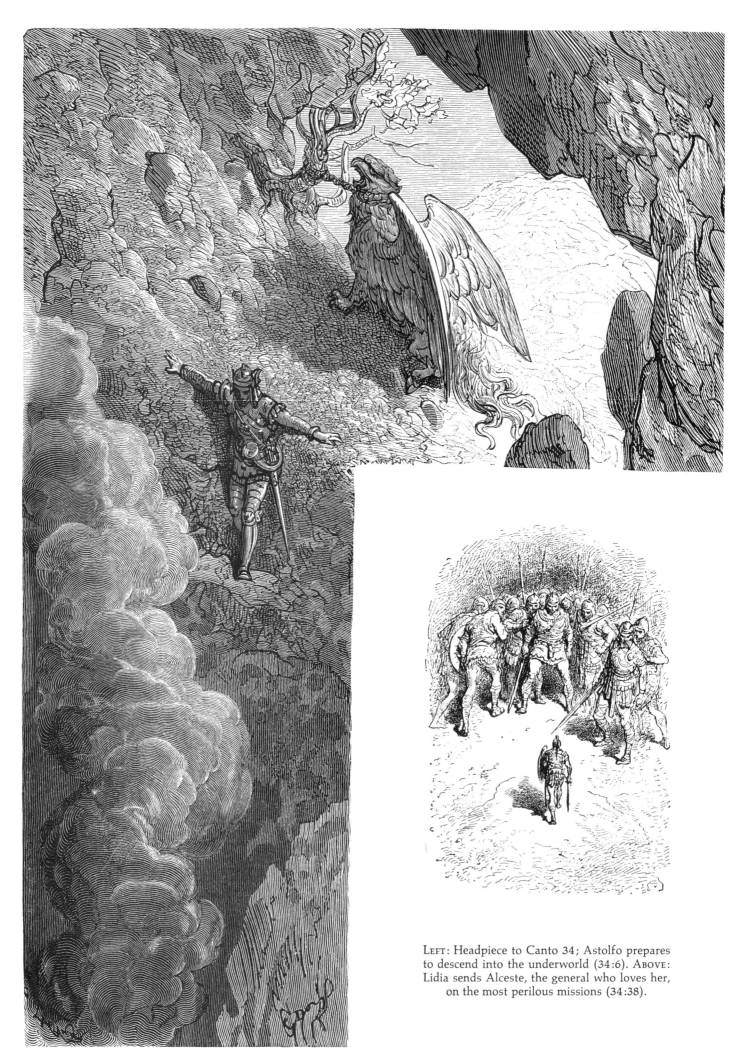

LEFT: Headpiece to Canto 34; Astolfo prepares
to descend into the underworld (34:6). ABOVE:
Lidia sends Alceste, the general who loves her,
on the most perilous missions (34:38).

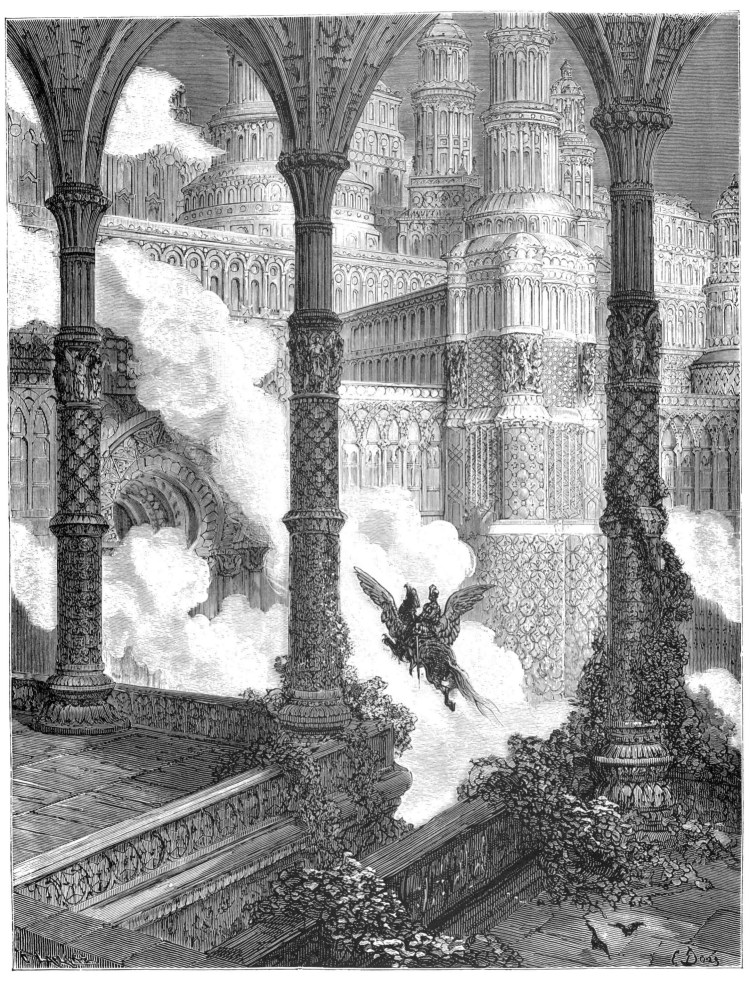

Astolfo arrives at a magnificent palace atop a lofty mountain (34:52).

Astolfo is received at the palace by St. John the Evangelist, the patriarch Enoch
and the prophet Elijah (34:60).

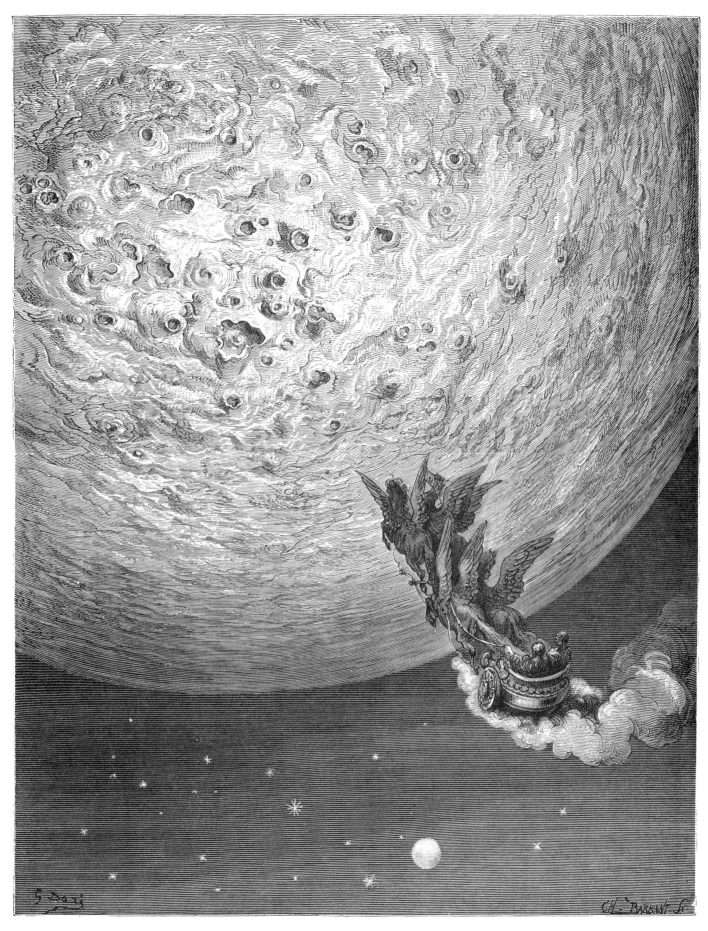

In Elijah's chariot, St. John and Astolfo travel to the moon in search of Orlando's lost reason (34:70).

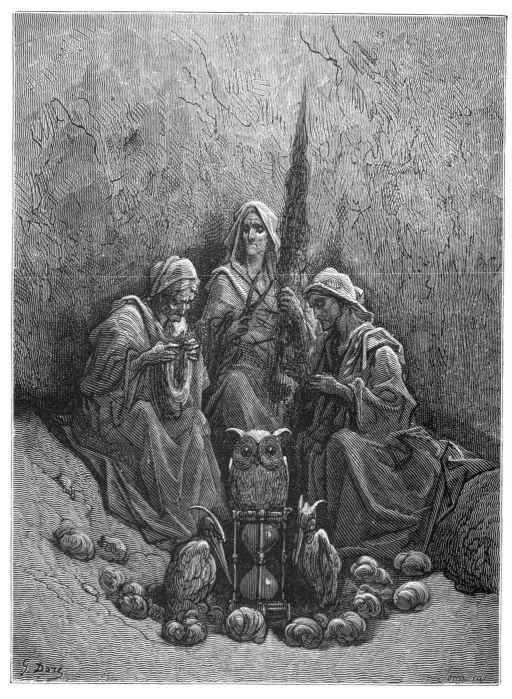

St. John shows Astolfo the three Fates spinning human destinies (34:89).

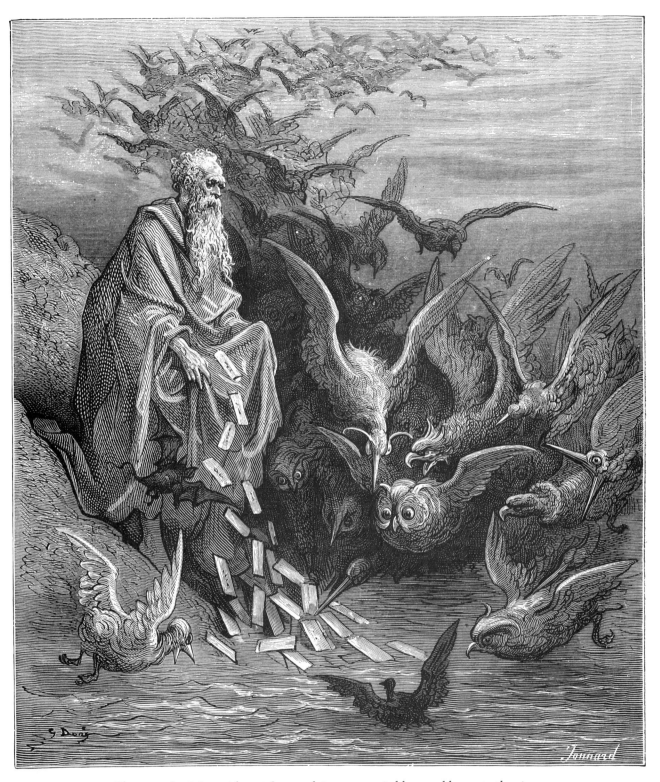

The spun destinies, with metal nameplates, are carried by an old man to the river Lethe, where they are thrown into the water (people destined to be forgotten after death) or carried off by birds; some of the birds drop their booty soon (people destined to be famous only in their lifetime), while others bring the names safely to the Temple of Immortality (35:13).

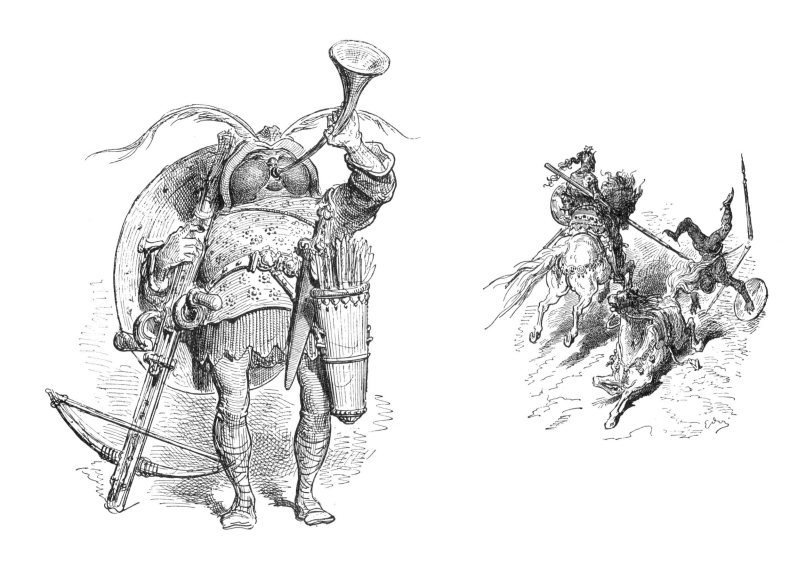

TOP LEFT: Rodomonte's watchman at the narrow bridge announces the approach of Bradamante (35:40). TOP RIGHT: Bradamante unseats the Moor Grandonio at Arles (35:71). BOTTOM: The inhabitants of Arles come to the city walls when Bradamante arrives to seek battle (35:66).

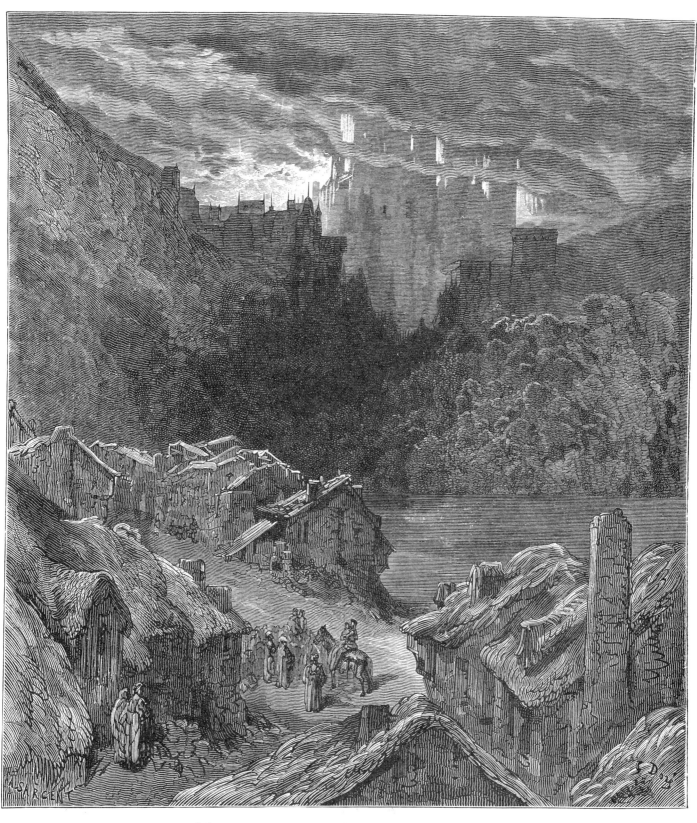

Ruggiero and his companions approach the castle of the cruel misogynist
Marganorre (37:42).

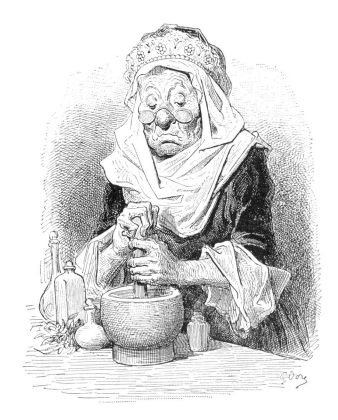

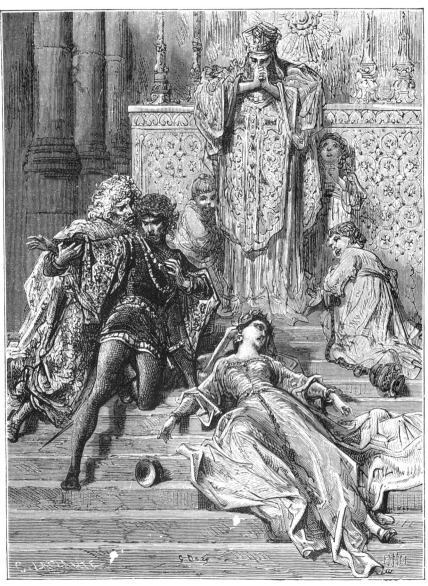

TOP LEFT: Drusilla's old servant mixes poison (37:67). TOP RIGHT: After Marganorre is vanquished, Drusilla's servant tortures him with a goad (37:108). BOTTOM: At the wedding ceremony, Drusilla poisons herself and her hated groom Tanacro, son of Marganorre (37:75).

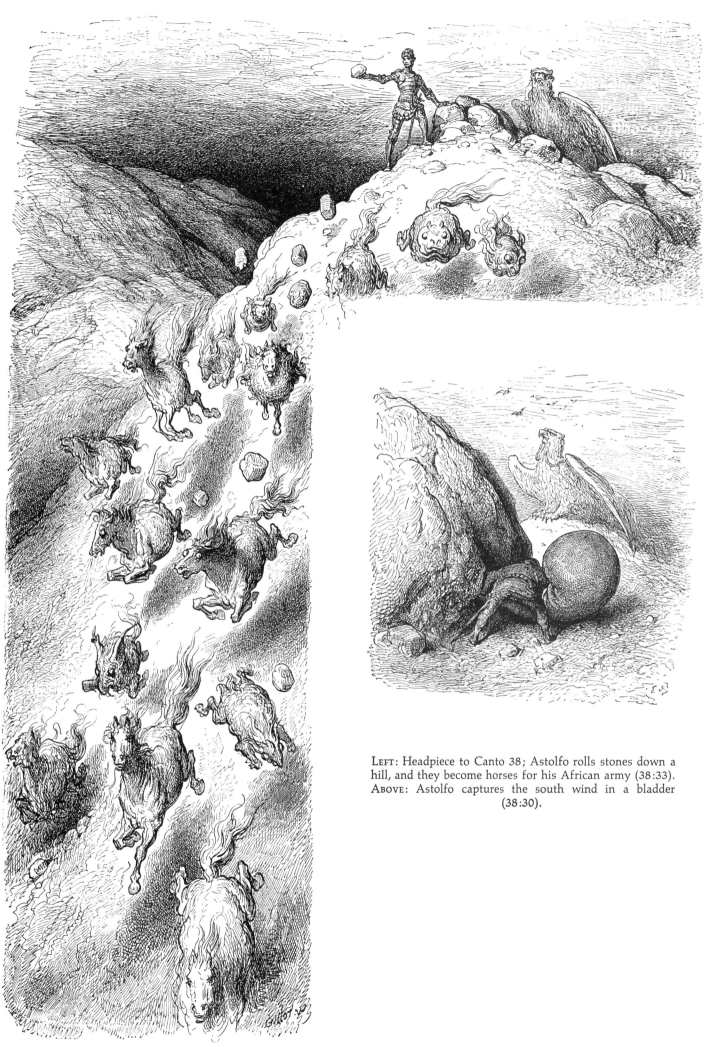

Left: Headpiece to Canto 38; Astolfo rolls stones down a hill, and they become horses for his African army (38:33).
Above: Astolfo captures the south wind in a bladder (38:30).

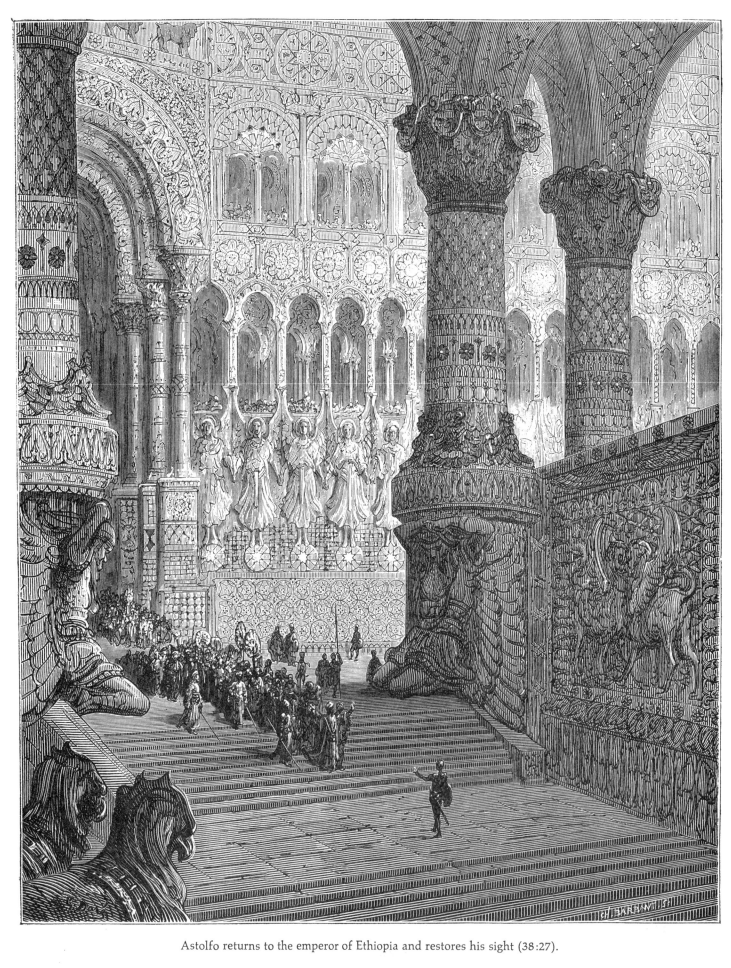

Astolfo returns to the emperor of Ethiopia and restores his sight (38:27).

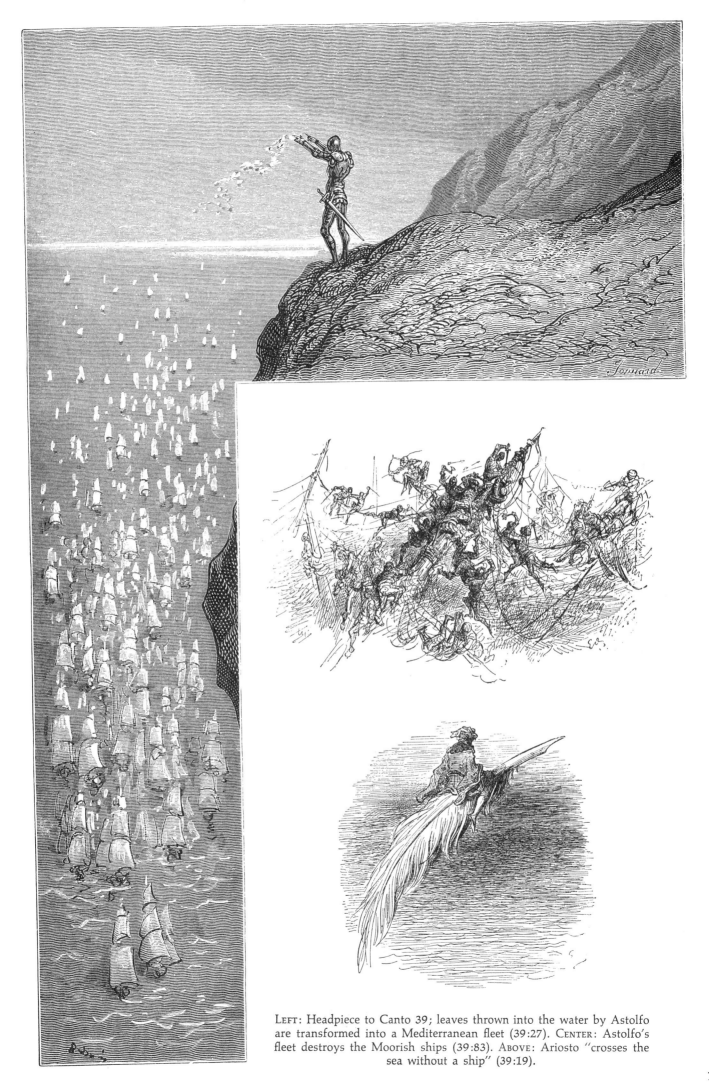

LEFT: Headpiece to Canto 39; leaves thrown into the water by Astolfo are transformed into a Mediterranean fleet (39:27). CENTER: Astolfo's fleet destroys the Moorish ships (39:83). ABOVE: Ariosto "crosses the sea without a ship" (39:19).

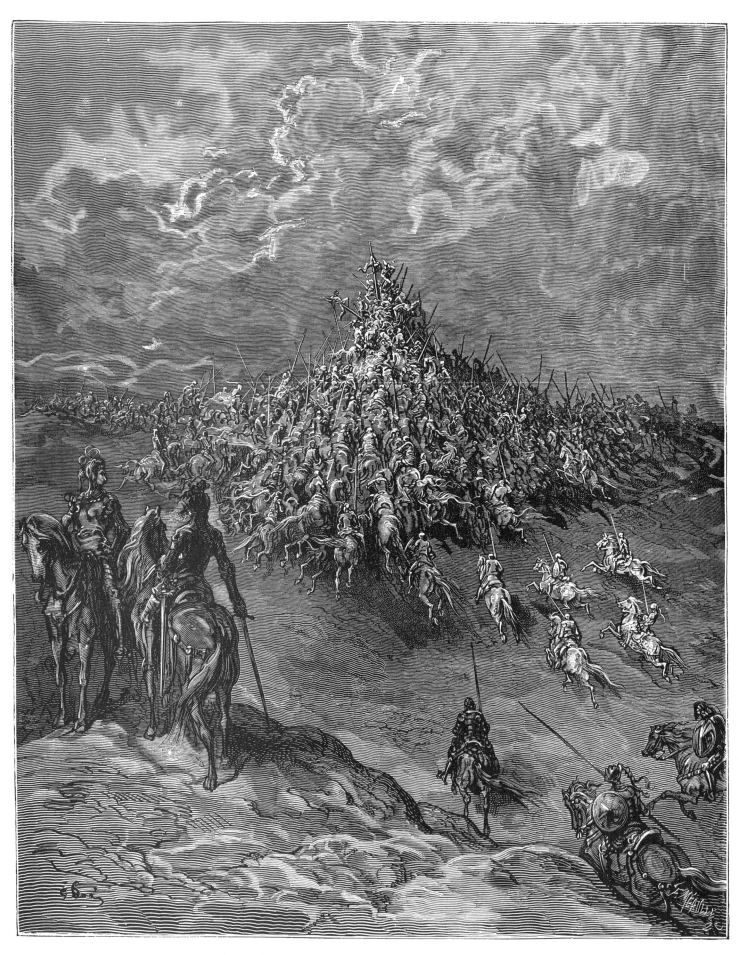

Ruggiero and Rinaldo stand aside as their planned duel turns into a free-for-all
(39:9).

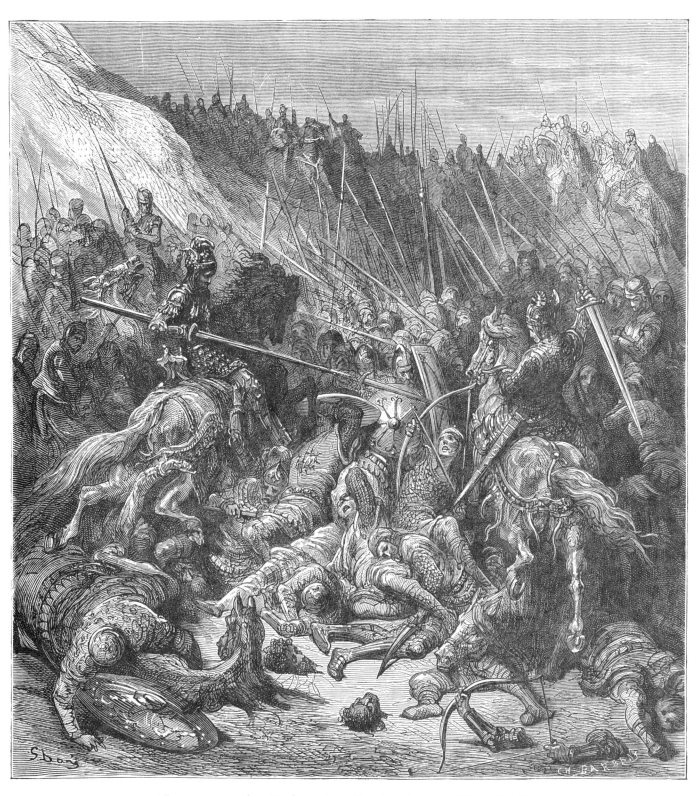

The warrior maidens Bradamante and Marfisa slay many Moors (39:15).

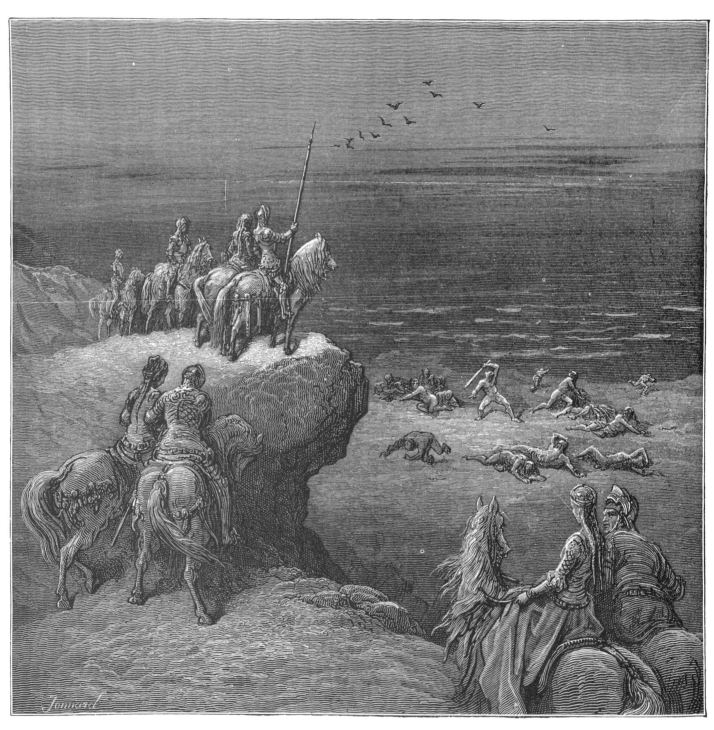

Astolfo's party comes upon Orlando battling against great numbers (39:36).

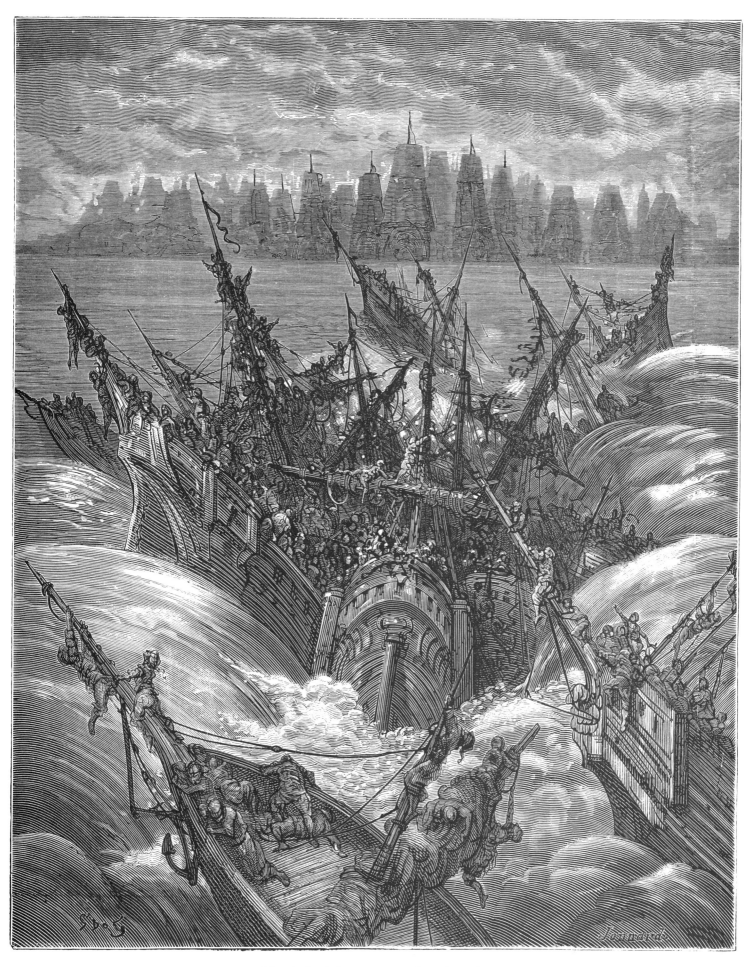

The clash of the two enemy fleets (39:81).

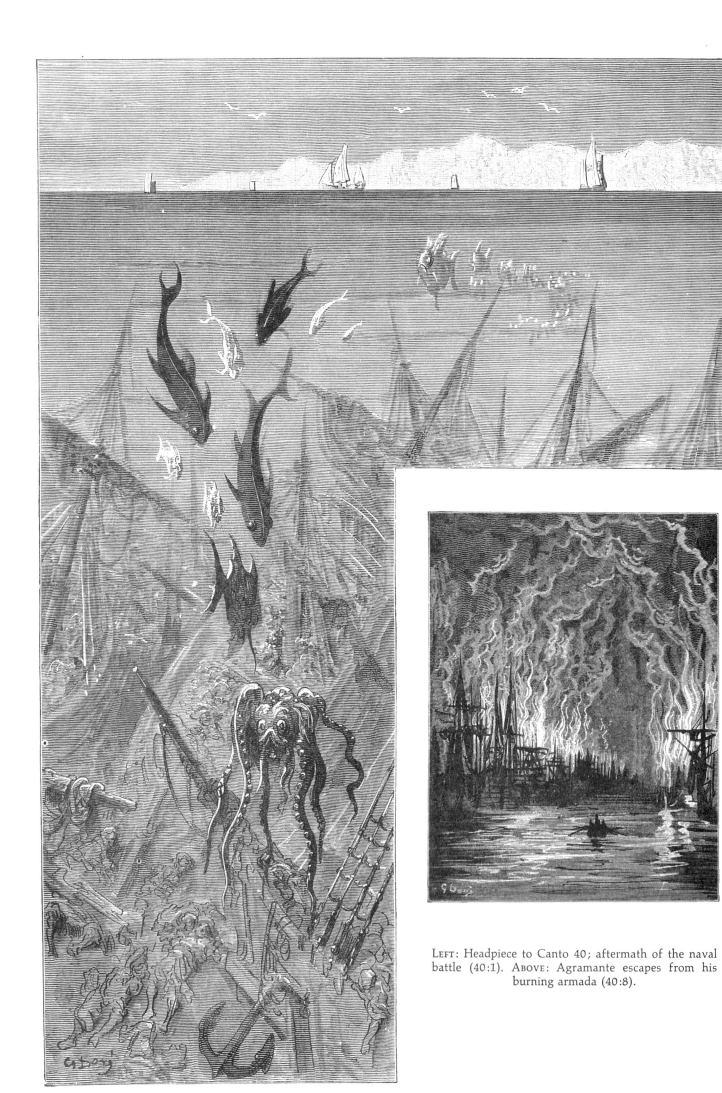

LEFT: Headpiece to Canto 40; aftermath of the naval battle (40:1). ABOVE: Agramante escapes from his burning armada (40:8).

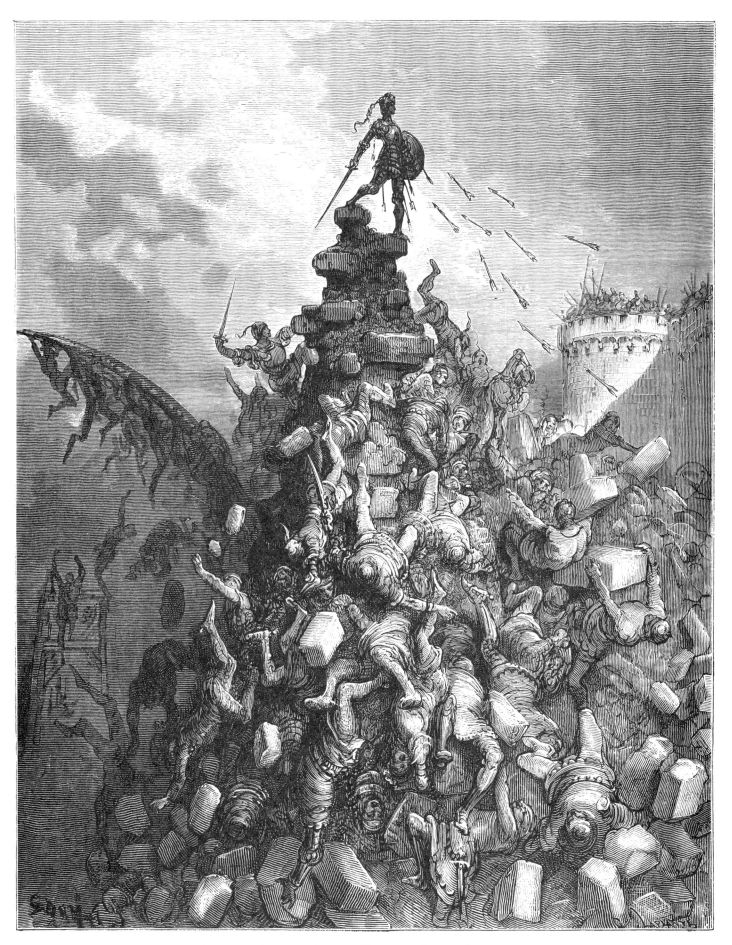

The besiegers of Bizerte take a tumble, except for Brandimarte (40:24).

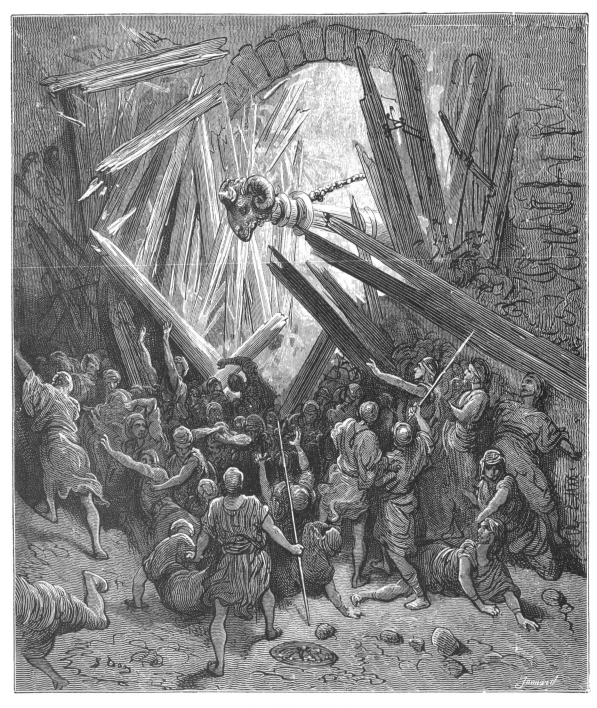

Battering rams breach the walls of Bizerte (40:30).

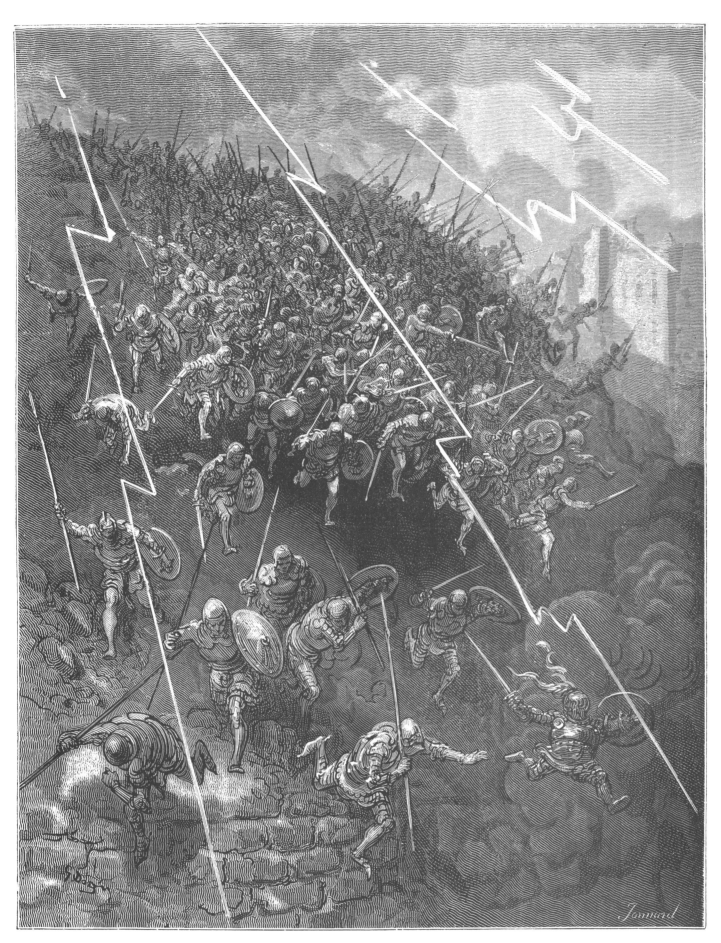

The storming of Bizerte (40:32).

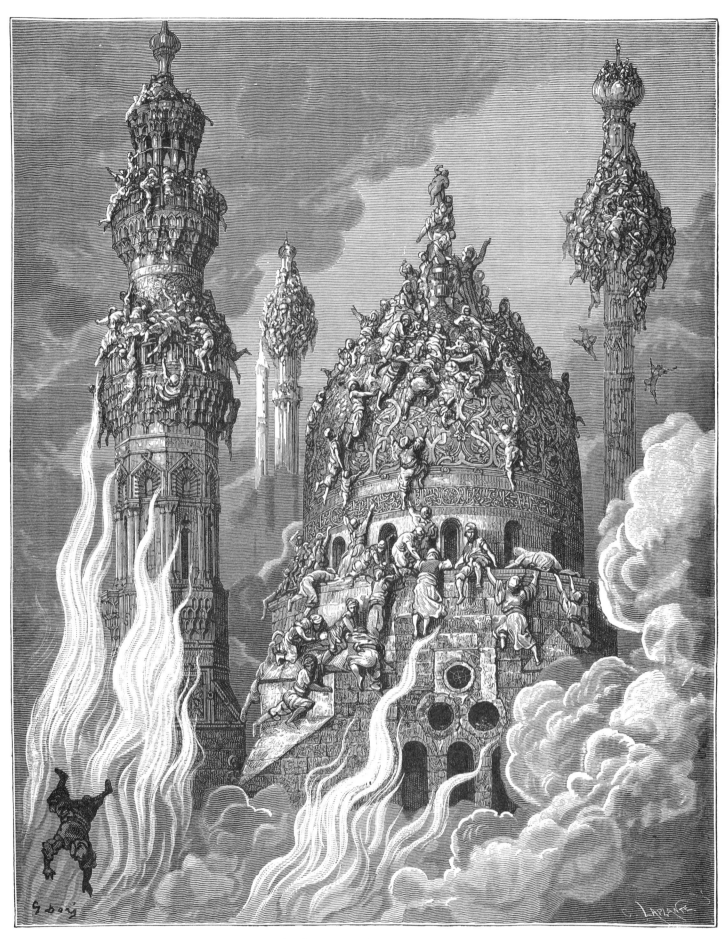

The destruction of Bizerte (40:33).

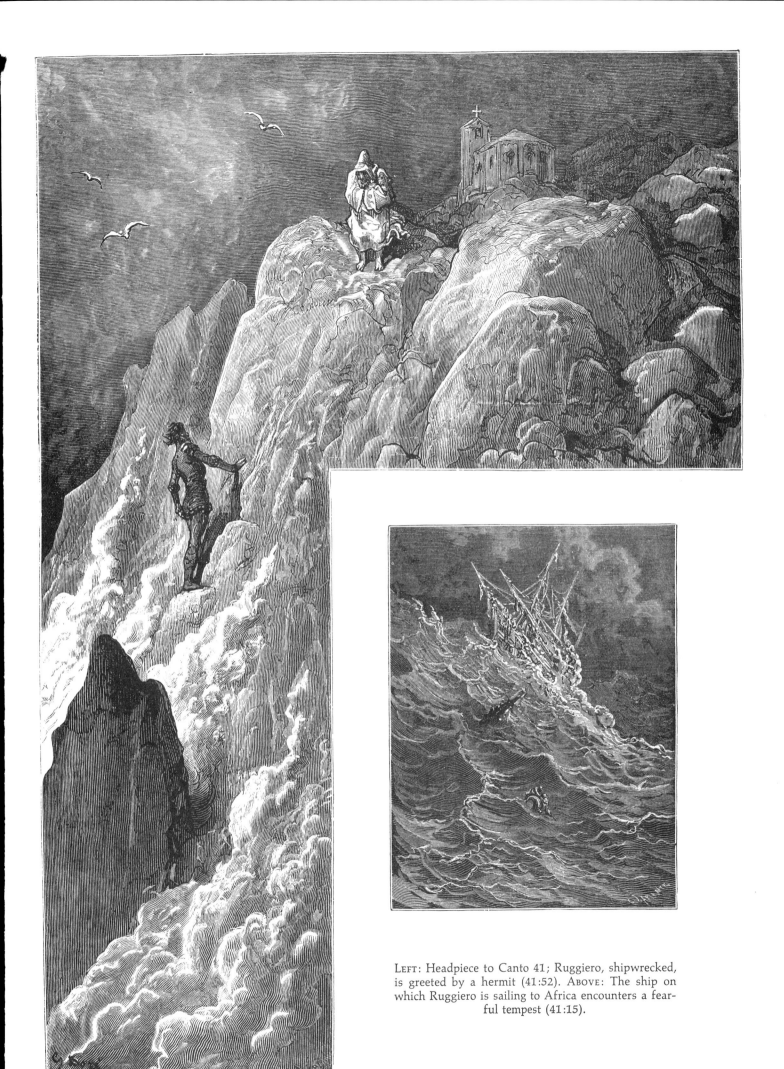

LEFT: Headpiece to Canto 41; Ruggiero, shipwrecked, is greeted by a hermit (41:52). ABOVE: The ship on which Ruggiero is sailing to Africa encounters a fearful tempest (41:15).

131

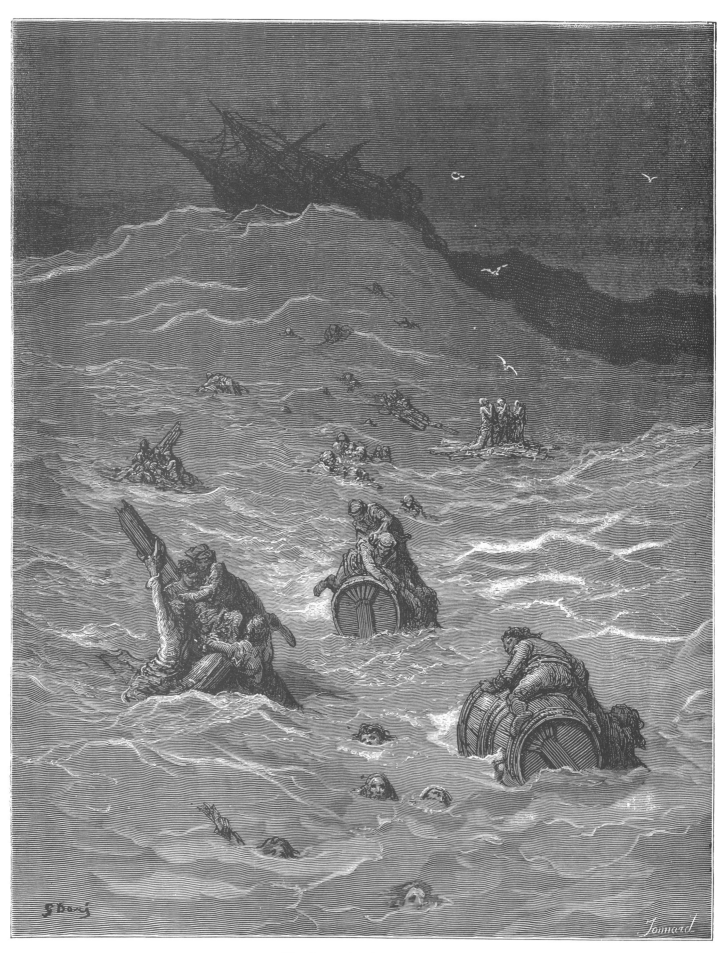

The ship is abandoned (41:18).

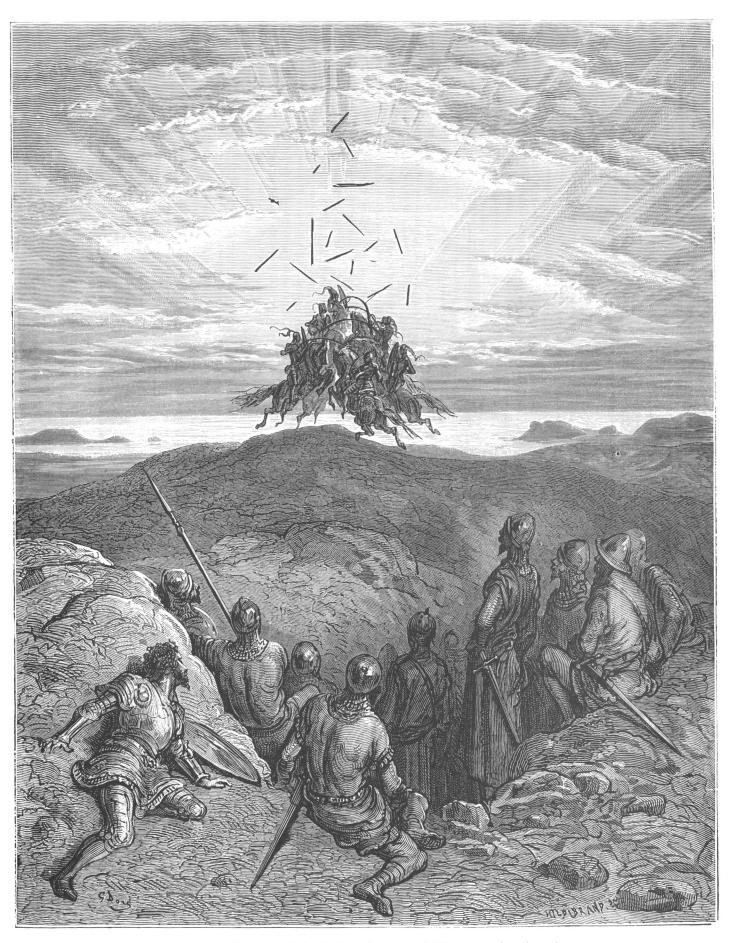

The Christian champions Orlando, Brandimarte and Oliviero combat the valiant
Moors Gradasso, Agramante and Sobrino (41:69).

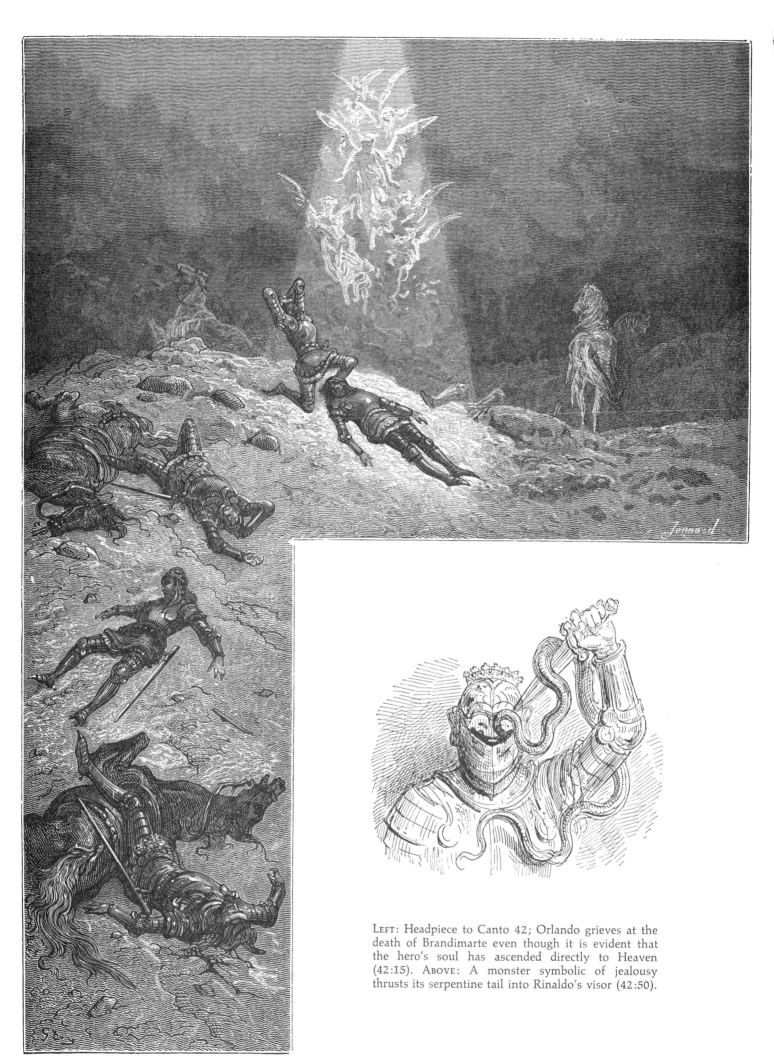

LEFT: Headpiece to Canto 42; Orlando grieves at the death of Brandimarte even though it is evident that the hero's soul has ascended directly to Heaven (42:15). ABOVE: A monster symbolic of jealousy thrusts its serpentine tail into Rinaldo's visor (42:50).

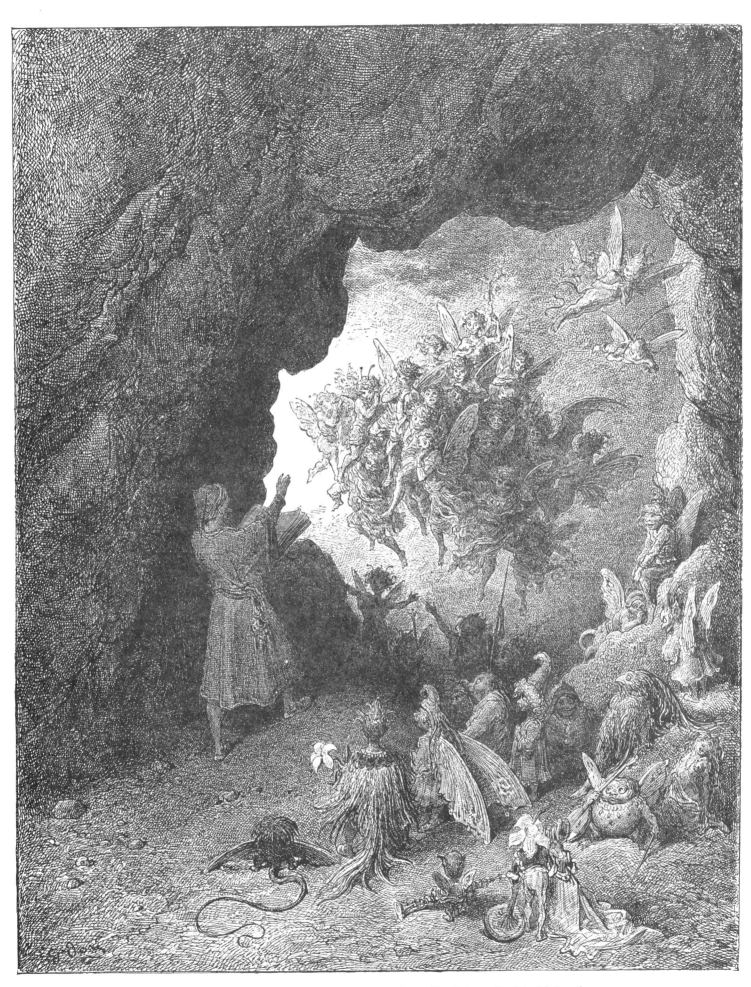

In his cave, Malagigi conjures up spirits who will tell him, for Rinaldo's sake,
what has become of Angelica (42:34).

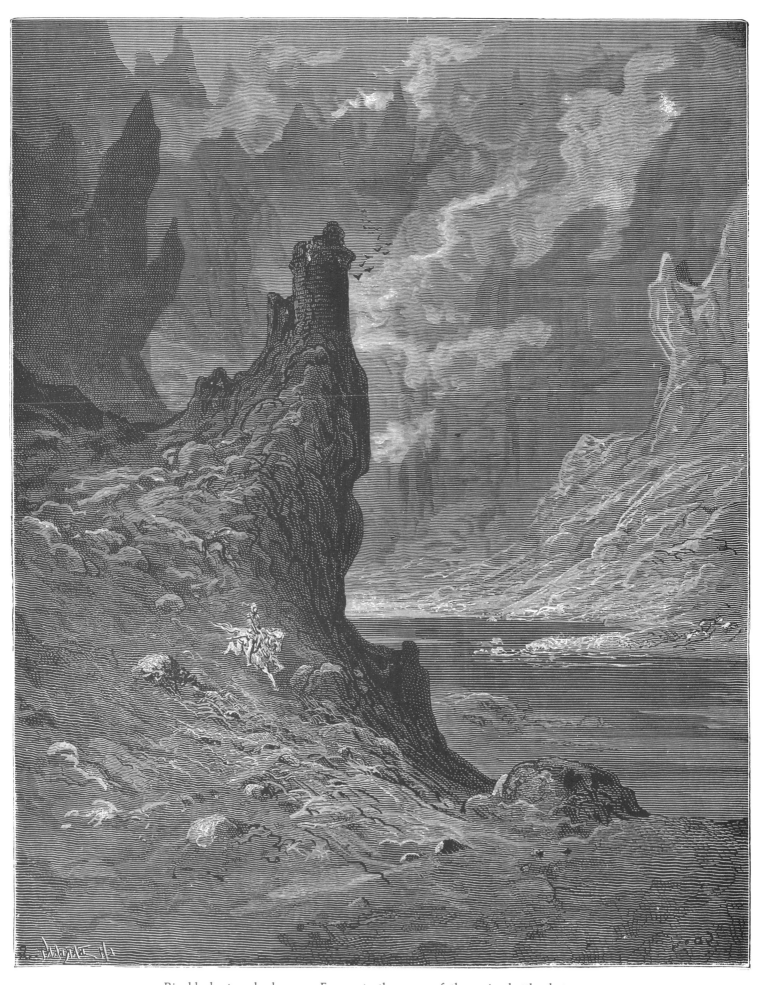

Rinaldo hastens back across Europe to the scene of the major battles between
Christians and Moors (42:69).

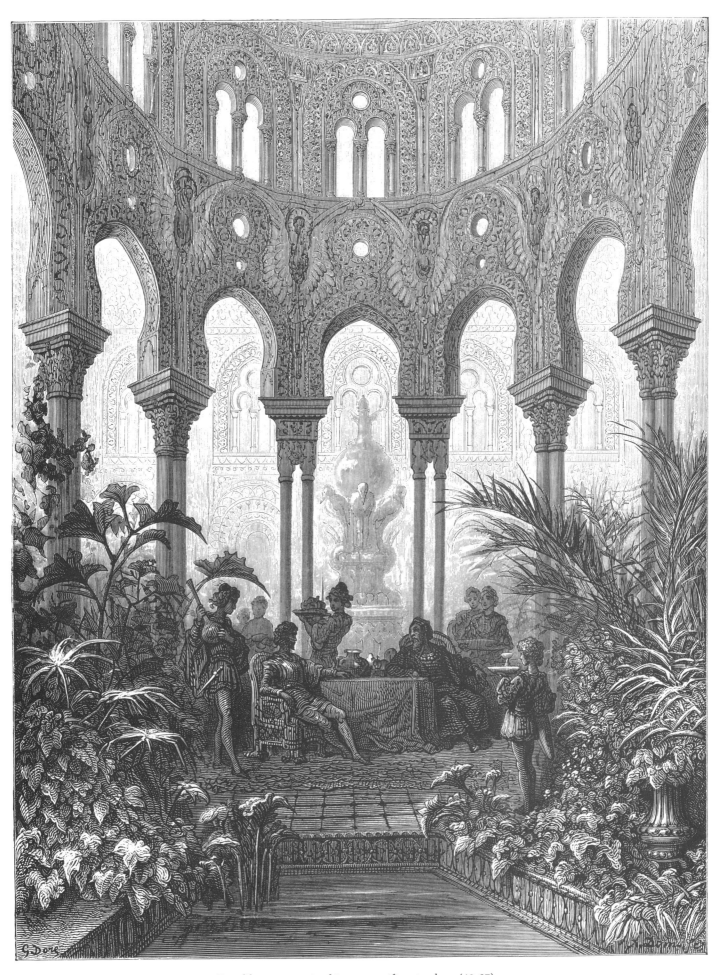

Rinaldo is entertained in a magnificent palace (42:97).

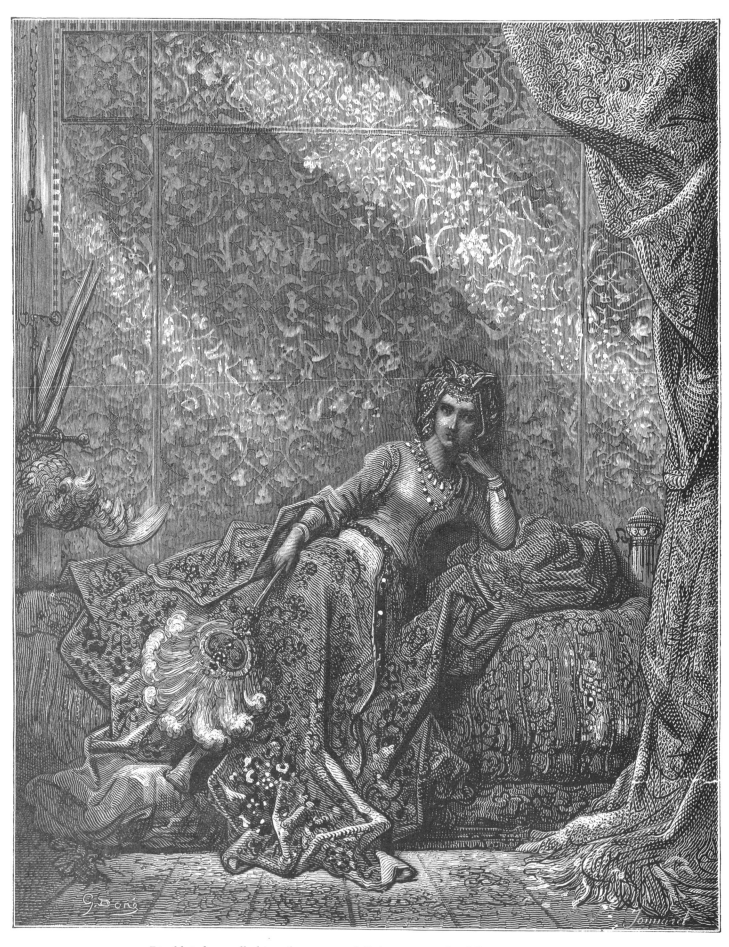

Rinaldo's host tells him of a woman skilled in magic who fell in love with him
(43:21).

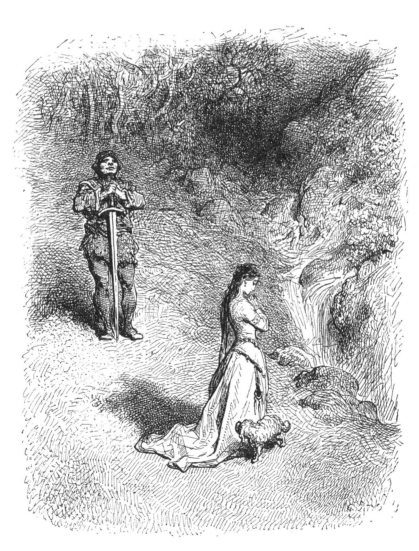

TOP LEFT: Judge Anselmo's astrologer friend (43:86). TOP RIGHT: Anselmo's wife Argia allows Adonio into her chambers because she is fascinated with his performing dog—really the fairy Manto in disguise (43:114). BOTTOM: Anselmo's servant tells Argia to pray because his master has ordered him to kill her for her adultery (43:126).

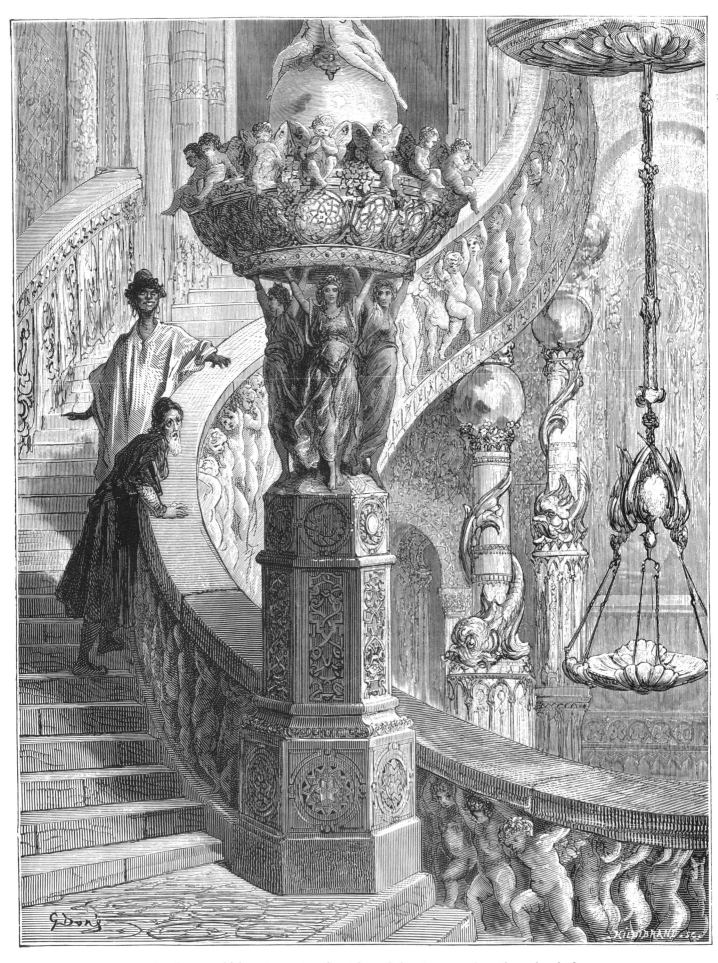

Anselmo would love to acquire the riches of the strange palace through which
he is conducted by his Ethiopian host (43:138).

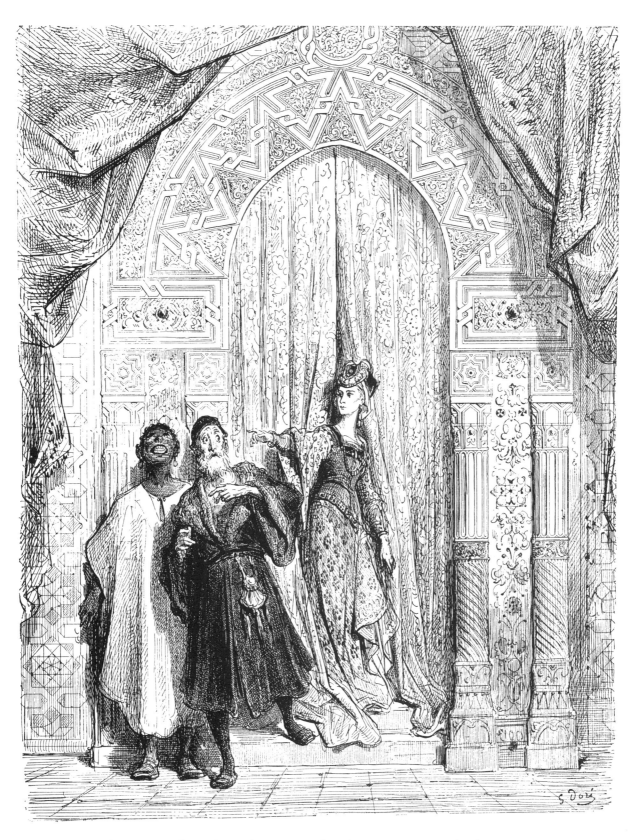

After Anselmo has submitted carnally to the Ethiopian as payment for the palace,
his wife Argia appears accusingly (43:140).

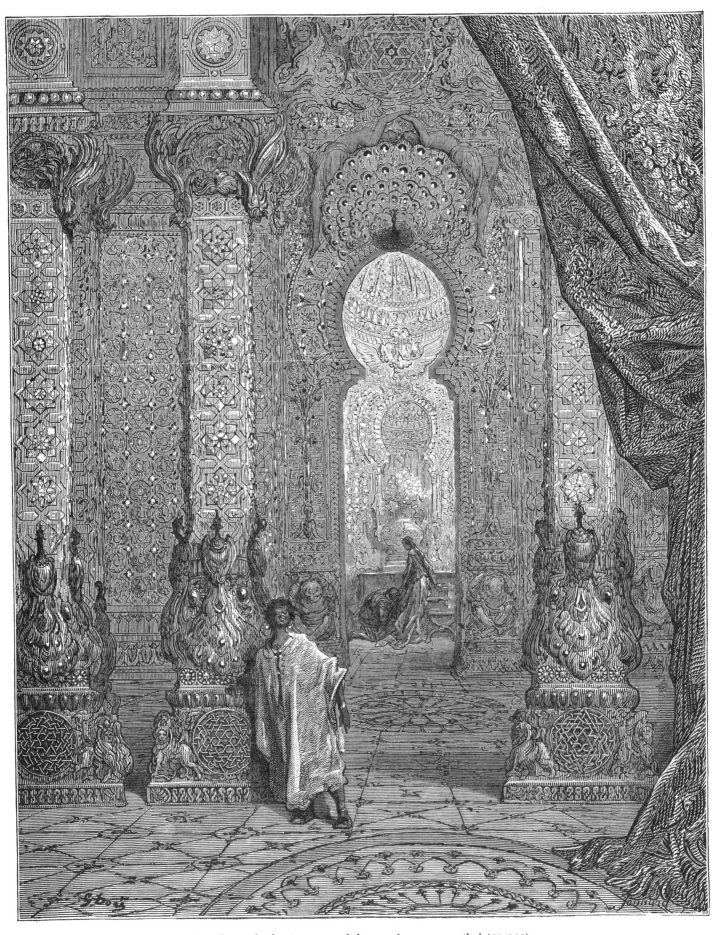

Anselmo asks forgiveness and the couple are reconciled (43:143).

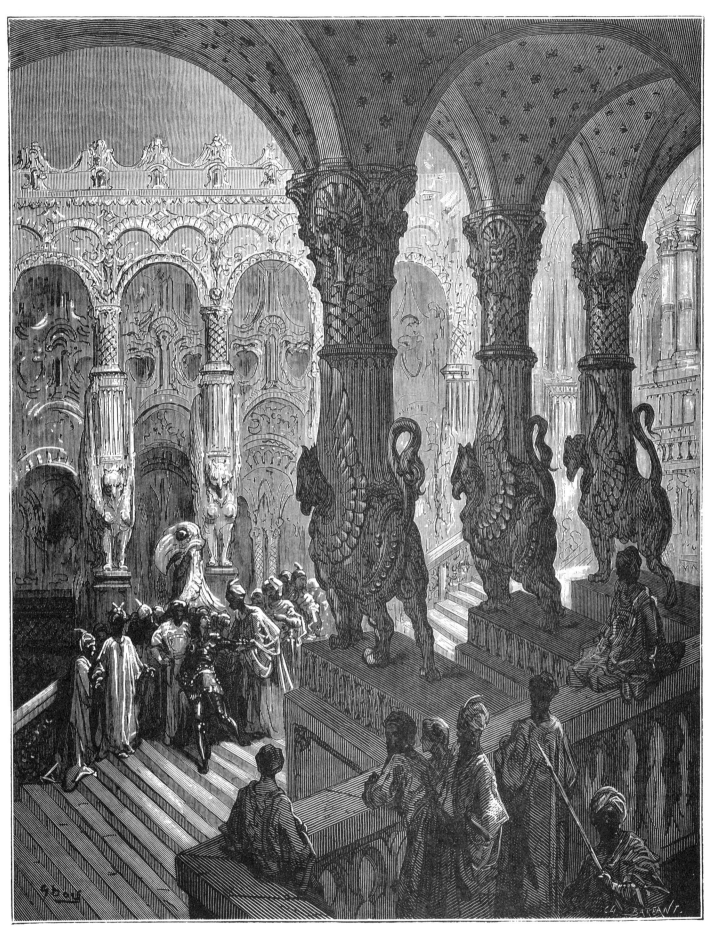

Astolfo takes final leave of the emperor of Ethiopia (44:21).

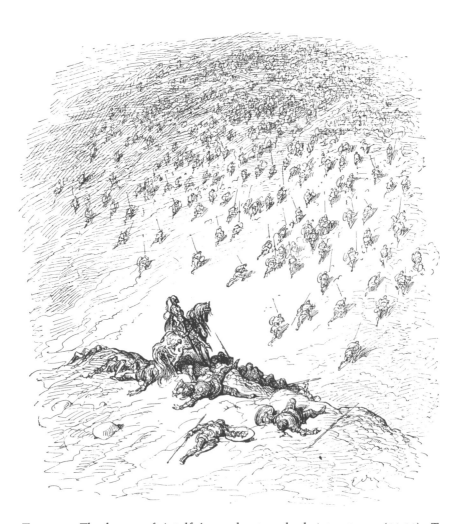

Top left: The horses of Astolfo's cavalry turn back into stones (44:23). Top right: Musicians amuse the people as Charlemagne prepares to entertain his paladins (44:34). Bottom: Ruggiero fights on the side of the Bulgars against Leo, son of the Byzantine emperor Constantine and his rival for Bradamante (44:95).

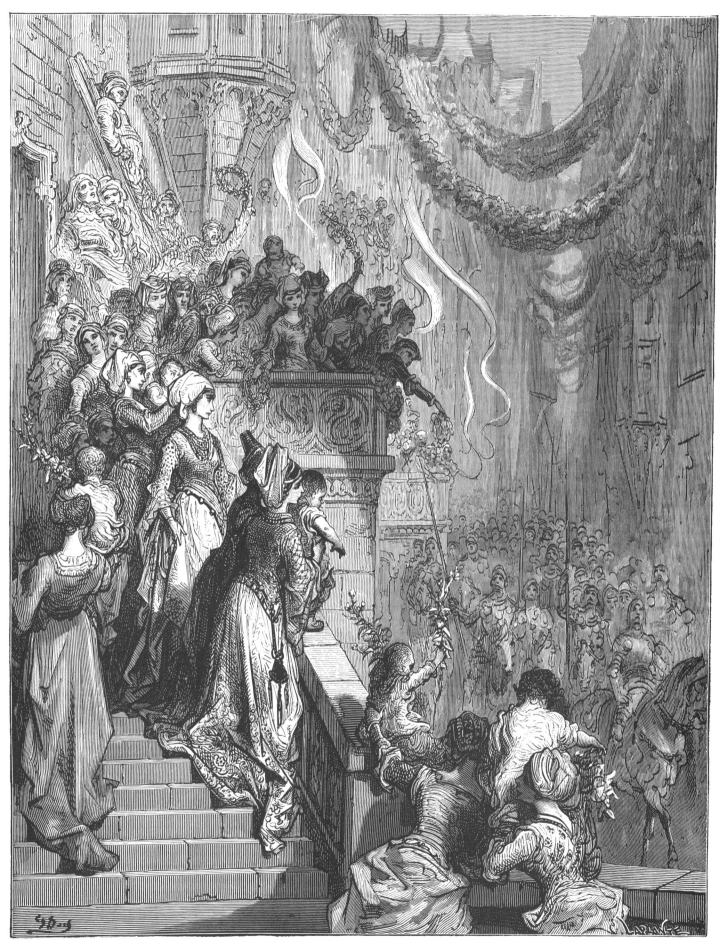

The Christian heroes enter the city to which Charlemagne has summoned them
(44:32).

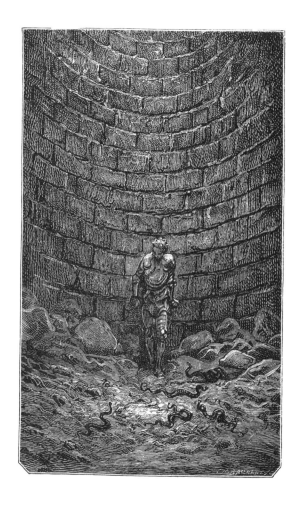

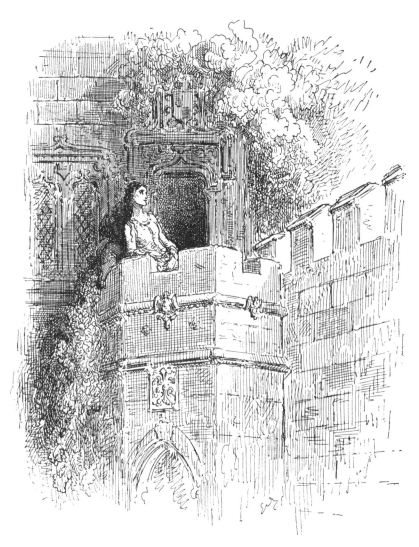

Top: Teodora, sister of Constantine, has Ruggiero imprisoned in a dark tower dungeon (45:20). Bottom: Bradamante pines for the absent Ruggiero (45:39).

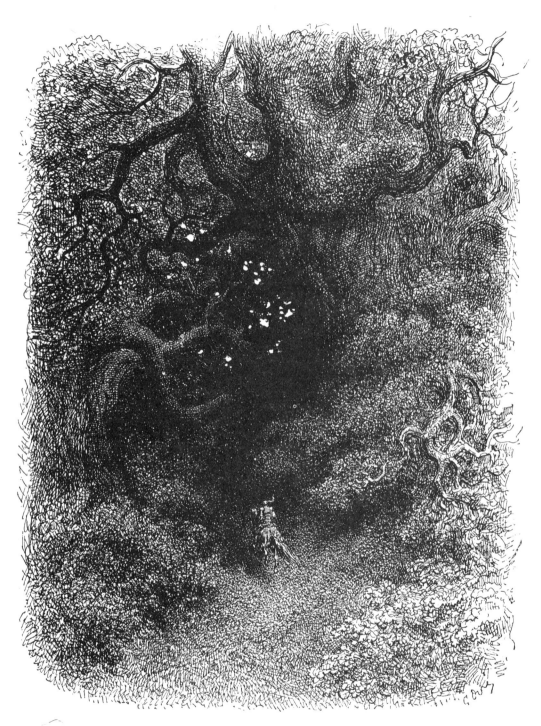

Ruggiero rides through the night, wretched because he feels he is duty-bound to
relinquish Bradamante to Leo (45:86).

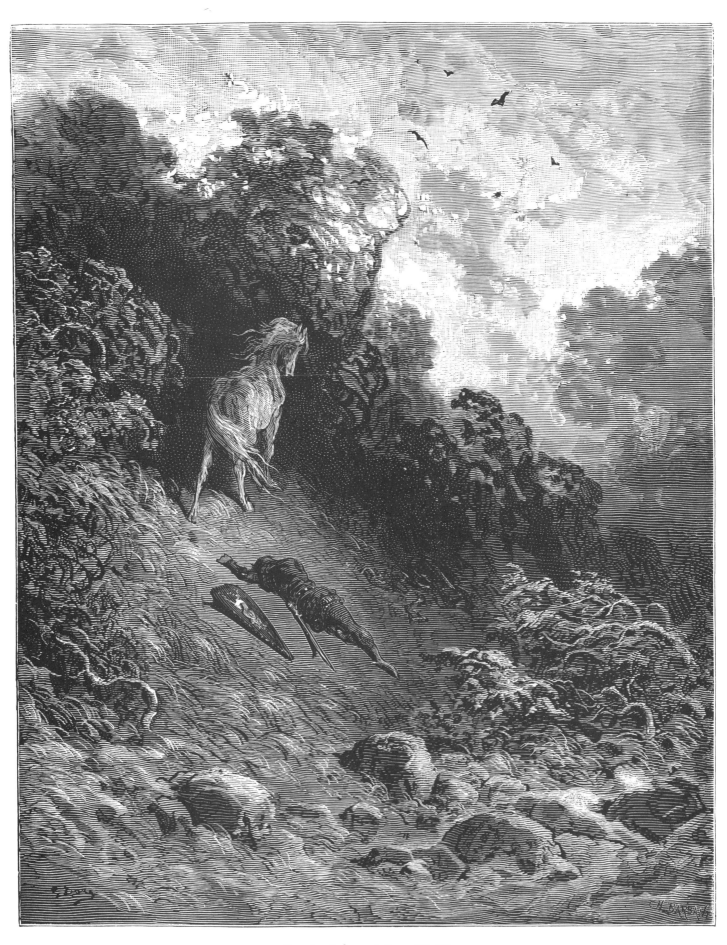

Ruggiero's lamentations (45:95).

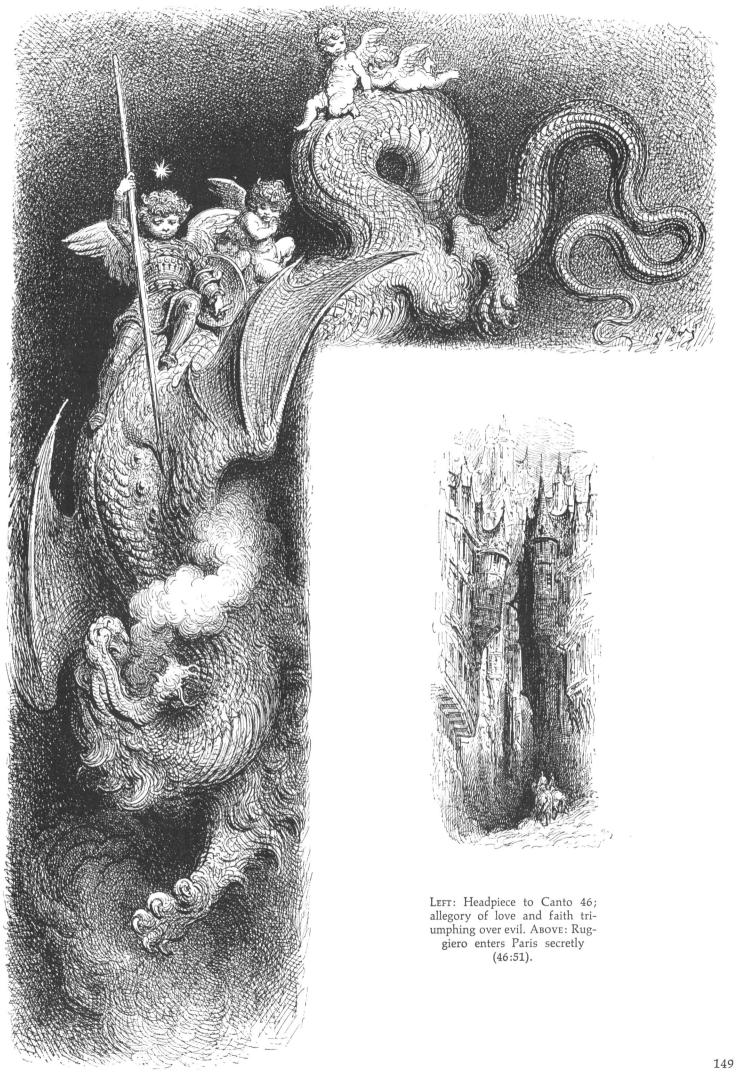

LEFT: Headpiece to Canto 46; allegory of love and faith triumphing over evil. ABOVE: Ruggiero enters Paris secretly (46:51).

Top: Ariosto pictures his author friends congratulating him on the imminent completion of his poem (46:12). Bottom: Ruggiero continues to grieve (46:25).

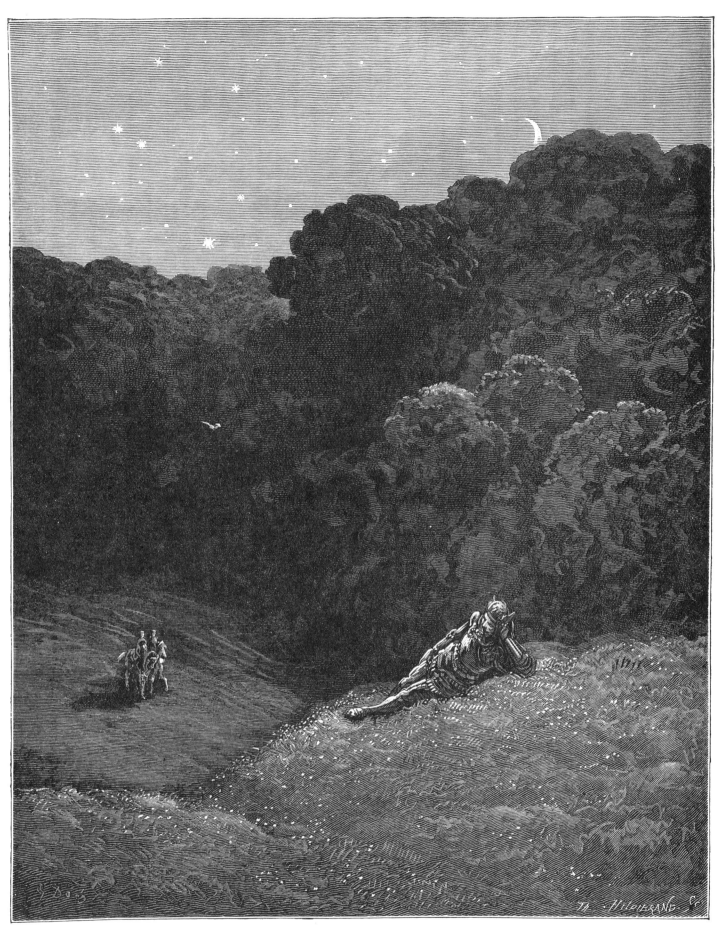

Leo and Melissa find Ruggiero nearly dead with grief and self-neglect (46:26).

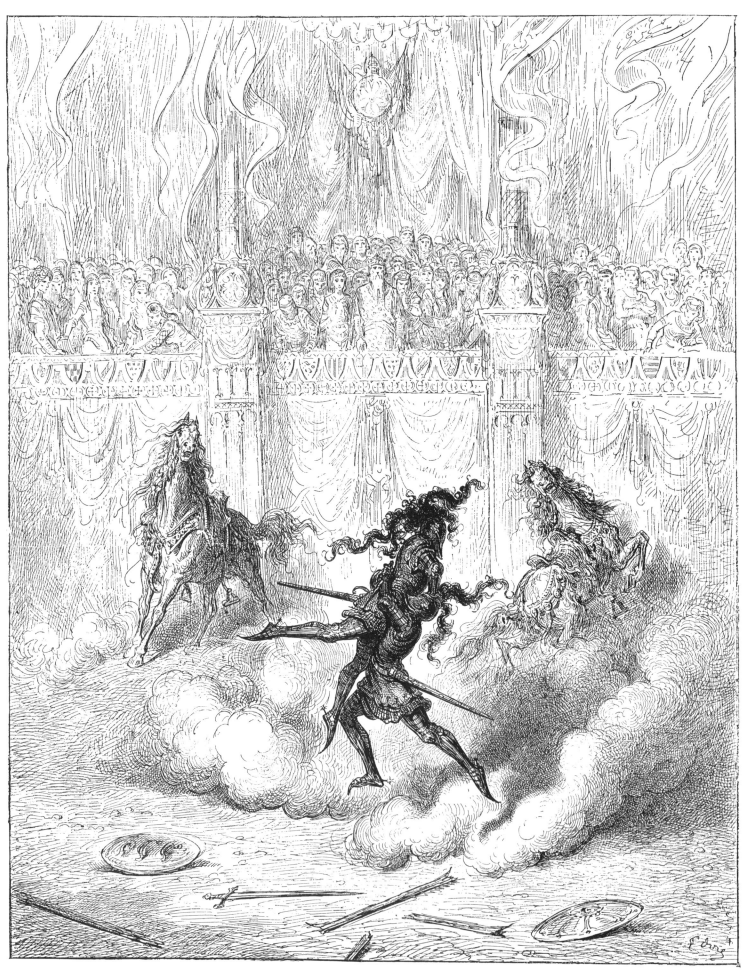

Having refrained from wearing arms for a year, a month and a day after Brada-
mante bested him at the narrow bridge, Rodomonte appears to combat Ruggiero
on the lovers' wedding day. The climax of the duel, when Ruggiero lifts Rodo-
monte bodily (46:134).

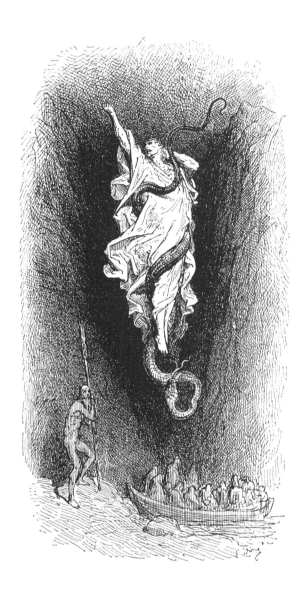

Top: Tailpiece to Canto 46, illustrating the final words of the poem (46:140), which refer to Rodomonte. "To the dreary banks of Acheron, released from its body that was colder than ice, fled blaspheming the angry soul that was so haughty in the world and so prideful." Bottom: Tailpiece to the translator's notes (final picture in the volume); Doré's acid commentary on the heroics of love and war.